WITHDRAWN FROM
THE LIBRARY

UNIVERSITY OF
WINCHESTER

KA 0398008 1

Storyboarding

Palgrave Studies in Screenwriting

Series Editors: **Ian W. Macdonald**, University of Leeds, UK, **Steven Maras**, University of Sydney, Australia, **Kathryn Millard**, Macquarie University, Australia, **J. J. Murphy**, University of Wisconsin-Madison, USA

Advisory Board: **John Adams**, University of Bristol, UK, **Jill Nelmes**, East London University, UK, **Steven Price**, Bangor University, UK, **Eva Novrup Redvall**, University of Copenhagen, Denmark, **Kristin Thompson**, University of Wisconsin-Madison, USA, **Paul Wells**, Loughborough University, UK

Palgrave Studies in Screenwriting is the first book series to focus on the academic study of screenwriting. It seeks to promote an informed and critical account of screenwriting and of the screenplay, looking at the connections between what is produced and how it is produced, with a view to understanding more about the diversity of screenwriting practice and its texts. The scope of the series encompasses a range of study from the creation and recording of the screen idea, to the processes of production, to the structures that form and inform those processes, to the agents, their beliefs and the discourses that create those texts.

Ian W. Macdonald
SCREENWRITING POETICS AND THE SCREEN IDEA

Kathryn Millard
SCREENWRITING IN A DIGITAL ERA

Eva Novrup Redvall
WRITING AND PRODUCING TELEVISION DRAMA IN DENMARK
From *The Kingdom* to *The Killing*

Chris Pallant and Steven Price
STORYBOARDING
A Critical History

Palgrave Studies in Screenwriting
Series Standing Order ISBN 978–1–137–28720–5 (hardback)
 978–1–137–28721–2 (paperback)
(*outside North America only*)

You can receive future titles in this series as they are published by placing a standing order. Please contact your bookseller or, in case of difficulty, write to us at the address below with your name and address, the title of the series and one of the ISBNs quoted above.

Customer Services Department, Macmillan Distribution Ltd, Houndmills, Basingstoke, Hampshire RG21 6XS, England

Storyboarding

A Critical History

Chris Pallant
Canterbury Christ Church University, UK

and

Steven Price
Bangor University, UK

UNIVERSITY OF WINCHESTER
LIBRARY

© Chris Pallant and Steven Price 2015

All rights reserved. No reproduction, copy or transmission of this publication may be made without written permission.

No portion of this publication may be reproduced, copied or transmitted save with written permission or in accordance with the provisions of the Copyright, Designs and Patents Act 1988, or under the terms of any licence permitting limited copying issued by the Copyright Licensing Agency, Saffron House, 6–10 Kirby Street, London EC1N 8TS.

Any person who does any unauthorized act in relation to this publication may be liable to criminal prosecution and civil claims for damages.

The authors have asserted their rights to be identified as the authors of this work in accordance with the Copyright, Designs and Patents Act 1988.

First published 2015 by
PALGRAVE MACMILLAN

Palgrave Macmillan in the UK is an imprint of Macmillan Publishers Limited, registered in England, company number 785998, of Houndmills, Basingstoke, Hampshire RG21 6XS.

Palgrave Macmillan in the US is a division of St Martin's Press LLC, 175 Fifth Avenue, New York, NY 10010.

Palgrave Macmillan is the global academic imprint of the above companies and has companies and representatives throughout the world.

Palgrave® and Macmillan® are registered trademarks in the United States, the United Kingdom, Europe and other countries.

ISBN: 978–1–137–02759–7

This book is printed on paper suitable for recycling and made from fully managed and sustained forest sources. Logging, pulping and manufacturing processes are expected to conform to the environmental regulations of the country of origin.

A catalogue record for this book is available from the British Library.

Library of Congress Cataloging-in-Publication Data

Pallant, Chris.
 Storyboarding : a critical history / Chris Pallant, Steven Price.
 pages cm.—(Palgrave studies in screenwriting)
 Includes bibliographical references and index.
 Includes filmography.
 ISBN 978–1–137–02759–7 (hardback)
 1. Storyboards – History. 2. Motion pictures – Production and direction.
 3. Animated films – Production and direction. I. Price, Steven, 1964– II. Title.

NC1002.S85P36 2015
791.4302′3—dc23 2015020285

Contents

List of Figures

Acknowledgements

We are indebted to the British Academy for an award under their Small Research Grant scheme which enabled us to conduct some of the primary research in the United States, and to secure the image reproductions. We are grateful for the assistance of the staff at many institutions: the Margaret Herrick Library, Academy of Motion Picture Arts and Sciences, Los Angeles – especially Jenny Romero, Barbara Hall, and Kristine Krueger; Joanne Lammers at the Writers Guild Foundation Library, Los Angeles; Rosemarie Knopka at the Art Directors Guild, Los Angeles; Claire Smith, Jonny Davies, and Nathalie Morris at the Reuben Library, British Film Institute, London; Gene Bundy at the Williamson SF Library, Eastern New Mexico University; Albert Palacios and Steve Wilson at the Harry Ransom Center, University of Texas at Austin; Daniel Selznick, President of Selznick Properties, Ltd; and Roni Lubliner at NBC Universal.

Storyboard artists Vera Brosgol, Marty Kline, Dave Lowery, Alex Tavoularis and Tony Walton, and visual effects artists and animators Mark Austin, Michael Fink, Samy Fecih, and Frank Gladstone were generous with their time and assistance, as were Daniel McCoy at Pixar Studios; Dan Richards and Stuart Clark at A+C; Mark Shapiro at LAIKA; and, at the Ray and Diana Harryhausen Foundation, the late Ray Harryhausen, John Walsh, and Tony Dalton. Julia Knaus provided us with invaluable translations of German language sources.

At Palgrave Macmillan, we are indebted to Felicity Plester and Chris Penfold for their commitment to the project throughout, and to the editorial team of the Studies in Screenwriting series: Ian Macdonald, Steven Maras, Kathryn Millard, and especially our volume editor, J. J. Murphy. We have benefited from the opportunity to present some of our preliminary findings at the Screenwriting Research Network's conference at Madison, Wisconsin in 2013; at the Society for Animation Studies conference at Sheridan College, Toronto in 2014; at two British Association of Film, Television and Screen Studies conferences, first at the University of London in 2014 and subsequently at Manchester Metropolitan University in 2015; at the International Trickfilm Festival: Festival of Animated Film, at the Literaturhaus, Stuttgart in 2015; at the Symposium on Storyboarding, at the Deutsche Kinemathek, Berlin in 2015; and at the London Screenwriting Research Seminar, co-ordinated by Adam Ganz.

Introduction

Why is a book about storyboarding appearing in a series entitled 'Studies in Screenwriting'? One might think the two practices are almost diametrically opposed. A screenplay tells a story in verbal form; a storyboard is visual. Screenwriting has existed, in some form, at least since the emergence of narrative films around 1903, whereas it is commonly held that storyboarding began in advertising and in animation, notably with the Walt Disney studio's *Snow White and the Seven Dwarfs* (1937), becoming established in live-action narrative cinema only with pre-production on *Gone with the Wind* (1939). For most studio-produced narrative films, a screenplay (albeit one that is likely to differ from the final shooting script) will have been written in advance of production, telling the whole story of the film – among other reasons, to make clear to potential artists and financial backers where their creative or economic energies will be invested. On the other hand, while some films are storyboarded in their entirety, most are not; if required, their production is often piecemeal and ad hoc, created to assist in the visualisation of particular elements of a film such as complex action sequences.

Storyboarding and screenwriting

Even in such a bald summary, however, certain cognate questions arise: about collaboration, pre-production, the relationships between a film and its pre-texts, and so on. In East Germany, in the 1960s, the story-board was even referred to, pleasingly, as the 'optisches Drehbuch' ('optical screenplay').[1] Throughout this book we shall be examining storyboards in these contexts of production and practical film-making. However, connections between storyboarding and screenwriting become

1

still more apparent when raised not in the context of practice, but of screenwriting (or storyboarding) *studies*. While film studies, media studies, and of course literary studies now have relatively long histories and well-established methodological practices, until very recently there has been almost no serious scholarship or analysis in the fields of either screenwriting or storyboarding; and the neglect of these two areas has been for very similar reasons.

Putting it starkly again, both film industries and academic film criticism have, until very recently and with some exceptions, tended to regard both screenplays and storyboards as little more than industrial waste products. Studies of cinema have tended to pay attention to completed films, and screenplays or storyboards could be largely ignored because they were merely staging posts on the journey towards the creation of a final work. Consequently, to the extent that they received any attention at all, it tended to be in the earlier chapters of book-length studies of individual films (of *The Making of...* variety). This marginalisation occurs in a different form within industrial practice: once the film is completed, the documents generated in their creation can be discarded. 'Everyone knows that when shooting is over, screenplays generally end up in studio wastebaskets', remarks the eminent screenwriter Jean-Claude Carrière, without regret.[2] The written texts used in the creation of films were indeed frequently consigned to the wastepaper basket, or even, in industrial-scale incidents of destruction, builders' skips.[3] An extremely important exception is Hollywood, where copies of screenplays were routinely retained even in the silent era as part of the studios' record-keeping practices. This means that, while there is no shortage of room for disagreement and differences of emphasis, it is possible to trace a broad history of screenwriting in Hollywood, if not always in other industries and countries.

The same cannot be said of storyboarding, however, to which the studios took a different approach. They did not systematically archive materials created within their art departments; storyboards were drawn on an ad hoc basis, and if they were created at all, they were frequently separated after shooting from the written records that were retained. Many of those that were produced failed to survive: partly because they were ephemeral documents that could be discarded after use, and partly because of the costs and other practical difficulties of archiving artwork as a routine measure. Moreover, the later downsizing and break-up of several studios in the 1970s meant that many of those materials that had been preserved were jettisoned, their survival becoming a matter of happenstance. As the author of a recent book

remarks, '[w]hen the studios broke up and the lots were taken apart, many valuable storyboards were sacrificed in the clear-out. Random works now survive in archives and in private collections – literally, the luck of the draw'.[4]

This has serious consequences for the researcher interested in story-boarding. Several major collections, such as the Warner Brothers archive at the University of Madison-Wisconsin, the MGM collection at the Margaret Herrick Library of the Academy of Motion Picture Arts and Sciences in Los Angeles (MHL), and the otherwise impressively full set of documents relating to the films of Alfred Hitchcock, which are also held at the MHL and which have formed the source material for several detailed studies of the director's work, contain enormous quantities of draft screenplays and shooting scripts, but little material relating to storyboarding. In a few cases, a reconstruction of sorts can be attempted by drawing on other collections: for instance, reproductions of images created for Hitchcock's *Psycho* (1960) are held in the Saul Bass collection in the same library as Hitchcock's own archive relating to the same film. The generally haphazard treatment of materials, however, is well illustrated by the fate of the artwork created by or under the direction of William Cameron Menzies for *Gone with the Wind* (1939), a large proportion of which has vanished after being sold, given away, or lost in transit.[5]

The initially casual approach of the studios to the preservation of story-boards can trap the researcher in this area in a double bind. On the one hand, for the reasons noted, the documentary record is fragmentary. On the other hand, although Hollywood was late to recognize the potential ancillary value of the reams of artwork accumulated in the creation of its films, once the commercial potential for their exploitation came to be understood the studios started to exert more pronounced control over their dissemination. One consequence is that potentially prohibitive costs confront researchers hoping to reproduce those materials that did survive. The study of screenwriting has been less extensively hampered by these conditions, since 'fair use' enables the scholar to reproduce a sense of the verbal style and other aspects of a screenplay without being confronted by quite the same permissions and copyright problems of facsimile reproduction, desirable though such reproduction might be. Meanwhile, unlike cognate areas such as literary criticism, which at least in theory tends to allow commentators to work with stable, published texts that have been edited with the needs of the scholar in mind, research into both screenwriting and storyboarding is hampered by a fragmentary historical record in which relatively little material has been

published in a form helpful to the critic lacking regular access to archival collections.

In addition to the piecemeal nature of the available materials, there is a second reason why few firm generalisations about storyboarding as a system can confidently be made: their sheer diversity, which contrasts with the relative formal regularity of screenplays. The latter tend to reproduce many generic elements, with a fairly uniform approach to matters of layout and formatting persisting throughout the classical studio period from the beginnings of sound onwards, especially in individual studios. After the decline of the studio system, a standardised approach to matters of formal screenplay presentation has been disseminated via screenwriting manuals and frontline studio readers, and although there are of course exceptions, this is apparent in most of the shooting scripts for films produced in mainstream film industries.[6] Meanwhile, the particular stylistic traits of a given writer – an ability to create distinctive dialogue, for example – is often held to be of lesser importance (in manuals, at any rate) than the ability to reproduce generic essentials such as structure, or to write a scene in a such a way that it can easily be broken down into discrete shots. For critics attempting to establish the singularity of a particular screenwriter's voice, the difficulty has lain in disentangling that voice from the generic orthodoxy of the screenplay as an industrial form, and from the contributions of other writers within scripts that in very many cases will be the result of extensive collaboration. In short, screenwriting research is hampered by a problem of establishing singularity in the face of generality.

A certain rigidity in notions of storyboarding form can take shape, just as it has with the screenplay. Beyond the familiar, general-purpose word-processing applications that can be used to produce screenplays and storyboards, several bespoke software 'solutions' have also been developed in recent years with the screenwriter and storyboarder in mind. Screenwriting software such as FinalDraft, which debuted in 2001, is almost universally used; meanwhile, for the professional storyboard artist there are applications such as Hibbert Ralph Animation's RedBoard, and Storyboard Pro from Toon Boom, although the pairing of Adobe Photoshop with a digital stylus and tablet is often preferred. For the aspiring amateur, a recent wave of applications designed for Apple's iPad offer, with varying degrees of success, all-in-one packages for storyboard creation.

Despite this, the history of storyboarding confronts the scholar with quite the opposite problem to that posed by screenwriting. It can be

plausibly said that individual storyboards display unique properties; they 'are just as different as the films for which they were created, reaching from soft, monochrome works in pencil or ink to powerful executions with an explosion of colour in coloured pencils, felt markers, chalk and watercolours [*aquarelle*]'.[7] In Vincent LoBrutto's words, '[s]toryboards visualize a film shot by shot', but 'can be comprised of expressive drawings or little more than stick figures'.[8] The nature of the medium makes the singularity of the individual storyboard artist's style more immediately apparent than is the case with the screenwriter. Certain kinds of regularity can be discerned in the history of storyboarding, just as aspects of individuality can be identified in the works of particular screenwriters, but what connects the study of the two practices is that each encounters the same problem – of arriving at a helpful balance between particularity and generality – but from opposite ends of the spectrum.

Screenplays, storyboards, and the blueprint metaphor

There is another area, too, in which screenwriting and storyboarding confront the analyst with cognate questions. Until very recently, the tendency to describe screenplays as 'blueprints' for films was almost ubiquitous. Exactly the same phenomenon is encountered with the storyboard, which Fionnuala Halligan, in her study of storyboards from an art history perspective, sees as 'a blueprint for a finished feature'.[9] The analogy is pervasive, with John Hart, from the completely different viewpoint of the practical 'how-to' guide, stating that storyboards are 'a vital blueprint that will be referred to [...] during the entire shooting schedule of the production and frequently right into the postproduction editing process'.[10]

Immediately, one is confronted with the problem that two very different documents, the screenplay and the storyboard, are held to have the same status, of being a blueprint for the future film. This demands consideration of the relationships between them. Since one is verbal and the other visual, we could propose that they represent two different ways of conceiving of the same material or story. Alternatively, we may be persuaded by Halligan's arresting subtitle to her book *Movie Storyboards: The Art of Visualizing Screenplays*. This implies that the storyboard takes its place in a linear series of discrete stages in film production, with the screenplay preceding the work on the storyboard, which is then followed by filming and post-production. While the neatness of this presentation of the process has a theoretical appeal, and we shall

certainly encounter many examples of storyboards that directly translate the written text of the screenplay into a precise series of visual images, the process of most actual film production tends to be messier and more complicated.

In several recent critical discussions of screenwriting, the blueprint analogy has been extensively discussed and widely contested. There are several reasons for this, but perhaps the most significant and pertinent objection in the storyboarding context concerns the implication that a neat distinction can be identified between a 'conception' stage to which both screenwriting and storyboarding belong, and an 'execution' stage in which the ideas worked out on paper in advance are filmed, and then edited and augmented in post-production. Steven Maras notes that the blueprint figure does have certain virtues, and for our purposes we may connect these as much to storyboarding as to screenwriting: 'Firstly, the idea connects the script to the process of production of which screenplay writing [and storyboarding] is a part; secondly, it foregrounds the composition or design dimension of cinema; and thirdly, it highlights the industrial scale of much film production'.[11] These arguments can certainly do justice to the design element of which storyboarding forms a part, although as we shall see, it would be more appropriate to associate storyboarding with narrative development, editing, camera angles, and so on, rather than with the broader architectural design of sets and costumes that is more properly the domain of concept art. Moreover, the storyboard tells us much less than the screenplay about 'industrial scale'. In the classical Hollywood era, the screenplay had multiple strategic purposes: it presented a film story in verbal form, but it also indicated divisions of labour (assisting the location manager in working out the number of scenes required in each location, for instance), which consequently made the screenplay a key document in budgeting. For these and other reasons, the submission of a final-draft screenplay was in almost every case a requirement in the planning of a Hollywood film, regardless of the extent to which the released version of the film deviated from that text. The storyboard is quite different, usually being created for localised, tactical purposes: to pre-visualise technical questions in editing or effects, for example.

This brings us to what Maras sees as the problems with the blueprint figure: 'The first has to do with the blueprint as a means of controlling production, the second with the technical nature of a blueprint and the third with the way the blueprint attempts to have the last word on planning'.[12] Regardless of the extent to which screenplays can or

should fulfill such functions, for similar reasons to those already noted the storyboard only very rarely functions as a blueprint in this sense; and then again, usually only for particular scenes. Seen in this light the blueprint becomes a needlessly restricted and prescriptive analogy, and we would do better to follow Kathryn Millard in adopting instead the figure of the 'prototype', positioning storyboards and written texts as only some possibilities among the many different kinds of material that a film-maker can exploit in preparing a project, including maps, graphic novels, sounds, videos, and so on.[13]

To insist on a radical separation of conception and execution of the precise kind implied in the blueprint metaphor also entails positing a particular kind of film, one that is largely hostile to improvisation.[14] Empirical research into individual film projects, of the kinds we shall be examining in later chapters of this book, has tended to undermine the neatness of the conception/execution model. Put briefly, film projects tend to be in a continuous process of revision throughout pre-production, shooting, and post-production; neither screenplays nor storyboards can possibly anticipate all of the vagaries of the process; and storyboards of many different kinds, just like screenplay revisions, are frequently composed on the spot in order to overcome difficulties or to try alternate approaches to individual scenes. Many will be revised, rearranged, or redrawn in response either to changes in the script or for other practical reasons. And, as we shall see, it is far from unknown for storyboards to be redrafted or even entirely composed after shooting has been completed.

Just as the publication of particular screenplays has had a tendency to fix for the reader a particular form for a written text that in most cases will instead have been subject to frequent and routine revision, so, too, the presentation of storyboards in fixed and linear sequences has had the effect of causing the viewer to perceive a definite narrative arrangement that often directly seems to anticipate the film as finally released. And, once again, this can be deeply misleading. In a catalogue accompanying a recent German exhibition of a very wide range of storyboards, Kristina Jaspers notes that while in many cases the images are presented in a consecutive numbered sequence, often they show evidence of crossings-out and renumbering.[15] This obvious point – that the frames of a storyboard can be rearranged to form different sequences and effects, just like strips of film in the process of editing – tends to be obscured in published storyboards, which fix a particular order in the mind of the reader, as does the completed film. This obscuring of a process of revision in pre-production and production can have

the effect of exaggerating the correspondence between storyboard and film, giving a distorted sense of the extent to which the former can be regarded as a precise blueprint of the latter.

Storyboards, animation, comics, and concept art

Despite the extraordinary variety of storyboarding materials and techniques, it is nevertheless possible and necessary to establish certain parameters of regularity. Generically, the storyboard can be distinguished from three other similar forms to which it is closely connected and with which it is often confused: animation, the narrative comic or *bande dessinée*, and concept art.

John Hart comes close to equating storyboarding and animation by titling the introductory chapter of his 1999 study *The Art of the Storyboard* 'The Storyboard's Beginnings: A Short History of Animation'. Describing the 'root' of storyboarding as 'telling a story through a history of drawings', Hart notes the precursors of animation in 'the traveling magic lantern shows of the 1600s and [...] the Optical Illusions of Phantasmagoria in the 1800s', before sketching a history of animated films beginning with the trick films of Georges Méliès at the end of the nineteenth century.[16] As Hart observes, '[e]ach of these animated cartoons, from *Felix the Cat* in 1914 to *Toy Story* in 1995, began as a drawing or series of drawings, just as so many popular cartoon characters like Popeye and Krazy Kat started as that prime example of a storyboard, the comic strip'.[17]

However, while the connection is undoubtedly significant (and it is one that we consider in Chapter 1 of this book), there is a clear danger of confusing distinct functions and practices if one suggests that a comic strip *is* a storyboard – or, indeed, that either of these *is* a film. Formally, the connection is clear: Hart notes in comics 'a very clever manipulation of the figures in action within each of the frames', and that '[u]ltimately, a cartoonist must place the story into a logical narrative sequence; and this, essentially, is the task of the storyboard artist'.[18] As practices in creative labour, however, the difference between them is just as obvious. Although the comic strip usually appears in regular daily or weekly fragments, which in some cases will then be collected, edited, and published as a bound volume, as an artwork it has a certain autonomy – unlike the storyboard, which is a document created in the service of bringing a later artwork, the film, into being. In this respect, as a precursor text the storyboard has clear connections not with the animated film but with the screenplay, of which a similar observation

can be made. This helps to explain why screenplays and storyboards, unlike films and indeed comics, have struggled to be recognised as literature or art.

Nevertheless, it is historically suggestive that the emergence of the comic strip, especially in the form of the Franco-Belgian *bande dessinée*, is more or less contemporaneous with the emergence of cinema, around 1895–1896.[19] Again, the distinction from storyboards must be stressed – the strips were not created in order to be turned into films – but in each case the medium allows for the telling of a complete narrative, and the evolution of the *bande dessinée* shows a fairly consistent attention to parallel developments in the cinema. A biographer of Hergé, creator of Tintin, notes a series of parallel developments:

> For the particular art of the strip cartoon [...] there seemed to be direct parallels with the cinematic techniques of shooting, cutting and framing. There can even be said to be a similar evolution, with 'talkies' superseding 'silent movies' just as speech bubbles took over from the texts above which the illustrations were previously placed in strip cartoons. Tintin first appeared in January 1929, the so-called 'year of the talkies' in the cinema. Then, during the 1940s, films graduated to colour from black and white, and so did the Tintin books.[20]

One could take issue with some of the specifics: colour did not enter the cinema on any scale until the 1950s, and then largely in prestige pictures developed to compete with the small-sized, black and white medium of television that only became prominent in households in that decade. As we shall see throughout this book, however, suggestive correspondences between the comic strip and live-action cinema, as much as animation, are maintained throughout the histories of these different media. Indeed, dialogues between them are evident in the world of Tintin itself: after the original animated feature *Tintin and the Lake of Sharks* (1972) was created without input from Hergé, a book version was created that was 'confusingly formatted exactly like an actual [Tintin] adventure',[21] while pre-production for a later series of animated films for television, based directly on Hergé's books and created by the Ellipse and Nelvana studios in 1991, used panels from the books to create the storyboards.[22] Tony Tarantini, who worked at Nelvana in 1991, notes that whenever 'Nelvana considered adapting an existing property for an animation series production, keeping the integrity of the original work was very important', confirming that in the case of Tintin, 'Hergé's drawings were

used to guide production'.[23] What this shows is that while the functions of storyboards and comic strips are distinct, they share several technical features, which are discussed more fully in the next section.

Meanwhile, it is these features, most of which concern movement and narrative action, that help to distinguish the storyboard from other kinds of production artwork. The most crucial distinction to draw is between the storyboard and what is commonly termed 'concept art' or 'concept drawings', or more generally 'production design'. In theory, the difference is straightforward. Concept drawings or paintings are normally single-frame illustrations, capturing some of the desired qualities of the *mise-en-scène* for a set, scene, or landscape: setting, light, colour, and mood. Characters are often, though not always, absent, whereas the storyboard, by contrast, 'clearly shows the relationships between the characters and their environment'.[24] These functions mean that not only does concept art rarely attempt the detailed representation of movement, but it also tends to present the setting as neutral, lacking the subjective experience or point of view of particular characters. As Jaspers observes,

> The production design outlines the concrete setting of the film, which is created as a set or 'on location' during shooting. It is often very detailed. Presentation usually occurs from a straight-on angle (human eye level), like in stage design, from a neutral, central point of view, which leaves open from which camera angle or camera frame this room will later be captured on film. Actors are usually not included. The production design presents the director with a stage for his story; how s/he explores this stage together with the cinematographer is left to him/her.[25]

However, characters can also be designed in processes that resemble those of set design, especially in animation. Edwin Lutz, writing in his early study *Animated Cartoons* (1920), hints at the important role played by concept art before the formalisation of storyboarding as a distinct process:

> Presuming, then, that the scenario has been written, the chief animator first of all decides on the portraiture of his characters. He will proceed to make sketches of them as they look not only in front and profile views, but also as they appear from the back and in three-quarter views. It is customary that these sketches – his models, and really the dramatis personae, be drawn of the size they will have in

the majority of the scenes. After the characters have been created, the next step is to lay out the scenes, in other words, plan the surroundings or settings for each of the different acts.[26]

Lutz's emphasis on the development of character and set design, rather than narrative structure, directly corresponds with the function of concept art in live-action film-making. Edward Carrick's 1941 entry in The Studio Publications' 'How To Do It Series', entitled *Designing for Films*, offers the following account of how the production process evolves once the scenario has reached a finished, or near finished, state:

> The word 'go' is then given and the art director prepares his sketches and models or has them made for him by a sketch artist and model maker, has them criticized, and then puts in hand-finished drawings and full-size details of each particular object. These drawings are passed on to the departments concerned, i.e. the carpenters, who build the framework of the walls, the doors, windows and other practicals; the plasterers, who surface them with stone, brick or other textures to enrich them with carvings; the painters who pick them out in different colours and age them down; the property rooms, which are responsible for furnishing them.[27]

In this materially physical and practically applied sense, the boundary between concept art and storyboard illustration is clear.

Again, however, while this linear development – from screenplay to set design to storyboarding to film – may certainly occur, the process often differs in many ways. Concept art, whether created with watercolour, charcoal, or ink pen, may develop in parallel with the storyboard, and while the creation of each develops from an initial story idea, this need not be in the form of a screenplay. As we shall see in later chapters, at a crucial stage in the making of *Gone with the Wind*, for example, it was the storyboards and concept art that formed the template for the production (see Chapter 3), with the screenplay – as is often the case – in a state of flux; while for *Jurassic Park* (1993), the storyboards for key scenes preceded the writing of the screenplay altogether (see Chapter 6). Moreover, the concept art and the storyboard can exert influence on each other: a specific graphic detail communicated through the concept art might require the storyboard to be drawn in a certain way, while the staging defined in a storyboard sequence might prompt a return to the concept art to explore alternate stage designs.

Today, digital processes are enabling all aspects of film-making – from pre-production to post-production and everything in between – to interact with one another, although the roles of concept art and story-boarding remain conceptually distinct, serving to refine graphic design and narrative design, respectively. Within animation, as Tony Tarantini demonstrates, the role of concept art (which he refers to as 'Design') and that of the storyboard develop in parallel across 'Traditional Process' animation, '3D Animation', and 'Flash Animation'.[28] While the 'Storyboard' link in Tarantini's flow charts remains a constant connective element in terms of story development from 'Idea' through to 'Animation', the 'Design' linking stage in '3D Animation' understandably facilitates additional layers of planning around activities such as 'Color & Texturing', 'Modelling', and 'Rigging'.[29] Critically, while both sets of documents – concept art and the storyboard – remain in flux throughout production, it is much less likely that the concept art will have significant editorial changes made to it, or will be expected to serve as an up-to-date record of the production as it develops. The storyboard, by contrast, frequently fulfils such functions, serving as a constantly evolving production bible.

This is not say that the storyboard necessarily remains a physical object in today's creative industries. In many cases, storyboarding, much like many other film-making processes, is now entirely digital – drawn directly onto a digital tablet with a stylus and reviewed on screen, either by an individual working on a computer or by a group viewing via a projector. This digital workflow carries a number of benefits, such as quicker and easier file sharing between remote studio locations via a secured network,[30] and rapid review via the 'slide showing' of story-board images in a consecutive manner, thereby potentially reducing the need to wait for an animatic to be edited together.[31] (In an animatic, all the storyboard panels and available sound assets are edited together to form a rough approximation of the intended sequence/film, typically used to review action, continuity, narrative, and timing before production begins.) Although this represents a radical shift in the materiality of the storyboard, however, its functionality remains relatively unchanged.

While these differing functions within production remain clear, the researcher encountering the images 'on the page' and after the fact may discover problems of identification, cataloguing, and taxonomy. Despite the distinctions drawn above, in individual cases the visual characteristics of concept art and storyboards may be difficult to distinguish one from the other: each may take the form of a

detailed illustration, occupying a single sheet of paper, with perhaps a few production notations (page number, production working title, and date) marked across several pages in a regimented manner. Complications become particularly acute when dealing with documents that clearly contribute to the design of a film, and appear to contain elements that we would today associate with storyboarding, but which predate the emergence either of the term or of the separation of storyboarding as a distinct practice within film production. For example, commenting on some of the production art created in Germany in the later silent era, Jaspers remarks that '[i]f one looks more closely at the production and animation designs of the later 1920s, it becomes visible that the angle is not always neutral, and the rooms not always without people. Especially in the case of more complex animation sequences, camera angles and frames were often already considered'.[32] Regarding the pre-production of *Im Bann des Eulenspiegels* (1932), Jaspers also notes how production designer Fritz Maurischat and director Frank Wisbar 'mounted 296 drawings to a 75 meter-long strip of paper, next to which were placed dialogues, directorial remarks, as well as notes for the camera takes and for the music in separate columns'.[33] This strip, described as the 'paper film' by the production team, could then be fed through a hand-cranked device for sequential review. Understandably, when confronted with artefacts that defy immediate classification as either concept art or storyboarding, many archives resort to the more general term 'Production Art', rather than risk creating an inaccurate bibliographic record. In such circumstances, particularly when the archive contains material that is many decades old, absolute certainty may remain beyond the researcher. We shall encounter many examples of this problem in the pages that follow.

Storyboards as material texts

However, even in hard cases, the original function of the texts can usually be determined from clues found in the material nature of the documents. Before examining this question in more detail, it should be noted that an additional source of confusion lies less in the functions or materiality of the texts themselves, than in the terminology used to describe them. In particular, the word 'storyboard' (or indeed 'board') itself tends to be applied to a range of materials that can be readily distinguished one from the other.

(i) As developed at the Walt Disney studio, the 'story board' (two words) referred to a large wall-mounted board on which a sequence of images to depict the narrative flow of the animated action could be mounted and rearranged (**Figure I.1**).

(ii) 'Storyboard' is sometimes used to refer to a single image, even though the very function of the storyboard, usually, is to present a temporal action via a series of images. This introduces a confusion that is easily removed if one substitutes the word 'frame' to refer to a single image. This word is particularly appropriate since the aspect ratio of the storyboard image can helpfully represent the aspect ratio in which the film is to be shot. An alternative term frequently used to refer to a single image in a storyboard is 'panel'.

(iii) After the practice of sequential mounting of images had become established, the 'storyboard' (especially as a single word) came to refer to the sequence of images itself, as opposed to the object

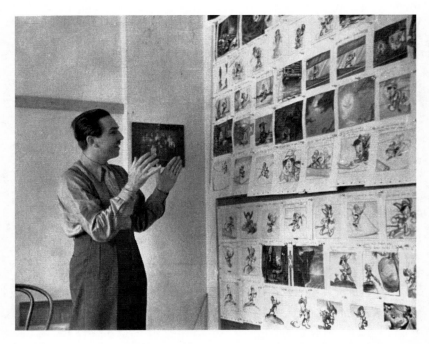

Figure I.1 A promotional still showing Walt Disney engaging with the story board for *Pinocchio* (1940). Permission courtesy of The Walt Disney Company.

upon which the images were displayed. This is the sense in which the word is most commonly used today, and it establishes one of the defining qualities of the storyboard, namely its *seriality*: it conveys a sense of developing action and narrative across multiple pages.

(iv) This sequence can be subdivided into individual pages or boards upon which more than one image is displayed, often in a geometrically repeated pattern. Routinely, such artefacts are themselves termed 'storyboards', whether or not more than one has been created in the visualisation of a particular scene.

It is worth pausing for a moment to consider the implications of this fourth kind of document, because it helps to establish that in addition to their seriality, storyboards are characterized by their *modularity*: they tend to be created in ways that facilitate the reordering of action and narrative through the editing and rearranging of the pages or images themselves. By contrast, published storyboards, storyboards circulated on the Internet, and storyboarding paraphernalia such as notebook templates have all contributed to the common perception that a storyboard is marked by repeated patterns of geometrically identical frames. For example, the popular 'Moleskine' notebook range includes a large storyboard notebook, 'for advertisers, graphic designers and filmmakers'. Occupying the outer half of each page is a descending sequence of four frames of approximately 1:33 aspect ratio, with the inner half blank for notes.[34] This is, of course, simply a convenient template, yet it is notable how frequently *completed* storyboard sequences are represented in similar patterns.

A striking example is a commonly reproduced series of 48 images composed by Saul Bass for *Psycho*. Because these comprise what is undoubtedly the most widely discussed sequence in the history of storyboarding, and because the controversies surrounding it touch on many of the most significant questions pertaining to storyboarding as a practice, we consider it separately and in detail in Chapter 5. For present purposes, however, it is noteworthy that the 48 images allow for a number of arithmetically pleasing subdivisions: into two pages of 24 images each, or into several modes of presentation in which the images appear in repeated patterns of three, four or six panels, rather in the manner of a comic strip. This might imply that the artist has conceived the work with this degree of arithmetical precision in mind; but as we shall see in Chapter 5, while Bass undoubtedly composed the images, there are strong grounds for doubting that he conceived the 48 frames as

a fixed and immutable sequence. Meanwhile, a moment's reflection will confirm that there is no logical reason why the images drawn in anticipation of a given sequence should result in a number that is divisible by three or four, rather than a prime number or any particular number. The obvious point, that a storyboard is a means of presenting an action in a series of images, tends to obscure the equally obvious point that the images are amenable to a theoretically infinite amount of editing and rearrangement.

The range of materials that may be used both to construct the boards themselves and to draw the images upon them is almost equally extensive. From the almost limitless possibilities, we may cite Bass' own frequent deployment of multiple small photographs that could be rearranged against a blank background; the A3-sized, charcoal storyboards produced by Akira Kurosawa for the film *Tora! Tora! Tora!* (1970); the cut-and-paste method employed by J. Stuart Blackton to plan *The Film Parade* (1933), whereby rudimentary sketches are glued alongside sections of the scenario to a card mount; the Universal Pictures template used to storyboard *Jaws 3-D* (1983), which is printed in widescreen, and which contains boxes to record stereoscopic information in anticipation of the pro-filmic event; the rough, small-scale ink sketches produced by Fred Zinnemann to plan sequences from *High Noon* (1952); the watercolour and moderately detailed storyboards produced by George Pal during the production of *Tom Thumb* (1958); and the very detailed, multicoloured storyboards produced by Richard Fleischer during the production of *Red Sonja* (1985).[35]

Editorial marks such as ticks, crosses, initials, signatures, the inclusion of annotations in different coloured inks, and the use of different coloured paper all indicate that the document has served to record a review process during the production of the text in question. Such elements are more common in the storyboard than in concept art, as is the appearance of portions of the scenario or script, cut out and pasted beneath drawn images, which again indicates the management of narrative development. The images encountered by a researcher may be mounted on larger sheets of thick paper or card to assist in the preservation and archiving of the original paper artefacts. Damage to the original paper around the corners (including tears, holes, or missing corners) tends to indicate that multiple pages have been simultaneously board- or wall-mounted, a key stage in animation (and sometimes live-action) storyboarding that enables a larger group of people to review often larger-scale sections of the story in greater detail. Lastly, storyboards often rely on much rougher draughtsmanship than

concept art, as the purpose of the storyboarding act is to plan the development of visual action and narrative, which contrasts with the typically much finer detail found in concept art, where the purpose is to explore alternative visual design possibilities during the early phase of pre-production.

While the material forms a storyboard may take are almost limitless, easier to define are the technical elements that may appear within the frames. Jaspers cites production designer Toni Lüdi, who identifies five such elements: the image detail, the actor or character in costume, camera perspective and focal distance of the lens, camera movement, and the rhythm of the montage.[36] To achieve the sense of movement *within* shots, individual frames may incorporate arrows (to suggest a tracking movement: **Figure I.2**), motion blur (**Figure I.3**), a smaller frame within a larger frame (indicating recomposition within the specific shot: **Figure I.4**), and illustration that continues beyond the edges of the frame (a common feature when panning or tilting motion is being conveyed: also see **Figure I.3 and Figure I.4**).

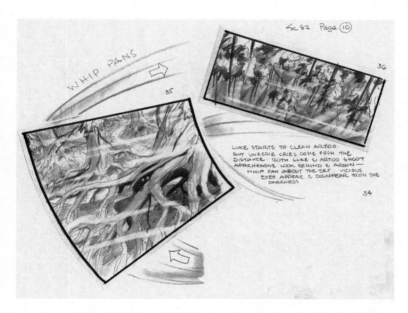

Figure I.2 A storyboard page detailing a whip pan sequence, produced in 1978 by Ivor Beddoes for *Star Wars – The Empire Strikes Back* (1978). Image provided courtesy of Lucasfilm and the British Film Institute.

UNIVERSITY OF WINCHESTER
LIBRARY

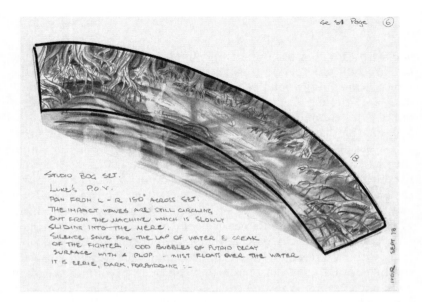

STUDIO BOG SET.
LUKE'S P.O.V.
PAN FROM L - R 180° ACROSS SET.
THE IMPACT WAVES ARE STILL CIRCLING
OUT FROM THE MACHINE WHICH IS SLOWLY
SLIDING INTO THE MERE.
SILENCE SAVE FOR THE LAP OF WATER & CREAK
OF THE FIGHTER. ODD BUBBLES OF PUTRID DECAY
SURFACE WITH A PLOP. - MIST FLOATS OVER THE WATER.
IT IS EERIE, DARK, FORBIDDING :-

Figure I.3 A storyboard page detailing motion blur across a POV 180 degree pan, produced in 1978 by Ivor Beddoes for *Star Wars – The Empire Strikes Back* (1978). Image provided courtesy of Lucasfilm and the British Film Institute.

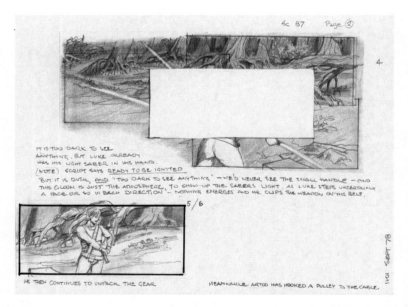

IT IS TOO DARK TO SEE
ANYTHING, BUT LUKE ALREADY
HAS HIS LIGHT SABER IN HIS HAND.
(NOTE) SCRIPT SAYS READY TO BE IGNITED
'BUT IT IS DUSK, AND "TOO DARK TO SEE ANYTHING' - WE'D NEVER SEE THE SMALL HANDLE - AND
THIS GLOOM IS JUST THE ATMOSPHERE, TO SHOW-UP THE SABER'S LIGHT, AS LUKE STEPS UNCERTAINLY
A PACE OR SO IN EACH DIRECTION' - NOTHING EMERGES AND HE CLIPS THE WEAPON ON HIS BELT.

HE THEN CONTINUES TO UNPACK THE GEAR MEANWHILE ARTOO HAS HOOKED A PULLEY TO THE CABLE.

Figure I.4 A storyboard page suggesting roaming camera movement through the drawing of several panels over one larger image, and the cutting and pasting of images between storyboard pages, produced in 1978 by Ivor Beddoes for *Star Wars – The Empire Strikes Back* (1978). Image provided courtesy of Lucasfilm and the British Film Institute.

Less easy to accomplish is an indication of the rhythmic movement *between* frames, which ultimately depends on decisions made within the editing of the film itself. In all of these respects the storyboard can bear a marked resemblance to the comic strip. However, a clear difference is that the *bande dessinée* ordinarily incorporates dialogue within 'speech bubbles', whereas a storyboard need not necessarily incorporate dialogue at all. Where it is included, like other forms of verbal information in a storyboard, it will ordinarily be placed below or alongside the image, instead of being incorporated within the frame. The position of the frames within the narrative may be indicated by scene number, a breakdown of shot numbers within a scene, an indication of camera angle, a few words from the scene heading or scene text of the screenplay, and so on; sometimes this information will be added within or pasted onto the individual frames, but it is more common for it to be placed on the board outside the frame.

Storyboarding and publication

Many of the materials that a researcher may wish to consult are unavailable: in some cases because they were discarded after filming, in others because they may never have existed, and in others because of the nature of copyright. One may quote from a screenplay, but only *reproduce* a storyboard – although, crucially, one can also *edit* it in ways that may or may not be apparent to the viewer – and the associated costs and permissions have consequences for the kinds of information most widely disseminated in this area. This difficulty with primary materials is perhaps partly responsible for a situation in which, just as books relating to screenplays are overwhelmingly self-help manuals, so many of the most prominent accounts of storyboarding have been practical, 'how-to' guides. Such an approach propagates the view of storyboarding, like screenwriting, as a craft that can be learned by the reader, with a view to securing employment in the industry as a result. Prominent examples include John Hart's *The Art of the Storyboard: Storyboarding for Film, TV, and Animation* (1999), Wendy Tumminello's *Exploring Storyboarding* (2005), Giuseppe Cristiano's *Storyboard Design Course: Principles, Practice, and Techniques* (2007), *The Spiritual Journey of the Freelance Storyboard Artist* (2011), and *The Storyboard Artist: A Guide to Freelancing in Film, TV, and Advertising* (2011), and most recently the third edition of Mark A. Simon's *Storyboards: Motion in Art* (2012). While the images in Hart's book serve no archival purpose, having been created by the author to illustrate particular aspects of the craft, the books by Tumminello, Cristiano, and Simon strike a more generous balance between self-drawn illustration and original reproductions, but are still limited in this regard.

Similarly, even in books published by or about very well-known film-makers, the storyboards they contain will frequently have been drawn in retrospect to illustrate aspects of film design or direction. A good example is *On Film-Making: An Introduction to the Craft of the Director*, a collection of writings and drawings by Alexander Mackendrick, who was probably best known as the director of Ealing comedies. This volume, edited by Paul Cronin, contains extensive storyboards created retrospectively by Mackendrick after he took up a teaching position at California Institute of the Arts in 1969. Mackendrick's book is one of the most respected guides to film-making, but the illustrations themselves are clearly of less significance in tracing the history of storyboarding itself. More complicated is a 1937 book by cinematographer Vladimir Nilsen, who had worked with Sergei Eisenstein on *October* (1928). Rather like Mackendrick's papers, this study explains via retrospectively designed storyboards some of the elements of composition, framing, and camera movement.[37] Nilsen also reproduced a series of Eisenstein's own, storyboard-like sketches, which Eisenstein referred to as 'visual stenograms',[38] and the images that were allegedly drawn during the production of Eisenstein's *Battleship Potemkin* (1925) have come to occupy a position of relative prominence as a consequence of their availability online. However, as Jay Leyda and Zina Voynow note, the precise dating of this 'storyboard' remains unclear, and they suggest that 'possibly it belongs to Eisenstein's later analysis of the *Potemkin*; it could be the draft of a series of frames drawn for an essay written in 1934'.[39] The uncertainty over the provenance of these sketches provides another illustration of some of the difficulties confronting research into the kinds of early screenwriting we shall discuss in Chapter 1.

Rivalling in popularity the 'How To…' book is the 'Art of…' collection: books authorized by a studio or franchise to celebrate particular films, series, or studios. This kind of project is well illustrated by *The Art of Bond: From Storyboard to Screen: The Creative Process Behind the James Bond Phenomenon* (2006), edited by Laurent Bouzereau. In some cases, multiple publications will be devoted to illustrate different aspects or parts of a film series, such as J.W. Rinzler's *Star Wars Storyboards: The Prequel Trilogy* (2013) and *Star Wars Storyboards: The Original Trilogy* (2014), which were published alongside, but are to be distinguished from, Lucasfilm's *Star Wars Art: Concept* (2013). These books continue the marketing of the *Star Wars* franchise, which (beginning with the original film release in 1977) remains perhaps the most prominent example of multiplatform exploitation, while following the practices of the Walt Disney studio in presenting high-quality reproductions of studio artwork. Like the *Star Wars* books, Disney worked with a single

author, John Canemaker, in publishing a series of books celebrating the work of artists at the studio. These include *Before the Animation Begins: The Art and Lives of Disney Inspirational Artists* (1997), *Paper Dreams: The Art and Artists of Disney Story Boards* (1999), and *Walt Disney's Nine Old Men and the Art of Animation* (2002), among others. This value is enhanced due to the tight control Disney exercises over the work-for-hire materials produced at the studio, partly by making such materials available only to selected scholars under strict conditions.

A related phenomenon is the museum or tour exhibition of design materials pertaining to a particular film, series, or studio. A recent and spectacular example is the Warner Bros. Studio Tour 'The Making of Harry Potter' in Leavesden, near London, which opened in 2012, and begins with a tour of the studio sets and ends with a gigantic model of Hogwarts school. Prominent in the exhibition is a display of concept art, architectural drawings, white-card models, and digital effects, although it is noticeable that the kinds of narrative function associated with storyboarding are much less prominent in the tour than the design of environments, characters, props, and sets. Meanwhile, publications accompanying such exhibitions frequently contain lavish reproductions of storyboards and concept art.

Because of the ownership and costs associated with companion editions of this type, the artwork itself becomes the main selling point. Such publications take on the appearance of the 'coffee-table', large-format, lavishly illustrated art book, necessarily aimed at a larger market than that associated with the scholarly monograph. They typically offer the reader a range of visually attractive images taken from the pre-production and production process, alongside short written elements comprising interviews with crew members, or contextual narrative. In almost every case where storyboard imagery is reproduced, this takes the form of individual sketches, rather than full storyboard pages, so much so that it is more noteworthy to comment on where this is not the case – such as *A.I. Artificial Intelligence: From Stanley Kubrick to Steven Spielberg: The Vision Behind the Film*, edited by Jan Harlan and Jane M. Struthers (2009). In numerous promotional interviews Spielberg stressed his desire to maintain continuities with Kubrick's original vision, an aim facilitated via the use of Chris Baker's storyboards, which bridged Kubrick's initial work on the film and Spielberg's completion of the project. The book enables the reader to grasp the full extent of the collaboration, and Baker's role within it.

Books of this kind sometimes present sketches alongside images from the final film, highlighting the accuracy with which the drawings antici-pate the final imagery, as in Mark Salisbury's *Prometheus: The Art of the*

Film (2012). A variant that is particularly pertinent in the context of the present study is Chris Guise's *The Art of The Adventures of Tintin* (2011), which offers several examples where stills from the recent feature film (Steven Spielberg, 2011) can be seen to repeat action from Hergé's original drawings. In these 'Art of…' books, a sampling of the concept art, rather than a rejected storyboard page, is generally offered to highlight the divergent designs that were explored before the desired look for the film was found, with *The Art of John Carter: A Visual Journey* by Josh Kushins (2012) being a good example.

Such an approach has its dangers. Firstly, the 'authorized' nature of the collection inevitably means that critical commentary is largely absent. More technically, such books impose a retrospective narrative upon the production of the film, generally privileging a linear version of production development, which in practice is frequently less straightforward than might at first appear. For example, presenting just the storyboard sketches and not the full storyboard pages as they might appear in the studio's archive will cause the reader to lose a clear sense of the pre-production editorial process. Furthermore, the editorial work of cropping, framing, and rearranging images for publication is frequently obscured. As we shall see on many occasions in this book, the published forms of screenplays and storyboards have tended to differ in crucial respects from the material that was actually created in the making of a film.

On the other hand, books of this kind can have real value, of the kinds well illustrated in Halligan's aforementioned *Movie Storyboards* (2013). This takes a much broader range of materials into consideration than is common in publications of this type, while Halligan also aims to 'lift the curtain' on the generally hidden world of the art department, and 'to show as many styles as possible, across the widest timeframe possible, and hopefully for films that hold an artistic significance in the history of cinema'.[40] It is an image-intensive study, with the focus on bringing artwork from an impressive range of sources into the public eye; but as with those books mentioned previously, the critical commentary itself is brief, the usually single paragraph of text that accompanies each image performing the function of identifying the work and briefly situating it within the context of the work of a particular storyboard artist. The overall effect is of a lightly annotated catalogue of the kind that might be created to accompany an exhibition, and in a sense this is what Halligan's work achieves by giving a historical survey of a wide range of striking materials, many of which will have been previously unknown even to those well versed in the field.

Zwischen Film und Kunst: Storyboards von Hitchcock bis Spielberg, a catalogue produced to accompany a 2012 exhibition in Berlin,

reveals something of the potential of this kind of publication.[41] Like Halligan, the curators and editors have included high-quality colour reproductions of artworks from the late silent era to the present, with many lesser-known films and artists alongside what might already be regarded as the more canonical films and illustrators that form the core of Halligan's book. While the bulk of the book – the section devoted to the images themselves – offers practically no comment at all, this is compensated for by the inclusion of six substantial essays at the beginning of the volume that survey, in some detail and with considerable historical and cultural contextualisation, the history and function of the storyboard (Kristina Jaspers), the relationships between storyboards and comics (Andreas C. Knigge), and storyboards in relation to other visual arts (Lena Nievers). Two essays (by Katharina Henkel and by Peter Mänz) examine a total of nine of the exhibits by tracing the position of the storyboards in relation to the respective films, while a more theoretical piece by Nils Ohlsen presents storyboards as 'the undiscovered genre between cinematic and pictorial art'. Collectively, the materials in this book show that the genre of the exhibition catalogue, which some of the other publications noted above mimic in certain respects, offers perhaps the most suitable medium within which to advance a critical understanding of the form.

In similar vein, but dealing with a single subject in considerably greater depth, is a landmark recent study by Steve Wilson, Curator of Film at the Harry Ransom Center in Austin, Texas, which was published alongside a 2014 exhibition held at the Center to celebrate the 75th anniversary of *Gone with the Wind*.[42] The newly published materials, and Wilson's commentary, represent the fullest reconstruction to date of the work carried out on the film by William Cameron Menzies and his collaborators. More wide-ranging if less detailed is the catalogue accompanying *Drawing into Film: Director's Drawings*, a 1993 exhibition at the Pace Gallery in New York, which casts fascinating light on how directors from many different eras and industries see the relationships between the drawn image and the filmed event. A final example of this kind of text is *Casting a Shadow: Creating the Alfred Hitchcock Film*, published in 2007 to accompany an exhibition jointly organized by the Mary and Leigh Block Museum of Art at Northwestern University in Evanston, Illinois and by the Academy of Motion Picture Arts and Sciences in Beverly Hills, which is the keeper of the Hitchcock archives. We consider some of the materials in these books in greater detail in Chapters 3, 4, and 5.

The current state of publication in the field of storyboarding suggests that a key function concerns the preservation, dissemination, and commercial exploitation of material that has previously been subject to

severely restricted access, or indeed completely hidden from view. Only quite recently have studios begun to recognise the value of such materials, through stand-alone reproduction in book form and via digital and electronic media. A second, less significant purpose has been to engage in more scholarly debates surrounding this material, such as the position of the storyboard within film production, associated questions of authorship and collaboration, and affirmations of its potential as a 'new' or legitimate form of art – a discussion directly related to that surrounding the possibility of perceiving screenplays as 'literature'.

Several of the commentators noted above, including Halligan and Nievers, argue in different ways for storyboards as possessing a relatively autonomous value as artworks, for example when Nievers traces allusions to prior pictorial works in an attempt to situate them within longer-standing artistic traditions. Most of the attention currently being paid to storyboarding, however, is more directly bound up with what can be regarded as essentially postmodern economic and cultural perceptions of artistic production. Storyboards have found a place within an industry that is devoted simultaneously to nostalgia and to planned obsolescence, via the continuous recycling and repackaging of familiar artworks in new iterations, most prominently in the 'extras' features of DVDs and Blu-ray discs. Similar manifestations of this manoeuvre can be seen in the 'bonus' tracks routinely added to the latest CD iteration of a familiar work of recorded music, for example. Meanwhile, the Internet has provided incomparably greater means both for the dissemination of these images, legally and otherwise, and for debates surrounding their merits and functions.

As a consequence of these developments, images created for fleeting, localised reasons, and with the assumption that they would then to all intents and purposes disappear, have been granted the kinds of permanence more commonly associated with the completed films towards which they contributed. This postmodern turn is also manifested in the willingness of both academic and general audiences to analyse previously deified artworks as constructs. Although several of the studies noted may promote the idea of a singular authorial vision on the part of a given director, attention to storyboards also tends to demystify the completed film text by exposing the means by which it was made. Finally, the study of storyboards also tends to illustrate the shift towards more scholarly, archival, empirical research into material texts in reaction to what many have seen as the excesses of critical theory in the 1970s and 1980s.

An academic, non-commercial publication cannot hope to match the range of reproductions in a coffee-table book in which the images

themselves are the primary focus of interest. Some of the publications noted have gone a long way towards satisfying the interest of those who wish to see what storyboards look like. Instead, our aim is to provide a critical analysis of aspects of storyboards and storyboarding at greater length than is generally found in the titles discussed above, and the images we have selected are intended to illustrate particular arguments within the book. For a greater range of images the interested reader should consult the aforementioned titles, while curiosity will be further satisfied by online searches or by browsing through the extra features incorporated in disc publication. In an extreme example, the 2010 Blu-ray release of the 'Alien Quadrilogy', which contains the four films in the *Alien* sequence (1979–1997), is said to contain '12,000 images, from storyboards and sketches to production stills and cast portrait galleries'.[43] We have not counted.

For reasons noted previously, the historical record of storyboarding is partial and fragmentary, and consequently a critical study will need to cite particular examples and practices rather than attempt a fully coherent narrative history of the form. In Chapter 1 we examine some of the precursors of storyboarding. Chapter 2 is devoted to the development of the storyboard as a key stage in the creation of animated feature films at the Walt Disney studio, most notably in *Snow White and the Seven Dwarfs* (1937). In Chapter 3 we explore the work of William Cameron Menzies, often credited with introducing minutely detailed storyboarding into live-action films, with *Gone with the Wind* inevitably a crucial case study. That film is often claimed to have been storyboarded in its entirety, but the lack of empirical evidence to support such an assertion prompts the approach taken in Chapter 4. Here, we make use of a range of storyboarding practices that emerged in live-action cinema from the 1940s onwards to present a different perspective on a familiar debate: that surrounding the question of whether Hollywood film-making took a decisive turn towards a cinema of spectacle rather than narrative in the late 1970s. After devoting much of Chapter 5 to a detailed consideration of the shower scene in *Psycho*, which has become a touchstone for scholarly debate surrounding storyboarding, we resume the debate in Chapter 6 by considering the part played by storyboards and storyboard artists within what Tom Gunning has described as the 'Spielberg-Lucas-Coppola cinema of effects'. In Chapter 7, we consider the role of storyboarding in the digital age, with a particular focus on contemporary animation. Our Conclusion looks ahead to some of the ways in which storyboarding is likely to develop in the future.

1
The Pre-History of Storyboarding

As noted in our introductory chapter, a number of challenges must be negotiated when attempting to piece together the pre-history of storyboarding: the lack of surviving material, the sometimes unclear original usage of the documents that have survived, and the difficult task of defining what exactly might be considered an early or prototypical storyboard and what should not. Similar problems have confronted historians of early screenwriting, but there are significant, and revealing, differences.

Arguably, the need for screenplays came into being with the introduction of narrative films around 1903. Prior to this point, the unique attraction of film lay in its ability to represent the movement of objects that were not physically present in the space in which the spectator was situated. By the early years of the new century, however, relatively complex narratives were being devised by such film-makers as Edwin S. Porter in the United States and George Méliès in France; and while the surviving evidence is sketchy at best, it seems likely that what Edward Azlant terms 'the prearrangement of scenes', to facilitate the preparation and telling of a narrative tale in cinematic form, brought about 'the birth of screenwriting'.[1] More or less simultaneously, film-makers began to create written texts for an entirely different reason: to copyright their work in the face of the film piracy that was particularly rampant in the United States at this time. While the resulting texts look very different from the screenplays of today, the combination of these two commercial imperatives resulted in the creation of documents that can reasonably be held to have many of the functions of screenwriting practice today. Until the copyright amendment of 1912, however, there remained 'a virtual free-for-all in the film business as making and distributing movies became increasingly profitable, with companies borrowing freely from each other's films as

well as from literary properties and seldom, if ever, giving proper credit'.[2] After this date, a film-maker seeking to copyright a film with the Library of Congress would have to deposit evidence of its existence. Commonly, submitted material included 'press books, scenarios, synopses, credit sheets, or photographs'.[3] Sketches, however, would not serve the same function, and are generally absent. In short, while questions of copyright materially advanced the development of early American screenwriting, it did not have the same impact on storyboarding.[4]

The widely received understanding of what a storyboard looks like also poses potential problems when attempting to trace the form's early history. In the context of archival work it requires that the researcher be alert to the cataloguing process itself. One example from the British Film Institute's Halas and Batchelor archive saw nine colour illustrations, mounted, three per page, upon black A4-sized card simply defined as *Animal Farm* (1954) storyboard material. While the individual images are pre-production arte-facts, from the archival description it was unclear whether the images had been produced in a formative storyboarding mode to plan a sequence of animation, or rather as a colour study to plan the visual mood of the sequence. The latter is accurate. As Vivian Halas and Paul Wells detail in *Halas & Batchelor Cartoons: An Animated History* (2006), first a compre-hensive set of board-mounted, black and white pencil storyboards were produced to plot 'the continuity of the film', before Philip Stapp 'joined Joy Batchelor in writing and producing a colour storyboard'.[5] Troublingly, in Fionnuala Halligan's more recent *The Art of Movie Storyboards* (2013), although two of the colour storyboard pages are reproduced, no reference is made to the formative, black and white pencil storyboard that would have informed these later colour boards.

As this example shows, the task of defining storyboard material in the broadest sense is problematic. Eadweard Muybridge's serial photographs of animal and human motor function serve as a useful illustration. Arranged on the page as a series of independent yet related panels, both recording and suggesting motion through the movement of the reader's eye, Muybridge's photographic studies do indeed share a number of visual similarities with what might now be called a storyboard. However, Muybridge was not concerned with planning for motion, but rather capturing and revealing it. As Philip Brookman writes:

> Muybridge created an analogous spatial grid of vertical and horizontal lines against which the time-based movements of his subjects were plotted. This grid of evenly spaced and numbered vertical lines, inter-secting with the horizontal rules across the bottom of the frame, was

designed specifically to mark the space so as to enable a scientific and visual interpretation of how his subjects moved through a defined fragment of space and time. Muybridge's strategy of presenting photographic information against the backdrop of a numbered grid was helpful in a variety of ways. The photographer used it to order his myriad images, and to mirror the grid structure of individual pictures in his final presentation of an entire sequence.[6]

Although it is tempting to point to Muybridge's latter endeavours to (re)animate his studies, thus bringing his panelled pages more closely in line with the remit of the conventional storyboard, this miscasts the work's original intention.

Given the lack of a singular starting point in the development of the storyboard as a document and storyboarding as a process, this opening chapter covers what might be considered the form's early or formative period, including the role that pre-production sketches played in the work of Georges Méliès; the early twentieth-century comic strips of Winsor McCay, and the question of whether these represent the first systematic and visible use of 'storyboarding' practices; and how live-action directors such as Cecil B. DeMille, D.W. Griffith, and Sergei Eisenstein made use of storyboarding processes in the 1910s and 1920s.

Georges Méliès

Méliès was perhaps the most prolific early adopter of pre-visualisation strategies. When planning his film projects, he produced numerous detailed drawings to help establish how characters would interact in scenes, and where they would be placed in relation to other points of action or interest. In fact, the large number of drawn pre-production materials produced by Méliès often causes him to be acknowledged as a 'pioneer' or 'precursor' in many of the practical 'How to' manuals, which promise to teach readers how to craft the perfect storyboard and carve out a successful career in the process.[7] Méliès was not a storyboard artist, however, nor did he employ someone in such a role; rather, he recognised the value to the efficient planning of his fantastical films from sketched illustration. Consequently, the sketches created and utilised by Méliès directly resemble the rough, pre-production work that is still penned today by production designers when tasked with crafting a new costume or piece of set. His pre-visualisation work is therefore best considered here as something of a first step towards the more formalised storyboarding process that we recognise today.

The sketches produced by Méliès around the time he worked on *Le Voyage dans la Lune/A Trip to the Moon* (1902), which are reproduced in Jacques Malthête and Laurent Mannoni's *L'Œuvre de Georges Méliès* (2008), range in origin: some were produced at much later dates to serve as promotional illustrations in exhibition catalogues, while others may genuinely have contributed to the pre-production process.[8] The sequence depicting the industrial-scale smelting plant, which is dated 1902, offers a particularly clear example of this latter application (**Figure 1.1**). It is striking to see how closely the finished film reproduces Méliès' initial vision. Comparing the planning sketch titled '*Le Fonte du Canon*' (which roughly translates as 'the smelting of the gun/barrel') with a corresponding frame from the recently restored colour edition of *Le Voyage dans la Lune*, it is clear that colour was being used to convey the ferocious mechanical ambition of the late Industrial Age.

Although hand colouration was not standard practice in the early cinema, Méliès made frequent use of the technique. In this instance, the sketch serves to establish the dominant colours that would be applied by hand to each frame: reds and oranges reflecting the heat of industry; blues and greys suggesting the cool and calculated of advance of science, alongside the increasingly wrought landscape of industrial France.[9]

Figure 1.1 A colour sketch (reproduced here in black and white) created by Méliès for *Le Voyage dans la Lune/A Trip to the Moon*, c. 1902. Permission courtesy of Bibliothèque du Film, La Cinémathèque Française.

The arrangement of the scene is also carefully planned in the sketch. In addition to calculating in advance the positioning of the astronomers and scientists, down to the waving of a top hat and the carrying of an umbrella, the sketch might also have served as a way of planning what proportion of the *mise-en-scène* could be filled with painted background and what would need to be physically constructed.

Similarity between Méliès' pre-production sketch work and his staging of the pro-filmic event is evident in many of the director's projects. In particular, *Les Aventures de Robinson Crusoé/The Adventures of Robinson Crusoe* (1902), *La Légende de Rip Van Winkle/The Legend of Rip Van Winkle* (1905), and *Les Quat'Cents Farces du diable/The 400 Tricks of the Devil* (1906) all reveal striking levels of visual continuity between pre-production sketches and their corresponding film scenes.[10] Furthermore, those sketches that were produced by Méliès with promotion in mind, after the completed production of film, may yet serve as instrumental documents in the restoration of a long-lost strip of film. As Harvey Deneroff notes in relation to *Le Voyage dans la Lune*, 'All known hand-colored prints of the film were considered lost until 1993, when a copy, in very poor shape, was turned up by Filmoteca de Catalunya in Barcelona'.[11] Naturally, the team behind the restoration of the film, which was completed in 2010, turned not just to the surviving black and white film reels for reference, but also to Méliès' sketch material, both pre- and post-production. This return to – and repurposing of – the Méliès sketches gives added weight to the assertion that Méliès 'story-boarded moving images for the first time',[12] an argument proposed by Lobster Films' Serge Bromberg and Eric Lange, the duo responsible for leading the film's restoration.

Although it might be tempting – especially here – to consider Méliès' pre-production sketches as constituting an origin story in the history of storyboarding, a reading of this nature distorts their original form and function. Such sketches, while related to the storyboard, are not quite storyboards. Prosaic as it may seem, a crucial ingredient of the classical storyboard form is the *serial* combination of multiple, discrete images within a larger containing frame, be that a sheet of paper, cork boards lining the walls of a film's production office, or the screen of a computer or tablet.

Reframing the comic strip

Although there is a temptation to cast the net as broadly as possible when attempting to reclaim and establish an early history of

storyboarding, it is essential to keep in mind the common conventions that inform our received understanding of the form. Despite such warranted circumspection, however, one storytelling medium, already well established by the end of the nineteenth century, looms large as a credible antecedent to the modern-day storyboard: the comic strip.

Comic strips, and comic strip anthologies, can be thought of as texts 'in which all aspects of the narrative are represented by pictorial and linguistic images encapsulated in a sequence of juxtaposed panels and pages'.[13] With this description in mind, the association with the storyboard becomes clear, especially when considering how the average storyboard also arranges information visually on the page, employing discrete panels to delimit each suggested shot. Furthermore, as Pascal Lefèvre notes, 'There is a closer link between cinema and comics than between other visual arts. Films and comics are both media which tell stories by series of images: the spectator sees people act – while in a novel the actions must be verbally told. Showing is already narrating in cinema and comics'.[14] It is hardly surprising, then, that static comic strip images, which reveal narrative when read, were quickly viewed as ready-made blueprints for moving image production.

Scott McCloud's influential *Understanding Comics: The Invisible Art* (1994) contains ideas that, whilst not intended to address the subject of storyboarding, nonetheless carry significant potential in this regard. While McCloud favours the term 'panel' throughout his study, the term 'frame' is used on occasion in an interchangeable manner, as when he considers the distinction between comics and animation: 'I guess the basic difference is that animation is sequential in *time* but not spatially *juxtaposed* as comics are. Each successive frame of a movie is projected on exactly the *same* space – the *screen* – while each frame of *comics* must occupy a *different* space. *Space* does for *comics* what *time* does for *film!*'[15] Crucially, McCloud does not dispute that comics, while serving to establish temporality in different ways to film, might themselves serve as useful blueprints for further creative development; however, they fulfil this role with characteristics that invert many of the attributes associated with the storyboard: being documents intended for public consumption, and which contain fixed images not intended for additional editorial review. It is the space between the images on the page that fosters this comparison, with both the comic and the storyboard seeking to prompt a bigger idea than is depicted in the individual panel or on the individual page in the mind of the reader. McCloud writes: 'See that space *between* the panels? That's what comics aficionados have

named the gutter. And despite its *unceremonious title*, the gutter plays host to much of the *magic* and *mystery* that are at the very *heart of comics!*[16]

Writing for *Vanity Fair* in 1922, Gilbert Seldes observed how 'between 1910 and 1916 nearly all the good comic strips were made into bad burlesque shows', before acknowledging that most of the comics had 'also appeared in the movies'.[17] Furthermore, as Paul Wells notes, between '1913 and 1917, the dominant mode of animated film was the adaption of the comic strip'.[18] In his excellent *Before Mickey: The Animated Film 1898–1928*, Donald Crafton dedicates an entire chapter to the adaptation process: 'From Comic Strip and Blackboard to Screen'. While it is not within the scope of Crafton's study to consider whether the comic strips that he discusses take on characteristics akin to the modern storyboard, he does note in relation to early filmmaking practices that the comic strip did 'make a primary contribution to the cinema by providing a virtually unlimited supply of gags and story material perfectly suited to the two- to five-minute running times of the films'.[19] As Crafton highlights, this tactic was not simply the preserve of animation: the Lumière brothers' *L'Arroseur arosé/Tables Turned on the Gardener* (1895) took direct inspiration from a Christophe (Georges Colomb) comic strip from 1889, which in turn referenced two earlier comic strips from 1887.[20]

Discussing the look and feel of George Herriman's *Krazy Kat* comic strips, Seldes highlights why *Krazy Kat*, and comic strips more generally, became such rich texts for animated adaptation:

> The first thing, after the mad innocence of Krazy, is to notice how Herriman's mind is forever preoccupied with the southwestern desert, the enchanted mesa. [...] Adobe walls, cactus, strange growths, are the beginning; pure expressionism is the end. His landscape changes with each picture, always in fantasy. His strange unnerving distorted trees, his totally unlivable houses, his magic carpets, his faery foam, are items in a composition which is incredibly charged with unreality.[21]

From the outset, animation has provided a natural space in which to bring distorted and metamorphic images to life (consider, for example, J. Stuart Blackton's *Humorous Phases of Funny Faces* [1906] and Émile Cohl's *Fantasmagorie* [1908]). It is unsurprising, then, that comic strips, which readily displayed the qualities described by Seldes, should have found a natural second home within animation.

While more concerned with exploring the commercial potential of adapting comic strips as animated short films than exploring the afore-mentioned metamorphic aesthetics of the form, any consideration of this act of adaptation is obliged to mention newspaper tycoon William Randolph Hearst. As Crafton notes:

> The International Film Service [IFS] was an offshoot of Hearst's International News (wire) Service (INS). Animated subjects were planned for the newsreel from its inception in mid-December 1915, and a studio was installed at 729 Seventh Avenue, joining the dozens of film offices already in the same building. By February, the Hearst-Vitagraph News Pictorial was running animated cartoons based on Tom Powers and George Herriman characters. By April 1916 the lineup of comic-strip artists was supposed to include Tom Powers, Tad [Thomas Dorgan's pseudonym], George McManus, Hal Coffman, Fred Opper, Harry Herschfield, [George] Herriman, Cliff Sterrett, Tom McNamra, and Winsor McCay.[22]

Although Hearst's animation venture was short-lived, with animation being wound down on 6 July 6 1918, the characteristic scale of Hearst's ambition to directly adapt from the comic strips during this period is evident in the list of high-profile cartoonists contracted to the IFS. While it is tempting to suggest that Hearst used the comic strips during this time in a pseudo-storyboard fashion, the limited availability of surviving documentation from this period makes it impossible to support such a claim unambiguously. What we are left with is the likely (but ultimately unverifiable) scenario that Hearst would have made use of the published comics to check, if not manage, the animation of the IFS production unit. A key motivation for Hearst to adapt his comic strips in this fashion was to create a promotional feedback loop between the moving pictures and his print publications. In October 1916 Hearst instructed Joseph A. Moore, who managed his magazine division, to 'get moving picture options on all stories and try to monopolize all best fiction and all best moving picture material'.[23] Hearst was explicit in his correspondence with Moore, emphasising the commercial appeal of such an approach: 'A great story ought to make circulation and prestige for the magazine and be valuable as a moving picture asset, and as a book asset thereafter'.[24] While Hearst's contribution to the tradition of animating comic strips is relatively limited, seemingly driven by a desire to exploit his intellectual property in the most comprehensive

manner possible, Winsor McCay, a cartoonist who spent time working for Hearst, enjoyed considerably more success with his animated short film *Little Nemo* (1911), which drew inspiration from his *Little Nemo in Slumberland* (1905–1926) cartoon strips.

McCay, who enjoyed a strained relationship with Hearst, was a well-known cartoonist before he entered the world of film, having had success with his comic strips *Little Sammy Sneeze* (1904–1906), *Dreams of the Rarebit Fiend* (1904–1925; albeit under the pseudonym 'Silas'), and *Little Nemo in Slumberland*. Like Blackton, McCay was a practiced 'lightning sketch' artist (a type of vaudevillian performance where chalk drawings are rapidly modified by the artist who also delivered an accompanying verbal narration), so it was a natural step for McCay's first film – under the tutelage of Blackton – to mimic such an act. *Little Nemo* opens with a live-action framing narrative that shows McCay agreeing to a wager, which, as we learn via an intertitle, requires him 'to make four thousand pen drawings that will move, one month from date'. On the one hand, because the short's opening title carries the proclamation 'featuring the famous cartoonist Winsor McCay', the very drawing of these individual images carries added significance: not only are these drawings that are to move, but this is also a comic strip coming to life. In *Little Nemo*, therefore, the characters achieve something that had been beyond them in the comic strip, regardless of how narratively *animated* their stories may have been. In short, McCay refashioned the drawn images of his comic through the pro-filmic event. It is in this way that the original comic strip drawings of *Little Nemo* can be seen as prototypical storyboards. Clearly, they lack the formal presentation of the pre-production documents that have come to define the received notion of what a storyboard is, but because of their direct visual translation they come to anticipate the position and function that the storyboard fulfils today. It should also be noted that this remains a popular tactic, as evidenced through the range of Marvel comic adaptations that have dominated mainstream Hollywood cinema in recent years, the graphic matches present in Steven Spielberg's *The Adventures of Tintin* (2011) that pay direct homage to the original Hergé illustrations, and, perhaps most like McCay, Enki Bilal's 2004 film *Immortals (ad vitam)*, which, as Sophie Geoffroy-Menoux notes, was adapted 'from his own well-known comic books'.[25]

Breaking down the animated sequence featured in *Little Nemo* shows just how much of the film relies on the comic strip for its form and content. The animation in *Little Nemo* begins after the camera finishes zooming in on a drawing of Flip, one of the central characters in the

cartoon series. This zoom also triggers a shift to hand-tinted colour. After the zooming movement has come to rest in a medium close-up on Flip, and following the brief insertion of a slide with the words 'Watch Me Move', Flip turns his head, inhales from his trademark cigar, and blows out a cloud of smoke. While Flip's appearance does not derive from a specific instalment of *Little Nemo in Slumberland*, his appearance matches McCay's typical illustration of the character. It could also be argued that Flip's blowing of cigar smoke in this particular framing constitutes an early moment of animated intertextuality, given its close resemblance to a sequence in Blackton's earlier *Enchanted Drawing* (1900), in which a top-hatted man blows out a cloud of cigar smoke. That McCay produced *Little Nemo* for Blackton at the Vitagraph Studio increases the likelihood that this was indeed an early animated in-joke.

Following the animation of Flip, Impie, another longstanding *Little Nemo in Slumberland* character, falls from the top of the screen in fragments and combines in a bottom-up, building-block fashion. For the next fifteen seconds, Flip and Impie march back and forth and engage in some brief rough-and-tumble, redolent of the playful rivalry that typified much of their interaction in the original cartoon strip. After this opening exchange, Little Nemo materialises in the centre of the screen. In both Nemo's appearance and his subsequent actions we see the first suggestion of McCay utilising the pre-existing cartoon strips for visual inspiration. Throughout the strips Nemo can be seen in a variety of different costumes, ranging from nightgown to naval commander. When Nemo appears in his Tudor-esque finery, it evokes a specific storyline that recurs throughout the strip's history: that of Nemo and the Princess. Although Nemo first meets the Princess in a strip dated 8 July 1906, the costume in question closely resembles, in both style and colour, one first shown three months previously, in a strip dated 1 April 1906. In fact, in the third panel of the 1 April strip we find the Candy Kid, who guides Nemo on his way to meet the Princess, remarking: 'You must look just so. Nemo!'[26] Given Nemo's appearance in the short, this statement takes on added significance in retrospect.

Immediately after appearing, Nemo begins to raise and lower his outstretched arms, causing Flip and Impie, who are standing on either side of him, to squash and stretch in appearance. The hall of mirrors effect generated in this sequence directly references the strip dated 2 February 1908, in which Flip, Impie, and Nemo are similarly distorted after entering 'Befuddle Hall'. Beyond being a reflection of the earlier

cartoon strip, John Canemaker suggests that this sequence also reflexively comments on the production process, writing that 'Nemo has become McCay's self-figuration, his alter ego, proving his mastery over the actions of his creations. This becomes most obvious in the next charming scene; Nemo imitates McCay's lightening-sketch act by drawing the Princess, who then comes to life (a cartoon version of the myth of Pygmalion and Galatea)'.[27] Taking this analogy a step further, the attraction of seeing Nemo's total mastery over the animated space is enhanced further when one appreciates how little control Nemo exerts within the cartoon strip, being always at the mercy of his sleeping – and inevitably waking – body.

With the introduction of the Princess, another cartoon-inspired sequence begins. As Nemo hands the Princess a rose, Bosco, the royal dragon that first appeared in a strip dated 10 December 1905, enters the frame from the left. Bosco is the dramatic means of transport chosen by the Princess to give Nemo a tour of her Palace grounds, a spectacle which ran over three consecutive issues in the summer of 1906 (22 and 29 July and 5 August). In keeping with this established utility, Bosco serves to carry the Princess and Nemo out of shot in the short. As Bosco's mouth opens to allow the Princess and Nemo to sit down, the similarity of this frozen image with the left half of the fourth panel featured in the 22 July strip is striking (**Figure 1.2**). Furthermore, the seating of the Princess on the left and Nemo on the right (**Figure 1.3**) matches how the two are arranged while riding in Bosco's mouth in the first panel of the 29 July strip.

As Bosco begins to walk away, Flip and Impie appear from the left of the frame riding in an automobile that is tethered to the dragon's tail. Various, often unusual automobiles appear throughout McCay's cartoon strip, indicative of the contemporaneous fascination that undoubtedly surrounded the emerging transportation technology. In one strip, dated 23 June 1907, which takes place on Candy Island, we see an 'automobile' that employs four goats in the place of wheels and a frog for a horn. Another strip (29 November 1908) sees McCay draw inspiration from R.W. Paul's curiously titled short *The '?' Motorist* (1906), depicting Nemo being taken on an automobile tour of Manhattan by Flip, during which they drive directly up the façade of a building. However, the automobile that experiences mechanical difficulties in the 3 May 1908 cartoon provides direct visual inspiration for the animated sequence (car trouble is a theme that surfaces on more

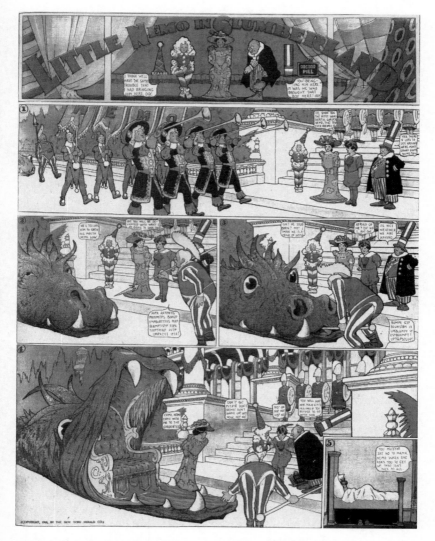

Figure 1.2 Winsor McCay's *Little Nemo in Slumberland* comic strip, July 22, 1906. Public domain.

Figure 1.3 A still from Winsor McCay's *Little Nemo* (1911). Public domain.

than one occasion in the original cartoons). This is quickly confirmed. After the towrope that Bosco had been pulling snaps, Flip coasts the vehicle for several seconds before turning to pursue Bosco. At this point we see a large cloud of smoke come from the rear of the vehicle, suggesting engine trouble; shortly after this the automobile explodes and propels both Flip and Impie into the air. In the strip that provides the inspiration for this sequence we see smoke clouds coming from the car with the word 'BANG' featured in three consecutive panels, thus prompting Nemo to ask, 'What ails it Flip?', to which Flip replies, 'Oh! Dat's nothing! You get used to dese things when you own an auto'.[28] Before Flip can finish his response, signalled in the speech bubble by the trailing dash, the explosion from the vehicle sends him skyward. The direction in which the car travels, the passengers in the car, and the explosive conclusion to the car's journey all suggest a direct adaptation of the strip's content for the purposes of creating this set piece within the *Little Nemo* short. Soon after this the animation freezes, and McCay's hand (we are meant to presume) begins to pull the paper on which the action has been animated away from the

camera, returning the short to the live-action framing narrative just as the closing title card shows.

In addition to the sequences that have been discussed so far, the colouration of the animation in *Little Nemo* also betrays the cartoon's influence. Scott Bukatman notes how the strip was

> published only on Sundays, when McCay could partake of the color engraving of the Sunday newspaper supplements: the adventures of his other characters – the rarebit fiends, Sammy sneezes, poor jakes, hungry henriettas, and others – could be found in the daily newspaper or perhaps (in larger incarnations) in the Saturday edition, but Nemo lived solely in the pages of the gorgeously rendered Sunday supplements.[29]

In the opening live-action sequence of *Little Nemo*, the bet agreed upon requires McCay to produce drawings that will move, not move and appear in colour, yet the animation does appear in colour. Therefore, that the colouration of the short matches the original strip only serves to highlight further the extent to which the original strip informed McCay's filmmaking.

While the similarities identified between the strips and the animated sequence support a retrospective reading of the strips as prototypical storyboards, it is important to remember that this is not how they originally functioned. Furthermore, the very act of reading the cartoons as makeshift storyboards introduces a textual dialectic, whereby the imagined storyboard text must contest the same space as the strips themselves, which, we should not forget, were prominent artefacts of popular culture in their own right. While for much of their history storyboards have existed as private production documents, destined and designed to be superseded by the production of a moving image text, this is not the case with the comic strips. The very fact that Nemo *was* publicly known perhaps forced McCay's hand stylistically, acting out 'the issue of primacy' which Lefèvre has since articulated in print:

> Usually people prefer the first version of a story they encounter. When you first read a novel, you form a personal mental image of the fictive world and when you first read a comic, you have a kinetic visual aid as well. Any filmic adaptation has to deal with these first personal interpretations and images: it is extremely hard to exorcise those first impressions.[30]

While the material dialectic of the cartoon's simultaneous existence as strip and prototypical storyboard is impossible to resolve categorically, the fact that the strip appears to have been used as direct inspiration when developing the animated sequence does anticipate a key function of the modern storyboard: to provide an artefactual site in which ideas pertaining to the subsequent production of moving images can be previewed, considered, and developed.

Storyboarding early live-action cinema

The shooting of a scene in one continuous take from a static vantage point remained the industry standard until the 1910s. Although what we might think of as production sketches or concept art does exist prior to this point, there was no need for anything resembling the breaking down of an action into a series of movements that is the *raison d'etre* of what we would ordinarily consider a storyboard. In the late 1910s and throughout the 1920s, a number of live-action directors started utilising pre-production documents that more closely resemble the visual construction of the classic bound storyboard, where multiple pages of storyboard material were fastened together for easy review on set. In particular, documents created by or for directors such as Cecil B. DeMille, D.W. Griffith, and Sergei Eisenstein indicate that 'storyboarding', although not formally named as such, was becoming a widely accepted pre-production process. A key characteristic that can be seen to develop in the prototypical storyboards produced during this period is a movement away from treating the page as the frame, whereby a single set piece or location would occupy a single sheet of paper, to having the page become a site on which to arrange multiple frames, with each frame being more closely related to a shot or key moment rather than a whole scene or set piece.

Phil A. Koury, writing in his study of DeMille, notes how the communication of ideas during pre-production was an ever-present difficulty for the ambitious director. In response to this, DeMille 'took to hiring an artist or two at the start of each picture. They produced numberless sketches. Like the writers, the artists suffered through one sketch after another, and only those with DeMille's initials in a corner were official. These were handed to department heads, and woe to him who departed in the smallest detail from the approved sketch!'[31] From Koury's description it is evident that such sketches were primarily intended as guides for the physical construction of sets, costumes, and other elements of the mise en scène about which DeMille felt strongly, rather than as direct guides for the cinematography of a given film.

Figure 1.4 A sketch made for *The Squaw Man* (Jesse L. Lasky Feature Play Company, 1914). Public domain, reproduced from: http://forum.westernmovies.fr.

In a pre-production sketch (**Figure 1.4**) from DeMille's *The Squaw Man* (1914), it is possible to see how such drawings might also have been used in a loose manner to guide composition. While there is little reason to doubt the authenticity of the image, which is hosted on cecilbdemille.com (a non-profit archive with no commercial activity encouraged on the site), where it is attributed to Wilfred Buckland, it is important to consider its possible origin.

Buckland, who is listed as providing 'Uncredited' Art Direction for the film,[32] was also no stranger to DeMille, as they knew each other 'from their days as students at the American Academy of Dramatic Arts'.[33] That Buckland's first formal credit, as art director, appears on *A Call of the North* (1914), which was released just five months after *The Squaw Man*, suggests that this was a case of introducing a formal credit where none had been before, to recognise the skilled pre-production work that Buckland was doing. Another measure by which we might judge the authenticity of the sketch is to consider what it depicts: two characters standing at the bar inside the Long Horn saloon. Although no shot can be seen in the finished film that identically matches the sketch (further suggesting the authenticity of the image – why would a counterfeit

image be based on a scene that doesn't feature in the film?), there is a sequence midway through that focuses primarily on Cash Hawkins (William Elmer), a villainous cattle-rustler, and a bartender, who serves Hawkins a bottle of alcohol much like that shown in the sketch. The direction from which this sequence is shot in the film is different to that sketched, but the fact that the two figures constitute the key narrative element suggests that this sketch might have influenced the composition of the shot to some degree. Furthermore, if Buckland was indeed the author of these sketches, then they represent set-designs that may have been put to additional use when staging the film's action. Arguably, it is in the appropriation of such sketches that the evolution of the modern storyboard might be traced.

In the case of D.W. Griffith, while there is agreement that the director made use of storyboard-like pre-production documents for the film *Broken Blossoms* (1919), there is some confusion regarding the exact name of the sketch artist that Griffith employed to produce this work. In both Robert M. Henderson's *D.W. Griffith: His Life and Work* (1985)[34] and David A. Cook's *A History of Narrative Film* (2008),[35] reference is made to a George Baker, while Karl Brown's *Adventures with D.W. Griffith* (1973)[36] and Richard Schickel's *D.W. Griffith* (1984)[37] credit a sketch artist called Charles Baker. All of the texts seemingly refer to the same Baker, an English artist with a cockney accent, but, as the original *Variety* review published in the year of *Broken Blossoms'* release confirms, Baker went by the name Charles not George (ambivalently, Intellect's 'Directory of World Cinema' cites Baker as both Charles and George in the same entry).[38] This factual inconsistency, while editorially careless and perhaps trivial, captures well the marginal status enjoyed by the storyboard artist, if not the storyboard, during American cinema's early decades.

Despite a lack of consistent recognition for Baker himself, the storyboards he penned for *Broken Blossoms* proved integral to the production of the film. Brown notes how 'Charlie would finish a sketch, tear it from the block, and show it to Griffith, who would always say it was fine, after which it was passed on … as Holy Writ'.[39] Having some experience of London, Griffith knew how he wanted the film to look, and he had Baker produce a series of watercolours in an attempt to capture his vision: 'Sets were not directly from Baker's designs, but rather were used to set the mood and spirit of the picture. This was the first time that Griffith had worked with an artist who might be called a designer in any real sense'.[40] In fact, almost a month was spent 'painting and re-painting the sets to capture colors that photograph[ed] in *the right way*'.[41] This *right way* refers to the look designed in the pre-production sketches, with Brown suggesting that a key ambition on the production was to

see 'Baker's painting reproduced in terms of a living, moving picture'.[42] For Schickel, reflecting on the film enhances the significance of Baker's watercolours, for 'one's first impression and one's final analysis both lead inescapably to the conclusion that, more than any other Griffith film, its force derives from its visual rather than its dramatic qualities'.[43] Baker's watercolours, therefore, no matter how divergent from modern notions of storyboard design, seemingly fulfilled a similar role during the pre-production of *Broken Blossoms*.

Outside of the United States, it is evident that hand-drawn pre-production documents were also being used to help realise complex visual ambitions during the 1920s. In Australia, for example, 'Cartoon Filmads were advertising the use of storyboards (or scenarios as they called them) as part of their pre-production process by at least 1920 (and were probably using them as early as 1918)'. This early use of storyboards makes sense, because, 'unlike a more standard narrative cartoon, an animated advertisement needed to communicate its message very clearly and succinctly', and 'since an external client commissioned each animation, it was essential that they could approve each film before the animation began, to ensure that client and studio shared the same vision'.[44] In his study *The Cinema as a Graphic Art* (1936), Vladimir Nilsen works hard to highlight the contributions of the camera operators who worked alongside better-known directors such as Lev Kuleshov, Sergei Eisenstein, Vsevolod Pudovkin, and Robert Wiene, to name but a few. While no reference is made to the use of formal storyboards, Nilsen recognises that drawn studies were often produced in advance of filming in order to pre-visualise how the image might work on a purely iconographic level. Given the challenging economic conditions in Germany and the scarcity of film stock in the nascent Soviet Union during the 1920s, it makes sense that film-makers would look for alternative ways to pre-visualise – or even just practice the process of film-making itself – before running film through the camera.

Nilsen argues that although Wiene's *Das Cabinet des Dr. Caligari/The Cabinet of Dr. Caligari* (1920) is usually regarded 'as a typical example of expressionism in film production', in fact, 'expressionism was applied chiefly in the formulation of the sets, the costumes, and the directorial treatment, and not (with the exception of the lighting), by means of specific resources of the camera-man's craft, which as a whole were exploited realistically'.[45] Nilsen's caveat regarding the importance of lighting anticipates his discussion of pre-production sketches made by the film's cameraman, Guido Zeber, which, with regards to the prevailing expressionist aesthetic, are strikingly close to the film's final look. Although the sketches clearly indicate that they provided a direct source of inspiration and reference when shooting, their fragmentary

and piecemeal nature falls short of indicating a more widely used and formalised pre-production process.

Similarly, surviving pre-production documents relating to various Eisenstein projects illustrate the importance placed on pre-visualisation by the director. In fact, in the case of the unfinished *The Glass House*, Eisenstein's notes and rough storyboard provide the only clues as to how the director initially planned to develop the work. In notes dated 17 September 1927, Eisenstein writes:

> Take the most ordinary actions and change the point of view.
>
> Take the most traditional types of psychological collisions and change the point of view. For the first – polishing floors – rolling up carpets – cleaning and placing furniture.
>
> Do it as farce, as grotesque, as nightmarish tragedy.
>
> Loneliness while constantly being 'among people' and being seen from all sides.
>
> Coldness of things. The cold of glass par excellence.
>
> That's where all the attempts to seek new points of view will be explored.[46]

Furthermore, the storyboard sketches reproduced in Jay Leyda and Zina Voynow's seminal *Eisenstein at Work* illustrate the conceptual centrality of glass in the planned film – principally the perceived ability of glass to render 'things' (by which we can infer American life) cold. Ultimately, *The Glass House*, which emerged in sketched form as an idea in the mid-1920s, and to which Eisenstein returned intermittently throughout his life, remained unrealised at the time of his death, meaning that in the absence of a final film the storyboards themselves take on added significance and importance.

No singular point of origin has been championed in this opening chapter, but it is our hope that rather than suggesting an impossible quagmire of competing traditions, preventing the development of further study around the storyboard as a distinct art form in its own right, this initial survey indicates the rich and multivalent traditions from which the modern storyboard has emerged. In the chapters that follow we will trace developmental trajectories that both link back to the forms discussed in this chapter, and mark breaks with earlier practices. Given the focus that has been afforded to the animated form in this early phase of the storyboard's development, it is fitting that our next step shall be to consider the conventionalisation of the form – as 'story board' – at the Walt Disney Studio in the late 1920s.

2
Storyboarding at Disney

The storyboarding practices at Disney, and more specifically the story-boarding of *Snow White and the Seven Dwarfs* (1937), represent a key moment in the history of the form. Disney's commitment to the story-boarding of this film redefines the production process within animation, but equally the practices employed at Disney can also be said to have made an impact on live-action pre-production via the work of William Cameron Menzies on *Gone with the Wind* (1939), which we discuss in the next chapter. *Snow White and the Seven Dwarfs* was released while producer David O. Selznick was making important decisions about the planning of his spectacular adaptation of Margaret Mitchell's 1936 novel, and Selznick reportedly became interested in the idea of story-boarding this project when his vice president at Selznick International Pictures (SIP), Merian Cooper, told him about Disney's storyboards for *Snow White*.[1]

In the years since, a myriad of storyboard forms have evolved, reflecting the specific demands of particular production contexts and the prefer-ences of individual storyboard artists; yet despite changing technological platforms, Disney's approach to storyboarding has remained relatively unchanged. When asked about the storyboarding process, Walt Disney 'always credited it to Webb Smith', one of his studio's staff members.[2] This confident assertion that the studio is deeply linked with the forma-tion of storyboarding continues to be borne out, whether in popular accounts, such as Stephen Cavalier's *The World History of Animation* (2011) or – rather fittingly – in the form of Paul Lamond's 1991 'Disney Story-boards' board game.

Aimed squarely at a family audience, 'Disney Story-boards' encourage players 'to recreate an enchanting Disney Film by placing ... Picture Cards in their correct order on the Story-board'.[3] At the start of each game,

players select a film, from those available in the box, to storyboard. The picture cards that the players acquire during game play contain images from their chosen film, alongside a short written description. For example, card A1 from the *Pinocchio* (1940) deck features an image of Geppetto painting Pinocchio, accompanied by the description: 'It was no ordinary village home into which Jiminy Cricket had stumbled. It was the workshop of old Geppetto who was putting the finishing touches to a new puppet he called Pinocchio'.[4] Winning depends on these cards being placed in their correct narrative position on the player's board before any other player is able to fully storyboard their rival Disney film.

Although playing this game hardly replicates the exact process of storyboarding as it developed at the Disney studio, it does hint at the significance that was quickly attached to storyboarding once the studio made the transition to feature-length animation. In the context of this game, each player essentially begins with the final film in an already complete state; all that remains is for it to be transferred, turn by turn, from the deck to the board. In reality, storyboard development at Disney was a much more fluid process, with every image open to potential change or deletion during production. Nevertheless, the very fact that Disney commissioned this game indicates the importance that the studio places on this particular process; after all, no comparable game exists for editing or filming, which are equally visual processes arguably carrying board game potential.

Given the Disney studio's reputation for fiercely regulating and monetising its creative property (even though much of this property relies considerably on the work of earlier folklorists and storytellers), it could be argued that the game reflects a desire on Disney's part to further extend the studio's ownership over a process that it is often cited as originating. In many of the 'how-to' storyboarding manuals, popular accounts of storyboarding history (whether in print, blog, or wiki form), and piecemeal scholarly accounts of storyboard history that exist, Disney's name is usually prominent.[5] However, as Chapter 1 has illustrated, the complex early development of the storyboard form problematises the attribution of a founding role to any one individual, although Disney did play a significant role in developing and conventionalising a particular type of 'story board'.[6] It is more accurate to see the Disney studio of the late 1920s and 1930s as a site of artistic convergence, where the 'story board', as a physical, board-based process was adopted to help bring order to gag development, and where, consequently, an altogether different – and new – form of storyboarding developed. This chapter

therefore traces the development of these two different storyboarding traditions at the Disney studio through the 1920s and 1930s, a time when an increasing emphasis was being placed on formalising the processes by which the studio's animation was produced.

Plane Crazy: the search for order

Disney used storyboard-like documents as early as 1928. John Canemaker, in his Disney-published study *Paper Dreams: The Art and Artists of Disney Storyboards* (1999), indirectly acknowledges this, drawing attention to the 'story sketches' that were produced prior to the production of the Mickey Mouse short *Plane Crazy* (1928). Canemaker notes how the *Plane Crazy* panels, 'six to a page, resemble a comic book and were at the time accompanied by separate sheets (now lost) of Walt's typewritten descriptions of action. That was the typical method of presenting stories at Disney before the *formal storyboards* came into use'.[7] Although Canemaker makes a distinction here between story sketches and storyboards (in keeping with that made by Disney himself), it is difficult not to see these 'story sketches' now as anything other than prototypical storyboards.

Canemaker's argument against such a reading hinges on the apparent ambiguity of the panels, noting that while they offer a snapshot of the main action in each scene, 'specifications regarding their various tasks are left untold'.[8] While this observation is partly accurate, Canemaker's purpose is, in effect, to privilege one specific style of storyboard over all else. Our own perception is different, and we see no good reason to completely – and retroactively – discount the *Plane Crazy* pages as simply precursors to the more formal storyboards that followed in the early 1930s. At the other extreme, *The Hand Behind the Mouse: An Intimate Biography of Ub Iwerks* (2001), an unsurprisingly partisan study co-authored by Ub Iwerks' granddaughter Leslie Iwerks in collaboration with John Kenworthy, presents matter-of-factly the proposition that 'in just two frenetic weeks, the first Mickey Mouse short [*Plane Crazy*] was completed. Every frame of the film was animated by Ub Iwerks: storyboards, extremes, in-betweens, backgrounds, *everything!*'.[9] Given that the *Plane Crazy* pre-production documents represent a site of taxonomic and definitional conflict, it is worth returning to the documents themselves to analyse how they relate to the final animated short.

Although Canemaker only reproduces two of the storyboard pages in his study, when reviewing all six pages it becomes clear just how important this document was to the pre-visualisation of the cartoon.

For example, the storyboard contains *apparent* evidence of an important phase of editorial decision-making, with four panels featuring red crosses marked over the centre of the image (**Figure 2.1**).

We exercise some caution here, referring only to *apparent* editorial work, as The Walt Disney Company during the preparation of the present study would not confirm that the markings had indeed been made by a Disney employee (past or present). However, given the precision with which all of the marks visible on the panels anticipate

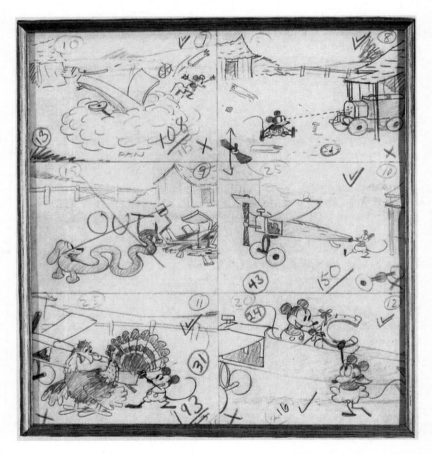

Figure 2.1 A series of story sketches detailing a scene from *Plane Crazy* (1928). Image provided courtesy of The Walt Disney Company (TWDC would like to make clear that they cannot confirm the red pencil markings, reproduced here in black and white, were made by Disney artists)

(or, more cynically, reflect) the final animation, it seems unlikely that anyone would create a fake storyboard that details deleted *Plane Crazy* sequences, before then marking up the storyboard in such a way to suggest an authentic editorial process. Perhaps we are being naïve about the commercial opportunities available to individuals willing to go to such lengths to fake such documents, but it is our view that those panels marked with red crosses, which do not appear in the final cartoon, do reveal a significant phase of editorial review. When viewed as a whole, it is easy to follow the cartoon's gag-driven narrative across the full thirty-six panels. Furthermore, when reading the document in such a way it is perhaps possible to recognise the editorial logic that prompted certain panels/sequences to be rejected and cut. In the case of all four rejected sequences the editorial decision appears to rest on avoiding repetition.

The first suggested cut follows Mickey's failed attempt to get his farm-built plane airborne. Having used a dachshund in place of an engine, coiling the dog's torso into a makeshift prop-shaft to power the plane's rotor blades, panel nine of the storyboard shows a shot of the stretched dachshund looking worse for wear next to the plane's wreckage. The elasticity of the dog again provides the means of propulsion when Mickey readies his second plane in panel 13, in a visual gag that is similar to the earlier prop-shaft sequence. This suggests that the decision to cut may well have rested on two factors: not wishing to overuse the stretchy dachshund gag, and wanting to avoid having the audience question why the dog would be so eager to help a second time having seen the dog's apparent physical distress after the initial failed take-off.

The other three crosses marked on the storyboard occur in successive panels on page three. The content of these panels indicates an extension of the chase motif that begins two panels earlier and extends for three panels after. Given that each storyboard page in this instance equates to approximately one minute of screen time, it is reasonable to imagine that Disney and Iwerks, the two individuals credited with creative responsibility on the short's title card, would have identified this section of the cartoon as being needlessly repetitive. Additionally, the suggested motion in these rejected panels is purely lateral, which, when compared to the variable depth of the previous panels and the striking tracking motion in those subsequent, would have represented an avoidable interruption of the cartoon's visual kineticism.

Precisely how the storyboard facilitated the practical animation of the images contained within the panels is now unclear, as the accompanying typed notes, which discussed the action as detailed by Disney and Iwerks, have, by all accounts, been lost to time. However, taking

Plane Crazy's close-knit production context into account, with just three animators and three inkers (two of which shared Disney's surname) employed during the making of the cartoon, it is likely that the story-board's images would have needed little accompanying notation to be easily understood by those involved in the production. Although Canemaker contends that any 'animator new to the project would have had many questions' when viewing the storyboard, this view seems more in keeping with modern production practices where animators, who might be required to work on various sequences across a large production pipeline, require clearly annotated and visually unambig-uous storyboards from which to work.[10]

According to Dick Lundy, one of the studio assistants at Disney in the late 1920s, a more intimate style of production management persisted until at least the end of the decade.[11] Central to this approach were 'round table' meetings, at which the entire creative team would gather together (initially in the director's room while the studio was still relatively small) to collectively define the story idea and how the gags might work best within it.[12] The storyboards for *Steamboat Willie* (1928), *When the Cat's Away* (1929), and *Mickey's Good Deed* (1932), for example, all reveal a desire to succinctly and unambiguously plot the key set pieces of the shorts prior to their production.[13] To achieve this, two general styles of storyboard developed, both physically similar in size (approximately A4), but each arranging the information differ-ently: the six-panelled page variety with separate written notes, and the three-panelled page, which incorporated the written notes along-side the vertically arranged sketches. For a short time, while the studio remained relatively compact, this improvisational method of story-boarding provided adequate support for Disney's early ambition.

Webb Smith: expanding the storyboard form

Following the successful addition of synchronised sound to the *Mickey Mouse* cartoons, Disney seized the opportunity to develop his studio's market share by developing a further musical series. Consequently, the *Silly Symphonies*, which debuted in 1929, increased Disney's work-flow considerably. In 1929 the studio released twelve *Mickey Mouse* shorts and five *Silly Symphonies*, in 1930 ten *Mickey Mouse* episodes and ten *Silly Symphonies*, and in 1932 twelve and ten respectively. This gradual increase put pressure on Disney to expand his staff, and by mid-1930 the number of people employed at the studio had passed thirty.[14] This desire to expand the operation continued the following year as 'the Disney premises expanded significantly, through the

construction of a two-story, L-shaped addition to the rear of the studio, and an adjacent sound stage'.[15] However, these increases in staffing and studio size would have placed inevitable stress on pre-production processes that had been forged when the entire staff could – and did – fit easily into a single, moderately sized office. In response, Disney established a Story Department at the studio in 1931, thus formally recognising the need for a more efficient approach to pre-production story development.

To populate this department Disney hired new staff from the East Coast, as well as reappointing individuals already employed at the studio. From the east, Disney poached Ted Sears from the New York-based Fleischer Studio, and newspaper cartoonist Webb Smith. From within, Albert Hurter and Pinto Colvig were moved to the newly formed story department. Publicly recognised in an October 1932 issue of the film industry trade paper *The Motion Picture Herald*, this four-man Story Department effectively professionalised the pre-production process at Disney. While all four men made important contributions in this capacity during the early 1930s, it is Smith who is usually identified as the key figure responsible for conventionalising a distinct pre-production process that quickly became defined as storyboarding.

It is impossible to date with any certainty when the term 'storyboard' was first used at Disney; however, the circumstances under which such a definition emerged are well documented. Smith, who was tasked with developing gags to fill the animated shorts, preferred to design such sequences visually, sketching them rather than writing out a description. In order to present these gag ideas in the most coherent way, Smith took to pinning his many sketches in order on empty walls. When exactly Smith first started to do this is again unclear, but it is likely that this approach evolved in mid-1933. Diane Disney Miller, describing a gag-planning exchange between her father (Walt Disney) and Smith, writes:

> One day Father said to him, 'Our dog, Pluto, is always sniffing along the ground. He never looks where he's going. What would happen if Pluto was sniffing along and ran into some flypaper?' He left Smith to ponder that suggestion and walked away. Two days later Smith had a wall covered with sketches of things that could happen to Pluto under those circumstances.[16]

Given that *Playful Pluto* (1934) concludes with an extended two-minute flypaper gag, it is clear that Smith's wall-pinned sketches played a key role in the early development of this short. Furthermore, with production averaging six to eight months at that time, *Playful Pluto*'s March

release suggests that Disney's exchange with Smith occurred during the late summer of 1933.[17]

However, Smith's wall-pinned method was merely the initial, improvisational phase in the development of an expanded storyboard form:

> At first, it is said, Disney was furious at the notion [of wall-mounting]: he claimed that the holes left by the pins would ruin the wall, which he had just spent a good deal to redecorate. But the conflict between his rage for artistic order and his rage for tidy housekeeping was resolved when quantities of corkboard were ordered (they had the virtue of being portable, too), and Smith's idea quickly became an established – even ritualistic – part of the studio's planning procedure.[18]

It is unknown who ordered the first corkboard, but the practice of mounting pre-production story sketches on corkboards quickly became the accepted convention for planning, arranging, discussing, and editing the animated shorts before commencing production (**Figure 2.2**).

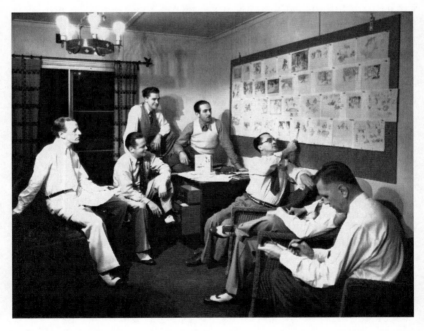

Figure 2.2 A promotional still, c.1933, showing a staged story planning session for *The Grasshopper and the Ants* (1934), featuring Webb Smith seated far left and Walt Disney in the centre. Image provided courtesy of The Walt Disney Company.

Amidst the hustle and bustle of a busy studio, it is easy to imagine that the habit of referring to these 'story corkboards' as 'storyboards' would have happened naturally and quickly.

The development of this alternative, large-scale storyboard method marks an important branching moment in the evolution of the form. While the roughly A4-sized, six-panelled page storyboard layout remained in use at Disney, the larger, cork-mounted variety became the dominant pre-production storyboard arrangement. A broader, perhaps more significant, distinction can also be loosely traced back to this moment of divergence: the act, and art, of storyboarding for animation as opposed to storyboarding for live-action. The process of making an animated film as opposed to a live-action one requires a fundamentally different approach, of course, and although digital technologies today are blurring this distinction (see Chapter 7), at the time of this divergence, in the early 1930s, the boundary was far more rigid. In simple terms, live-action filmmaking is a subtractive exercise, while animation, by contrast, is necessarily additive. In almost every situation the live-action filmmaker will seek to capture more raw footage than is required, with the foreknowledge that it is the post-production phase of editing that provides the opportunity to best assemble – through distillation – the already-imagined film. Contrastingly, the process of animation typically sees the same pre-agreed narrative building blocks remade over and over, with increasing refinement on each pass, until what remains is the complete material artefact – the final film. These very different film-making processes therefore demand different qualities from the storyboard itself. For example, a live-action storyboard is unlikely to anticipate the frame-by-frame construction of a film; instead, the images in the storyboard will typically plot character interaction and camera motion within each scene. The characteristics of live-action storyboarding are considered in more detail in the following chapters.

In terms of the professional responsibilities and expectations of the staff working within Disney's evolving Story Department, greater attention began to be placed on the early visual development of current projects. As Michael Barrier writes:

> The emergence of the storyboard led to yet more specialization later in 1934, when 'story sketch men' began to assist the writers; Bob Kuwahara, who joined the staff in the January 1933, most likely as an inbetweener, was probably the first. The sketch men were not the first cartoonists to work in the story department – by 1934 Albert

Hurter had been part of it for two years – but the sketch men were not expected to come up with ideas on their own; they were instead to give visual shape to the story men's ideas.[19]

The contributions of the sketch men encouraged the story team to begin developing their ideas more fully in the first instance. At the encouragement of Disney, who circulated a memo to the story team that directed them to work harder to pursue 'visualized possibilities', the writers and sketch artists stopped simply at submitting 'just a title or a setting' for consideration, turning their attention instead to crafting a more rounded plot or situation.[20] In doing so, Disney's studio also crystallised a labour dynamic that spread throughout the American animation industry.

As described by Matt Stahl in his 2005 and 2010 articles on labour practices in American animation production, the storyboard frequently provides a creative site where dialogue and gag ideas originating from the storyboard artist are crystallised. As these ideas progress through the production pipeline others will rework them, which has the effect of obfuscating the contributions of the storyboard artist. This approach to animated feature film production sees work begin 'with no more than an idea or outline', before 'moving right into the visual development, and then boarding and scripting simultaneously'.[21] As Stahl notes, in recent years there is greater opportunity for storyboard artists to feature 'prominently in the supplemental material packaged with animation DVDs', where they are often 'portrayed as creative, energetic, funny, and sensitive artists'.[22] Troublingly, however, Stahl reveals how allowing this kind of exposure to 'accrue into individual star value for creative workers in animation' carries unfavourable consequences, recalling the assessment of one former Animation Guild union officer who conceded that when faced with a rising star 'producers are going to have to abandon them and try and find somebody else who's brand new' in order to have the job (which, in the case of storyboard artist, is viewed as non-specialist) completed at the minimum rate.[23] Such attitudes are a product of the Taylorist conditions favoured by Disney, whereby the division of labour served not only to enhance productivity, but also to de-emphasise the artistic contributions of those individuals other than Walt Disney.[24]

As Stahl notes, central to the sustainability of large scale animation production is the 'division of waged artistic labor', which is contingent on an artistic autonomy that becomes 'a productive requirement of capital which both produces worker consent (through the artistic, professional, and personal investment, satisfaction, and growth it enables) and

reduces costs (by making possible the distribution of expensive conceptual work amongst artists officially categorised as executants)'.[25] While this might be a palatable working arrangement for many storyboard artists, the positioning of storyboarding as a lesser craft to screenwriting, as detailed by Stahl, gives rise to troubling authorial tensions.

In 2002 a group of Animation Guild writers, well aware of the authorial contributions by lower-paid storyboard artists, sought to shore up the boundaries around their own positions and downplay the originating work of the artists. They argued that storyboard artists should not be referred to as 'artists' at all but should be reclassified as 'graphic enhancers.' Storyboard artists were 'livid'; they and the writers elected representatives to debate the issue at the Motion Picture Screen Cartoonists (MPSC) Local 839. The reclassification was rejected, but writers and storyboard artists were made more acutely aware of the problems with marginal distinctions between less creative/less valuable and more creative/more valuable work, even within a below-the-line guild.[26]

To close this discussion of the on-going labour dynamics that Disney effectively set in motion, it is worth noting that within the realm of television animation the written word still supersedes the drawn storyboard – no matter how influential it may be in terms of composing the final animation. For Al Jean, long-time writer and story editor on *The Simpsons*, this is a pragmatic arrangement, whereby 'the writing credit is used to pay royalties', meaning that 'if you think of the idea, and you did the first draft, you get all the royalties'.[27] More disconcertingly, in the case of John Kricfalusi's high profile fallout with Nickelodeon over the production of *The Ren & Stimpy Show*, Kricfalusi's preference for a fluid, storyboard-first development, where separate 'storyboard teams and layout teams would be led by different directors, with Kricfalusi overseeing the entire process', is likely to have strengthened Nickelodeon's case when they came to fire the show's creator.[28] As Mark Langer notes, Kricfalusi 'allegedly missed production deadlines and exceeded budgets on a regular basis', and with a reliance on simultaneous parallel storyboard-based development it is easy to imagine how this would have happened. In this instance, the absence of a central, or even pre-agreed, script contributed directly to Kricfalusi's Nickelodeon exit.[29] Ultimately, it is important to heed Paul Wells' words *vis-à-vis* the relationship between script and storyboard: 'Storyboards are not an *illustration* of a script but another *iteration* of script, working as a model of editorial and creative construction in

the same way as rewriting text, or using the proverbial "blue pencil" to edit or cut scenes'.[30]

Since the development of the board-mounted storyboard at Disney in the early 1930s, this style of layout has become the preferred means by which to visually plan and manage large-scale animation projects. John Lasseter, director of five Pixar films, sees the mounted storyboard as also encouraging and supporting a form of dynamic, pre-production editing:

> Not only did this [large board] format allow a sequence to be restructured or refined on the spot, it made it easy for an artist to 'pitch' (describe and act out) the scene to others. Walt Disney's reputation as an unparalleled storyteller was cemented in front of such boards, as he analysed sequences, suggested changes, acted out key moments, concocted gags, and tweaked character shading.[31]

That the evolution of an increasingly detailed pre-production process at Disney can be seen to coincide with the studio's first real period of sustained profitability is probably no accident. Steven Watts notes that 'although not as big as enterprises such as Universal, Columbia, and RKO, Disney's independent operation had clearly entered the realm of big business by the early 1930s'.[32] Emboldened by his studio's hard-earned financial stability, and armed with the means to efficiently manage increased production, Disney began to contemplate the possibility of producing a feature-length animation.

Storyboarding *Snow White and the Seven Dwarfs*

The transition to feature-length animation was made easier by the fact that Disney's staff numbered more than 250 by the start of 1935,[33] more than double the 107 listed as being employed at the studio only three years previously.[34] With this increased workforce in place, Disney began to prioritise his ambition to create a feature-length film, dedicating greater numbers of staff to the production of *Snow White and the Seven Dwarfs*. In order to coordinate such a large workforce effectively, the studio used numerous large-scale storyboards, which could be carried between offices, to help keep production in check. However, these storyboards were certainly not fixed reference points, and were subject to revision throughout production. In fact, many of the pre-production documents relating to *Snow White and the Seven Dwarfs* reveal that both

mounted and single-paged storyboards existed in parallel, before settling into a clear textual hierarchy.

An example of this can be seen in the work conducted to establish the unique identities of the seven dwarfs. In a conversation with Bob Thomas, Disney recalled how he wanted each dwarf to have an identifiable personality beyond simple superficial mannerisms: 'we've got to take the time to have her meet each dwarf individually, so the audience will get acquainted with them. Even if we bore the audience a little, they'll forget it later because they'll be interested in each individual dwarf'.[35] In response to this directive, staff across the studio pursued a variety of pre-production strategies in addition to sketching and storyboarding. One important early strategy, but one which is often downplayed in studio-sanctioned accounts of Disney's animation process, was the utilisation of live-action film as a reference. In addition to filming several real dwarfs, Colvig, who had been put to work delivering Grumpy's voice, was also filmed 'performing Grumpy's actions at the beginning of [...]the washing sequence, as Grumpy, fuming, takes a seat on a barrel'.[36] However, while live-action reference material did prove useful on a mechanical level to the animators, helping to inform how the dwarfs moved, it presented no obvious advantage to the story department staff tasked with the job of refining the story structure as a whole. Unsurprisingly, in this story-orientated context, storyboarding remained key.

Roy Williams, a member of the expanded story department during the production of *Snow White and the Seven Dwarfs*, designed several comic situations involving Dopey. To present these ideas Williams drafted a series of single-paged storyboards.[37] One gag, which runs across two, four-panelled pages, sees Dopey come into possession of magical shoes that are revealed to have an agency of their own. After putting his hands into these shoes they immediately take control of him, forcing his hands to split and his face to hit the ground, after which they force him to 'hop along a la goat' (according to Williams' handwritten description beneath that panel), before dragging him face-first under a chair.[38] Williams' decision to arrange the panels as distinct boxes on each page might also suggest a desire to present his ideas in such a way so that they might easily be incorporated into a larger, mounted storyboard, through the straightforward method of cutting out panels as desired and then pinning them to a work-in-progress large-format storyboard.

Canemaker writes, in an analysis of Williams' work that also reveals a continued desire to establish a singular, settled form of storyboarding,

'[o]n several more pages, Williams attempted to form a continuity of the gags by putting them sequentially into small boxes (as in *prestoryboard* days)'.[39] We have previously suggested that Canemaker's decision to imply a fixed and universally agreed history of storyboarding is misleading; but on the other hand, his understanding of the work in question as a speculative act, directed towards some yet-to-be-realised *final* storyboard, helpfully positions the work as being, potentially, both storyboard and pre-storyboard.

Once the sketches assumed a position on the large-format, mounted storyboards, they continued to play a central role in both the narrative and visual evolution of *Snow White and the Seven Dwarfs*. Story meetings became a pivotal event in the development of the film, development that stretched over several years. At the centre of these meetings were two key ingredients: Walt Disney and the storyboard. Disney himself quickly gained a reputation for being a skilled performer, able to retell the story with great emotion and range. Ward Kimball and Marc Davis, two of Disney's so-called Nine Old Men (the nine most senior animators and supervisors who gained considerable influence during the 1950s and 1960s), note how when Disney was in the zone he could be carried away 'with the story or gag situation', and his performance would reach such a level that 'he was just as great as Chaplin'.[40] Drawing these sketches in isolation, and then adding them to the evolving storyboard, was the perfect test to see if the information contained within the sketches worked as a whole, effectively feeding into the shared development of the feature-length animation project – which, by virtue of its length, represented uncharted territory for Disney's studio. Disney's performances, then, became the central filter through which the storyboard passed, ensuring that it conformed with his grand vision for the project. Not only did these performances respond to the boards in front of him, they also would often spiral out and give shape to new ideas. Moments such as these presented a challenge to the animators and story men in the room, as Steven Watts notes:

> For many animators, the big fear was that they would be unable to capture in drawing what they had just seen Disney act out. Moreover, his skill at pantomime fed the pervasive search for personality in the studio's films. While other animated movies from this era relied on comic episodes and outlandish gags, Disney humor flowed naturally out of character traits and quirks. 'Without personality, the character may do funny or interesting things, but unless people are able to identify themselves with the character, its actions will seem unreal,'

Disney once said. 'Without personality, a story cannot ring true to the audience.'[41]

At the other extreme, Disney gained a reputation for taking great delight in deconstructing boards that – in his opinion, *the* opinion that mattered – did not work. In typically showman-like fashion, Disney would rip whole sequences off the boards under review, delivering a powerful reminder to the artists present never to stray too far from the narrative and visual design he favoured. In such a context, narrative and visual development was not the responsibility of an individual, or a very select group; rather, the development was subject to almost Darwinian conditions of evolution, with only the strongest ideas being allowed to survive, and the reputation of the artist affording no protection to a weak idea. At the heart of this constructive/destructive process was the relationship between Disney and the storyboard, with the board providing something akin to a roadmap for the studio head; without the surrounding storyboards it is difficult to imagine that Disney's performative activity would have been as precise and effective with the switch to feature-length production.

Evidently, large-format, mounted storyboards were crucial during the development and production of *Snow White and the Seven Dwarfs*, providing a site for creative convergence. Furthermore, the hierarchical relationship between the page-sized and mounted storyboards can also be mapped with some confidence, with the page-sized storyboards feeding, and perhaps even evolving into, the mounted storyboards. While these mounted storyboards undeniably provided an essential means of flexibly fixing the narrative of *Snow White and the Seven Dwarfs* before animation began, the increasingly formal nature of such pre-production documents brought undesirable consequences for the animators. As Barrier notes, 'over the previous few years, Disney and his directors had cultivated an atmosphere in which animators felt encouraged to experiment and develop characters; now, on *Snow White*, they were expected to hew closely to designs and characterizations that other people imposed in them'.[42] Although Barrier makes no explicit reference to these designs or characterisations being storyboarded, it is logical that storyboarded sequences, along with character model sheets, would have informed much of the animators' decision-making and output, and assisted in coordinating day-to-day production at the studio.

Storyboards also underpinned the shifting attitude during the 1930s regarding the type of animation that the studio should produce. Keen to leave behind the occasionally abstract and often metamorphic style

of the studio's early cartoon work, Disney sought to increase the life-like quality of his feature animation. This prioritisation of realism across the films *Snow White and the Seven Dwarfs*, *Pinocchio* (1940), *Dumbo* (1941), and *Bambi* (1942) proved so effective that, as Wells suggests, 'it may still be the case that all animation both within the United States and elsewhere in the world, remains a response to "Disney" – aestheti-cally, ideologically and technically'.[43] Although Disney was not alone in seeking to enhance the realism of his animated works at this time, unlike the Fleischer Studio, which relied heavily on rotoscope to endow the eponymous protagonist of their animated feature *Gulliver's Travels* (1939) with a lifelike quality, Disney sought to avoid what Paul Ward more generally describes as the 'eerie' appearance of closely roto-scoped animation, trusting his animators to use live action purely as a guide to movement.[44] Ultimately, 'believability, rather than absolute realism, became the driving principle underpinning Disney's animation during this period'.[45] However, for all of the studio's aesthetic refine-ment, which resulted in increasingly believable characters, landscapes, and soundscapes, without a coherent and compelling narrative all of Disney's efforts would be for nought.

Extensive and effective storyboarding was therefore critical to Disney's feature-film vision. Neal Gabler, in his biography *Walt Disney: The Triumph of the American Imagination*, records a revealing exchange that took place during the pre-production of *Pinocchio*:

> Sketch artist Bill Peet remembered the staff being summoned to a *Pinocchio* meeting and the animators carrying what he estimated to be at least seventy storyboards as they huddled around Walt's armchair in the Projection Room No. 4. Walt's mood, which had been lighthearted as the morning session began, gradually dark-ened. 'There's too much stuff here,' he barked, and every so often he would, as Peet recalled it, get up and rip a whole row of sketches off the board, summarily shortening the film. The only calm in the storm was when they came to the character of Honest John Foulfellow a conniving fox who waylays Pinocchio, and Walt trans-formed himself into the villain to act the scene. By the time the two-day session ended, Walt had eliminated half the boards, though as he left, 'he turned to us with a satisfied smile and said, "That was a hell of a good session."'[46]

From this account, echoing the working practices developed during the production of *Snow White and the Seven Dwarfs*, we can see that

storyboarding quickly became the hub around which much of Disney's pre-production and production was managed. Without storyboards to help plan and refine narrative development, which in the case of *Pinocchio* spanned almost ninety minutes, it is difficult to imagine how Disney would have delivered these early features in such a coherent and economical fashion.

As Disney's interests widened, spanning theme park development, network television production, wildlife documentary, and live-action feature filmmaking, to name but a few, his focus on – and participation in – the daily development of his studio's animation was naturally reduced:

> Increasingly he functioned as a kind of corporate manager in a large-scale economic setting. Instead of the old micromanagement style he used in the prewar period, actively involving himself in every animated project coming out of his studio, he now supervised more generally a vast array of undertakings in several different media. He still played an important role in defining projects, but seldom did he become completely involved in any one undertaking. Walt's task increasingly was to keep his machine running smoothly by overseeing skilled personnel and lubricating its array of moving parts with creative ideas.[47]

Disney himself acknowledged this inevitable shift in his working habits, but made clear that he remained the most important cog in the studio's creative process, by effectively 'setting up projects at "the formative stage", then turning the day-to-day production over to talented artists and trusted supervisors, helping out when "we hit a snag," and making decisions on the final project as "a good editor."'[48] As Watts notes, 'for all his increasing reliance on organization, Walt did not become an absentee landlord in the creative process. He still worked intensely with his greatest love, scripts and story'.[49] The storyboard, therefore, remained a key working document throughout Disney's managerial reign, enabling the studio head to be brought quickly up to date on a range of simultaneously advancing projects. Furthermore, the aforementioned Nine Old Men, in particular Wolfgang Reitherman, who began to inherit directorial responsibility from Disney in the late 1950s with his work on the film *One Hundred and One Dalmatians* (1961), could rely on the shared creative space established by the storyboard as a way of communicating Disney's editorial revisions amongst the film's production team, without Disney himself having to be present.

While the aim of this book is to establish a broad critical history of storyboarding across animated and live-action filmmaking, these first two chapters illustrate how animation has contributed significantly to the conventionalisation of the storyboard as a formal document. Furthermore, Disney's own often-repeated claim that 'storyboarding began at the studio' carries profound taxonomic significance. Arguably, this chapter prepares the ground for a particularly narrow definition of storyboarding, one which describes a pre-production activity, reliant on hand-drawn illustrations, which collaboratively constructs (and reconstructs) a sequential narrative in the form of contiguously mounted – yet discrete – sketches upon a large-format board. In relation to this, single-page storyboards would simply become story sketches – as they were described during Disney's reign. Such a restrictive definition would also prompt a similar redefinition of live-action storyboards, which, while often resembling the story sketches discussed in this chapter, might be renamed pre-visualisations, or simply 'the previs', as it would probably be abbreviated on set.[50] The fact that digital pre-visualisation has become an integral part of contemporary film production makes such a name even more compelling. However, rather than attempting to dogmatically redefine the entire history and process of storyboarding, it is more productive to simply acknowledge the formative role played by Disney in settling the large-form, mounted storyboard model, whilst also recognising that this model of storyboarding constitutes just one approach and tradition in what is a rich and diverse textual form.

Ultimately, the reason why Disney's contributions to the evolution of the storyboard still resonate today relates to his fastidious archiving of the vast majority of the documents that contributed to the production of his animated films. This desire to catalogue and preserve the pre-production endeavours of his studio, especially through the 1920s, 1930s, and 1940s, perhaps reflects the reality that much of the work produced remained consistently innovative, encouraging the desire to keep a reference of how certain things were planned and achieved in case that might prove useful during the production of a subsequent film. By contrast, the pre-production materials produced in support of live-action filmmaking have frequently been considered disposable once production has wrapped.

3
William Cameron Menzies, *Alice in Wonderland*, and *Gone with the Wind*

The pivotal place that William Cameron Menzies today occupies in the history of storyboarding initially derived from common perceptions about the role of storyboarding in the making of *Gone with the Wind* (1939), and the assumption that the pre-production of the film was significantly influenced by the Disney studio's innovations in creating *Snow White and the Seven Dwarfs*. Menzies, however, had been working on related approaches to film design since the 1920s, and Selznick tested the waters by asking him to work first on a smaller-scale film for SIP, *The Adventures of Tom Sawyer* (1938). By 29 July 1937 the producer was envisaging that Menzies 'will be able to do a broken-down sketch script of the entire production' of *Gone with the Wind*,[1] and as a result, the claim continues to be made that the film was 'completely storyboarded'.[2] Supporting evidence can be drawn from the surviving materials, the most frequently cited being an extensive sequence of images depicting the burning of Atlanta.

In reality, the picture is a great deal messier; in particular, as we shall see, this view of the extent and nature of Menzies' storyboarding for the film has been convincingly challenged in the exemplary scholarship of Alan David Vertrees.[3] Yet *Gone with the Wind* still takes its place as the culmination of the advances Menzies had made since serving in New Jersey as an assistant to Anthony Grot, who has been credited with developing the idea of pre-production continuity sketches in the early 1920s. Grot and Menzies both made their way to Hollywood, and the latter had already become one of the more noted Hollywood art directors when, in 1923, Douglas Fairbanks engaged him to work on *The Thief of Bagdad* (1924). Much of the lure of this still-appealing spectacle lies in the balletic, gymnastic grace with which Fairbanks dances his way through the stunning fantasy world that Menzies created. Throughout

the remainder of the silent era Menzies' reputation grew, culminating in his receiving the award for best art direction on *The Dove* (1927) and *The Tempest* (1928) at the first-ever Academy Awards in 1929, a year in which Menzies also worked on *Bulldog Drummond*. For this light, British-based thriller, only six sets were initially planned; but '[b]y the time he was done working on the scenario with director F. Richard Jones, there were 60 sets and over 300 drawings'.[4]

In retrospect, Menzies' achievement on *Bulldog Drummond* and other films of around this date is arguably more significant, if less visible, than the receipt of the Oscar, because it shows him working on an approach that sees the anticipated film through the eye of the camera, with an awareness of composition and the possibilities of editing the continuity from shot to shot. Some support for the view that a significant historical change in film design was occurring more generally at around this time is provided by Paul Rotha in his important article 'The Art Director and the Composition of the Scenario', published in 1930. Rotha sees the essentially theatrical mise-en-scène of the German expressionist film between 1919 and 1925 giving way to an Eisensteinian cinema in which each image contributes to 'the whole composition of the film vibration'. Accordingly, 'art-direction must take its place in the construction of the scenario-manuscript, as an integral part of the pre-conception of the film in literary terms before its realization on the studio floor, on exterior, or in the cutting room'.[5]

As David Bordwell remarks, '[u]nlike most set designs, which show empty settings or people in undramatic poses, Menzies' drawings look more like what we now call storyboards',[6] which at the time were more commonly referred to as 'continuity drawings'. However, what the extant storyboards that Menzies drew for this and other projects, including *Gone with the Wind*, do not indicate is movement *within* the shot. Throughout his career, Menzies remained more adept at conceptualising a scene, and detailing the possibilities of camera angles and narrative montage, than at dramatising the action within the mise-en-scène. His early achievements had been confined to art direction, with set designs that were imaginative, spectacular and innovative, yet also, of course, static; whereas the human warmth, movement and energy of *The Thief of Bagdad* are supplied by Fairbanks.

What is in effect a division of labour in securing the overall effect of the film became noticeable when Menzies took on the role of director for *Things to Come* (1936). This was a still more spectacular achievement in design than *The Thief of Bagdad*, yet one can say of *Things to Come* what Richard Sylbert, who much later, in the early 1950s, noticed

in working with Menzies on some Fu Manchu stories for television: 'It was obvious his great strength was not in the area of performance; [although] visually, the stuff looked great'.[7] Bordwell suggests that Menzies was uninterested in the dialogue scenes that entered cinema with the talkies, and finds in his ideas 'a brutally Modernist approach: Chisel out the composition as a pure play of graphic energies, and then fit your setting, props, and players into it. Even in action scenes, the human figures are dominated by the larger design'.[8] Later, in a series of collaborations with director Sam Wood, this resulted in a very clear division of labour. According to cinematographer James Wong Howe, who worked with both men on *Kings Row* (1942), 'Menzies designed the sets and sketches for all the shots; he'd tell how high the camera should be; he'd even specify the kind of lens he wanted for a particular shot. [...] Menzies created the whole look of the film. I simply followed orders. Sam Wood just directed the actors, he knew nothing about visuals'.[9]

Sylbert recalls that in directing the Fu Manchu episodes Menzies worked from his own storyboards. Although this practice does not seem ultimately to have enabled Menzies himself to develop as a major director, the boards did become crucial for other directors with whom he collaborated. An article in *American Cinematographer* in 1945 reported that Menzies saw his role as that of 'pre-staging': 'There is a spot in between the scenario and the direction that an artist, trained in film fundamentals, can usefully fill. His production designs are, in that sense, an intermediate process between the printed word and its visualization on celluloid'.[10] These words, which appear to be Menzies' own, refer specifically to production design, but we can also read the description more literally to mean work on the scenario, or screenplay, itself. While his role on *Gone with the Wind* did not extend to rewriting the script, that is precisely what he did for an earlier film, a draft of which shows him meticulously, and literally, filling in space on the pages on which the words are printed, in an attempt to improve their visualisation on the screen.

Alice in Wonderland (1933)

That film was *Alice in Wonderland*, an all-star, live-action but effects-laden Paramount production, which amalgamated material from both of Lewis Carroll's celebrated tales *Alice's Adventures in Wonderland* (1865) and *Through the Looking-Glass, and What Alice Found There* (1871). There are two extant iterations of the Paramount script. The later version, of

which director Norman Z. McLeod's own personal copy is held in the archive of his papers at MHL,[11] represents a reworking of the former, immediately prior iteration, to which we shall return. The McLeod copy is bound, printed on pink paper, and prefaced by an illustrated title page, which gives the full title (*Alice's Adventures in Wonderland and Through the Looking-Glass by Lewis Carroll*), crediting the 'screen play' (two words) to Joseph L. Mankiewicz, with 'Six Hundred and Forty-Two Illustrations by William Cameron Menzies'. On the following page are further credits, and a dramatis personae presented in alphabetical order of players. This kind of deluxe presentation of a screenplay was often distributed to key members of a production team (a similar extant document is a bound copy of a script for MGM's *David Copperfield* [1935], signed by all members of the cast),[12] and strongly suggests that it was intended as a final draft or shooting script.

There follows an eight-page prologue ('Sequence A'), presented in the unusual but, for this period, certainly not unique form of two columns, with dialogue on the right-hand side of the page and the scene text elements, including scene headings, to the left.[13] During the prologue, Alice talks to the governess about the chess players fighting, the rabbit in clothes, and other fantastical happenings, before apparently falling asleep. At the end of the script, a four-page epilogue is presented in the same distinctive parallel-column format. This shows an initially tearful Alice re-entering and finding new wonder in the real world, supported and encouraged by her sister, who believes her story, and coming to terms with the stern, disbelieving governess, who had appeared as the Red Queen in Alice's fantasy.

The prologue and epilogue are, however, dwarfed by the material to which they form the bookends, and to which they bear no formal resemblance. Every page of the script aside from the prologue and epilogue has been illustrated: that is, every page that takes place within the fantastical dreamscape that is framed by the 'real' world, including the transitions to and from it. With very few exceptions, each of these 642 pages contains three kinds of material. First, the top half of the page presents an illustration by Menzies, evidently designed to approximate a shot within a film. For instance, on the first page we see Alice standing in front of the fireplace. (Our reproduction of this page in **Figure 3.1** is sourced from the earlier script iteration, to which we shall return).

Second, a description of the scene and action represented in the drawing is typewritten in upper-case underneath the illustration: in this example, 'INTERIOR LIVING ROOM – MEDIUM SHOT – ALICE CROSSES TO THE MANTELPIECE AND CLIMBS UP UPON IT. SHE

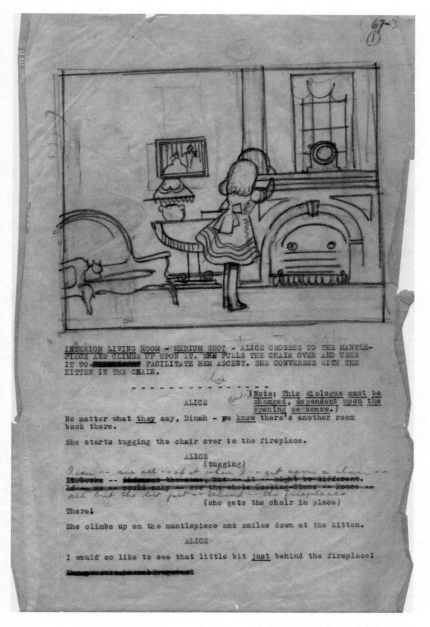

Figure 3.1 *Alice in Wonderland* – script, William H. Wright collection, Margaret Herrick Library of the Academy of Motion Picture Arts and Sciences. Courtesy Universal Studios Licensing. © 1933 Paramount Pictures.

PULLS THE CHAIR OVER AND USES IT TO FACILITATE HER ASCENT. SHE CONVERSES WITH THE KITTEN IN THE CHAIR.' The third kind of information on each page is mostly dialogue, printed in lower case, with the speaker's name centered and in upper case. In our present example, ALICE speaks to the kitten: 'No matter what they say, Dinah – we know there's another room back there'.

A further distinction needs to be made between the two typewritten kinds of text on the illustrated pages. The dialogue at the bottom part of the page is routinely accompanied by additional reports of character actions as the shot develops, with Alice's words (in our example) immediately followed by the information that 'she starts tugging the chair over to the fireplace' – even though the preceding material typed in upper case has already indicated some of the action of the scene. The distinction appears to be that the reports of action presented in upper case on the middle of the page are used to establish what we might call the mise-en-scène of the shot, just as the opening directions of a stage play indicate the actions taking place at the beginning of a scene; while any action descriptions interspersed within the dialogue, in the lower part of the page, describe a temporal sequence of events that subsequently unfolds within the shot. Here, what needs to be established within the shot is that 'SHE CONVERSES WITH THE KITTEN'; any other action within the shot is consequent upon this.

At first glance, *Alice in Wonderland* may appear to be exactly what its title page proclaims it to be: a screenplay by Mankiewicz, illustrated by Menzies. A reader today may be surprised to find shot specification ('MEDIUM SHOT') routinely specified within a screenplay, but this is commonplace in scripts of this date; similarly, the dialogue, and any reports of the action that accompany it, conform to the conventions of screenwriting in place at the time. However, the peculiar presentation of the text elements helps to establish what Menzies' precise role was, and it went well beyond the already formidable achievement of providing an illustration for every proposed shot. Instead, the *Alice* script shows Menzies working in a manner that precisely and *literally* demonstrates his role as he described it in the article for *American Cinematographer*: 'an intermediate process [the technical material described in upper case] between the printed word [the screenplay dialogue and directions at the bottom of the page] and its visualization on celluloid [in the illustrations at the top of the page]'. In other words, the technical material in upper case literally intervenes, in the middle of the page, between the screenplay material at the bottom and the illustration that anticipates the desired visual effect at the top, to suggest how the words are to be

translated into the image. For example, after specifying a 'CLOSE-SHOT – NEAR LEG OF A TABLE', the technical directions on page 115 suggest that 'THE LEG OF THE TABLE AND THE BACKGROUND ARE MADE INTO A TRANSPARENCY. ALICE WORKS IN FRONT OF THIS'. Similarly, on the following page, 116, we have an 'INSERT – BOX. (THE COVER IS LIFTED BY INVISIBLE WIRE OR THREAD)'. This shows Menzies working as an art director to establish solutions to problems in representing the fantasy world of *Alice*.

The extent to which Menzies was transforming the screenplay into a precise pre-visualization of a potential film can be still more strongly established by comparing the McLeod text to what is manifestly the immediately preceding iteration **(Figure 1.3)**. This earlier document is also held in the MHL, this time among the papers of William H. Wright, who was a producer at Paramount at this time.[14] The illustrations in Wright are Menzies' original, pencil-drawn sketches, which have been cleaned up in McLeod by stencil and tracing to produce clean, hard lines, with the straight lines previously drawn by hand now rendered more accurately with a ruler. The edges of the frames in the earlier document are defined by a blue template, but with another frame outline hand-penciled over it; the frame outline in McLeod is hard and consistent. The first few pages in the earlier iteration have 'Done' handwritten in the left margin, presumably to indicate that they have been reworked into the form they are to take in the later text, but this practice is soon dropped.

A comparison of the two documents, and an examination of how the illustrations work alongside the verbal text, confirm that each illustration is intended to represent a single shot. For example, in the Wright version the dialogue is so extensive on page 14 that two pieces of paper have been pasted together, producing a page that is about 50% longer than normal. In McLeod, the corresponding material occupies two pages: 14, which includes the illustration, and 14-a, in which the dialogue continues but without a further illustration. Conversely, some do not have the screenplay material that ordinarily occupies the lower portion of a page. These include pages 29–31, which detail a series of shots in which Alice tries to help the White Queen, and most of pages 77–82, as Alice falls down the rabbit hole.

Every page has some technical information, in some cases limited to slug-line information that may derive from the iteration of the screenplay from which Menzies is working, as in the terse 'CLOSE SHOT – AT TABLE' of page 105. However, there is considerably more of this kind of direction earlier in the script; as the screenplay progresses, there is a

greater preponderance of purely live-action (in Menzies' word, 'real', or 'actual set' [p. 599]) sequences, which require relatively little in the way of technical comment. For example, the Mad Hatter's Tea Party takes place on a 'real set' (236); therefore, all of the pages detailing this scene (237–274) are simply shots, and the technical information is confined to slug lines, such as 'CLOSE SHOT – GROUP', 'CLOSEUP – DORMOUSE', and so on. This causes the scene to read more like a conventional continuity (or screenplay) text of the period, except with illustrations; unsurprisingly, there are very few changes between Wright and McLeod in this sequence.

Overall, however, the Wright version represents not just the storyboarding of an existing screenplay, but a radical reworking by Menzies of an ur-scenario, largely or wholly by Mankiewicz. One reason why Paramount (or perhaps Menzies) may have gone to the trouble of revising each of the 642 illustrations, which were already so perfectly serviceable that some (as on page 393) required almost no reworking for the later iteration, is that the *written* text of the Wright version contains such extensive additions, deletions, and rewording that the material had to be completely retyped anyway, with McLeod then representing a completely clean copy of both the words and the images of Wright.

It is not surprising that Menzies made some alterations to the material in upper case that prescribes or suggests shot type, aspects of production design, and special effects. Much more extensive in the Wright pages, however, are what appear to be his own handwritten revisions to the dialogue. Returning to the first page as our example, the original typewritten words of Alice that immediately follow her first speech to the cat have been replaced with entirely new, handwritten dialogue: 'I can – – see all – – of it when I – – get upon a chair – – all but the bit just – – behind – – the fireplace'. As with seemingly all of the myriad such emendations, this new text is adopted in the subsequent iteration. Several pages in Wright (such as 177–178) are entirely handwritten as well as hand-drawn, with this writing then forming the typewritten text of the corresponding pages in McLeod. While a draft Mankiewicz screenplay appears to have predated Menzies' direct involvement, then, Menzies did not just translate it into visual images but directly transformed the written text itself, with words and images developing simultaneously. Meanwhile, the images are harmonised with the technical directions that are presented immediately below them, so that not only is the shot type both prescribed and illustrated, but problems posed in the realisation of particular shots or scenes are already being addressed. In effect, this *Alice* is not a screenplay, nor a

set of storyboards, but a production Bible, and 'Menzies' involvement in the writing process resulted in the subsequent decision to credit him alongside Mankiewicz as co-writer of the screenplay, the only writing credit he would ever receive.

Given this prodigious contribution, it comes as something of a shock to note that Menzies did *not* receive credit for the art direction. By then, however, the film had undergone dramatic changes, including radical cuts to the storyline, and while many of the effects suggested in the screenplay have been retained, the whole look and conception of the film has gone. Even though he knew he was drawing for live action, Menzies' line drawings have a charm and playfulness that is appropriate to the material he was adapting and augmenting, but which would have been better realised in animation of the kind that is suggested to a reader who becomes immersed in the hundreds of illustrations. The film was severely truncated for release, but in any case there is a disappointingly prosaic crudity to the studio-bound live-action, suggesting that in this respect also the film failed to match the ambitions evident in the detail of Menzies' technical directions.

Another disappointment lies in the editing. At the turn of almost every page of the screenplay the reader is presented with a strikingly different shot or angle from that which precedes it, but little of this is captured in the unexpectedly long takes and static camerawork in much of the film. A related difficulty perhaps lay in a certain confusion surrounding the functions of the illustrated screenplay. As is characteristic of Menzies' work, the individual images with supporting technical commentary suggest that he was largely concentrating on creating a distinctive look for each shot, but the continuity between shots, and – in particular – movement within them, is largely absent. For *Gone with the Wind*, an attempt to eliminate this confusion may have been made by separating the role of design, associated with the concept art, from the pre-visualisation of editing, which would now be taken by what we might term the storyboard proper. As we shall see, however, the situation is a great deal more complicated.

Gone with the Wind (1939)

Gone with the Wind represents a fascinating case study for examining the role of storyboarding in film production. This is not the place to attempt yet another reconstruction of the making of the film, a task that has already been undertaken in several extremely scholarly studies, which have made productive use of the voluminous collection

of materials relating to the film in the David O. Selznick archive at the Harry Ransom Center in Austin, Texas.[15] Our purpose in revisiting the film here is to attempt to determine where Menzies' work on the project fits into the history of storyboarding as a practice, and this involves taking another look at the kinds of illustration he provided, its extent, and its specific purposes in the context of the making of the film.

Arthur Fellows, one of the assistant directors, recalled that 'the whole look of the picture was pretty well dictated by Bill Menzies' storyboards: the sets, the people, they made you absolutely feel what the finished picture was going to look like'.[16] Vincent LoBrutto, singling Menzies out for special attention in his introduction to *By Design: Interviews with Film Production Designers*, states that Menzies 'created a blueprint for shooting the picture by storyboarding the entire film. His detailed work incorporated color and style, structured each scene, and encompassed the framing, composition and camera movement for each shot in the film'.[17] If so, this would make it one of the first films, and certainly the most complex to that date, to have had each shot planned in advance in this way. An immediate challenge to this argument, however, is presented by the notoriously chaotic production of a project that can equally well be cited as a powerful illustration of the near-impossibility of planning a film at this level of detail and precision. Alan David Vertrees concludes from his exceptionally detailed analysis of the surviving screenplay and design materials that 'The truth is that Selznick rarely predetermined anything and that every element of his production was subject to change',[18] with the claims for the role of storyboarding in the film ultimately amounting to little more than a 'legend'.[19]

This means that the theoretical and conceptual potential of storyboarding, exemplified in the claims for Menzies' work on this film, has become enmeshed in two completely contradictory representations of the nature of Hollywood film-making: as following a meticulous process of industrial planning appropriate to the scale of the economic investment, on the one hand, or as being subject to constant revision and derailment as a result of interventions and accidents coming from any quarter and at any time, on the other. Each side of this contradiction is epitomised in the personality and working methods of David O. Selznick, the driving force behind *Gone with the Wind*.

On 29 July 1937, Selznick was envisaging that Menzies 'will be able to do a broken-down sketch script of the entire production',[20] and reiterated this intention subsequently and in many forms, his famous

memos preserving a detailed record of how he saw Menzies' role. By 12 August he was envisaging the text upon which Menzies was engaged as a 'complete cutting script with sketches from the first shot to the last', which 'may be the answer to what I have long sought for, which is a pre-cut picture [...] we might be able to cut a picture eighty per cent on paper before we grind the cameras'.[21] On 1 September he informed Jock Whitney, chairman of the board at SIP: 'I hope to have *Gone with the Wind* prepared almost down to the last camera angle before we start shooting, because on this picture really thorough preparations will save hundreds of thousands of dollars.'[22] Selznick aimed to 'utilize all of Menzies' time' in the preparation of certain key sequences that the producer already knew would appear in the film, 'until we can give him a complete script. When he gets the complete script, he can then do all the sets, sketches, and can start on what I want on this picture and what has only been done a few times in picture history (and these times mostly by Menzies) – a complete script in sketch form, showing the actual camera set-ups, lighting, etc.'[23] It is worth noting here, to qualify some of the more extreme claims made for the status of the film in the history of storyboarding, that these remarks show that the producer himself was well aware that any innovation lay in the scale, and not the nature, of the task confronting Menzies. Menzies was to work on this 'mammoth job' alongside George Cukor, whom Selznick had selected as director. 'In short, it is my plan to have the whole physical side of this picture [...] personally handled by one man who has little or nothing else to do – and that man, Menzies. Menzies may turn out to be one of the most valuable factors in properly producing this picture'.[24]

The nomenclature surrounding the job title that Menzies would ultimately be accorded is historically significant. Press releases in January 1938 stated that he would be 'designing' the film. In response to director George Cukor's objection that 'drafting' would be a better term, Selznick responded that 'Menzies' task is a monumental one and I am anxious that he receive a fair credit. Actually what he is doing is "designing" the picture and "designing" it in color, if it is to be made in color'.[25] Selznick accordingly created the title of 'production designer' specifically for Menzies, in order to distinguish his contribution clearly from that of Lyle Wheeler,[26] who as 'art director' was taking on a role already recognised in the industry. Menzies' duties went beyond this, since the central coordinating tasks that Selznick envisaged for him included not just the design and construction of sets, much of which Menzies was able to delegate to Wheeler, but also the meticulous pre-planning of

all aspects of the cinematography, as well as working to harmonise the live-action work with the special effects. In coining the term 'production designer' to capture the extent of Menzies' contribution, Selznick brought into being a role that would become central to much subsequent film production. The on-screen credit in the opening titles of *Gone with the Wind* prominently proclaims: 'This production designed by William Cameron Menzies'.

The design role became still more significant as it emerged that, despite Selznick's ambitions, Menzies never would receive that 'complete script' – because a complete script never existed. Sidney Howard was engaged to work on the screenplay in late 1936, and delivered an initial treatment on 14 December, followed by a first draft, amounting to some 250 pages, on 12 January 1937. His second draft, a result of collaborative work in July 1937 with Cukor and Selznick, came in even longer (on 5 August) than the first. The situation was in some ways exacerbated when Selznick, in grappling with the script's unfeasible length and other complications, brought in several additional writers. Although Howard was employed for longer on the script than anyone else, others made substantial contributions, including Oliver Garrett and Ben Hecht. Importantly, '[o]f the more than a dozen writers known to have worked on the screenplay of *Gone with the Wind*, almost all began their work after filming had commenced',[27] resulting in a multiplicity of versions, of which the composite 'rainbow script' is the most celebrated. In the summer of 1938 Selznick spent a month on revising a script 'which now consisted of four packing-cases full of drafts. ... The script was a mess, because really only one man was now writing it: David Selznick'.[28] One of the actors (Evelyn Keyes) recalled that 'there was no original script, it was all re-written, every day'.[29] As David Thomson concludes, 'an accurate continuity on paper [...] didn't exist, because there had never been a final script. After all the rewrites, it only existed in Selznick's head',[30] with changes being made right through the editing process. As all commentators agree, much of the final shape of the film results from Selznick's work in the editing room, as he cut nearly half a million feet of film to around 20,000.

Partly as a result, the budgeting function commonly associated with the screenplay in the classical Hollywood cinema fell to other media: 'Selznick did not wait for a final shooting script of *Gone with the Wind* before preparing its budget. Various indices produced from the novel by the SIP story department served as "blueprints" for planning as much as did Howard's revisions of the continuity script'.[31] Similarly, with

the script unable to function adequately as the basis for the narrative, once Victor Fleming was recalled as director he decided to complete the film specifically (according to Thomson) 'with the help of Menzies' storyboards'.[32]

A complication arises here as a result of the incomplete nature of the extant materials. In contrast to earlier estimates of some 1,500–3,000 production sketches by Menzies, Vertrees' researches unearthed only 'approximately two hundred original drawings pertinent to the production of that film, many of which are story-board material. This number hardly supports the existence of a completely delineated script'.[33] The surviving storyboards depict only a few, disparate scenes, and a disproportionate number of these images – sixty-six – pertain to a single sequence, the burning of Atlanta. As Vertrees notes, however, a large number of drawings known to have been composed for the film are missing. It was only after the film had been completed, and the studio came up with the idea of mounting a promotional exhibition, that they began to see this material as having an additional or independent value; and it was only at that point that they realised how many drawings and paintings had already gone missing as a result of being sold, passed on as gifts, or lost in transit. An idea of the scale both of the work of the Menzies team and of the quantity that has disappeared can be glimpsed in the many paintings and storyboards that are visible in photographs taken of Menzies and art director Lyle Wheeler at the time of the film's production, but which are no longer extant. At this distance a precise reconstruction of the artwork no longer seems to be possible, but Steve Wilson, author of the most recent and voluminous study of these materials,[34] concurs that it is highly likely both that more storyboards were created than have survived, and that the film was not storyboarded in its entirety.[35] Consequently, attempts to establish a precise correlation between Menzies' illustrations and the completed film are fraught with difficulty.

What does seem clear is that there was not, in the final analysis, anything resembling a complete version of either a screenplay or a storyboard that could function as a 'blueprint' for the entire film; nor is there a linear progression from screenplay to storyboard, or vice versa. Instead, Vertrees' analysis finds strong indications that several of the surviving boards correspond to particular sequences of shots in the film, which in turn correspond to particular iterations of the script. This suggests that some storyboards were composed in response to changes in the screenplay; but conversely, the script or film could be restructured partly in line with the pre-existing concept art (more,

it seems, than with the storyboards), as for example when Fleming resumed directorial duties.

Part of the 'legend' surrounding the storyboards seems to have arisen, therefore, as a result of problems in the nomenclature surrounding the artwork. Selznick's memos support Kristina Jaspers' contention that although the producer used a wide range of different terms to refer to the materials that Menzies was to create, 'the term "storyboard" [...] did not once emerge during the entire production'.[36] According to a press release, Menzies would 'place on paper, in watercolors, every scene in the screen play, sequence by sequence'. In a series of intriguing phrases, the release described the intended result as 'photographic conceptions of each scene. When this project is completed, the sketches will form an "art gallery preview" of the picture itself. The process might be called the "blue printing" in advance of a motion picture'. As well as saving time and effort, the release cites Menzies in claiming that 'the sketches afford a visual story plan, augmenting the typewritten descriptions of the script'.[37]

These suggestive terms might apply as appropriately to the voluminous concept art (an 'art gallery preview') as to the storyboards ('a visual story plan') that Menzies and his team created for the film. The concept art and the storyboards are visibly different kinds of material: the former are larger-scale, single paintings created as part of the visual design for settings, costume, and atmosphere, all of which are especially important given the film's investment in Technicolor, as we shall see below; in the latter, several smaller frames (usually either four or twelve) are arranged to form a discrete sequence of images pertaining to a single scene. Examples of all of these kinds of illustration are visible in the many photographs taken during the pre-production of *Gone with the Wind* that show Menzies or the art director Lyle Wheeler alongside some of the artwork. Nevertheless, there is a degree of overlap: some of the storyboards, such as that for a conversation in the library, will situate the characters within the carefully realised architecture of a scene; conversely, the widest frames of the burning of Atlanta storyboard closely resemble, in composition and apparent function, the concept art for some of the other scenes.

Loose or anachronistic terminology may help to explain why it is the storyboarding rather than the concept art that has tended to receive greater attention in claims for innovations in the film's production. Other explanations might include the chronological proximity to *Snow White and the Seven Dwarfs*, as well as the effect of contemporary publicity. An article in the *New York Times Magazine* of 10 December 1939 referred to

the design illustrations as 'sketches, almost after the Disney technique', and accompanied its description with a photograph of Wheeler holding a twelve-frame storyboard as he kneels beside an open drawer full of other pictures.[38] Fascinatingly, the remainder of the small mountain of images in this drawer all appear to be individual sketches, and beside them can be discerned what appears to be a small stack of mounting boards. Some of the extant illustrations in the Selznick archive are single illustrations of this kind; of those arranged on boards, some have been affixed, while others have been drawn directly onto the board. What must be emphasised is that this method of working facilitated the rearrangement of frames into alternate sequences, and that the story-board must be seen as an inherently and purposely unstable artefact. Suggestively, the drawer beside which Wheeler kneels in the photograph is the bottom of a chest of six, planting the idea that each is stuffed with a similar number of illustrations.

Many of the surviving drawings perform the 'augment[ation of] the typewritten descriptions of the script' in a literal sense, by the logical device of affixing a typewritten note to the top right corner to indi-cate the scene for which the painting has been created: for example, for the opening 'TARA – PLANTATION MONTAGE SHOTS', or 'Set # 16 EXT. ATLANTA STREET HOSPITAL', or 'Set #44 – Ext. Shanty Town'.[39] Such annotations, which utilise the slug-line form of scene heading peculiar to screenplays, are found on the concept paintings and story-boards alike. This recalls, in quite different form, Menzies' work on *Alice in Wonderland* by again 'augmenting the typewritten descriptions' through the arrangement of illustration, screenplay extract, and tech-nical commentary.

A further reason for doubting that storyboarding on *Gone with the Wind* took place on the minutely detailed scale suggested in some commen-taries is that questions of continuity, to which storyboarding offers a potential solution, were in theory no more obvious or pressing on this film than on many others, with the possible exception of certain spec-tacular scenes. Selznick's work on *Gone with the Wind* overlapped briefly with that on *David Copperfield*, an adaptation of a Charles Dickens novel that was in its own way as unwieldy as Margaret Mitchell's. In both cases the problems of adaptation concerned scene selection as much as anything else, and Selznick was, as usual, keen to preserve as much of the novel as he could within the scenes that were chosen. Seen from this perspective there is no particular reason why the producer would have felt impelled to storyboard the later film in its entirety for narrative purposes, having felt no such necessity with *David Copperfield*.

By contrast, what was peculiar to *Gone with the Wind* were the problems of working with the relatively new colour processes; and one reason why the concept art for the film was voluminous, and the storyboarding less so, was that in creating it Menzies provided a set of answers to Selznick's anxieties about the costs and practical difficulties of using Technicolor.[40] Colour seems to have been uppermost in the minds of both men: it was largely as a result of Selznick's advocacy that Menzies received a special award at the 1940 Academy Awards, and it is notable that this was for 'outstanding achievement in the use of color for the enhancement of dramatic mood'.[41] In his own words, Menzies 'had long felt that the full dramatic effect to be achieved with color had not yet been realized'.[42] Much of the concept art accordingly consists of large, single-frame colour paintings of sets and landscapes, sometimes containing one or more characters, and aiding in the visualisation of a setting by capturing the desired qualities of mise-en-scène: setting, light, colour, mood. In this task Menzies was assisted by other artists, including Dorothea Holt and J. Macmillan ('Mac') Johnson. Some of the paintings bear the signature of a particular artist, but in many cases the precise attribution remains uncertain.

Later, Menzies would discuss in detail the particular palette for individual scenes:

> The silhouette foreground from where Ashley and Melanie observe the barbecue brings out the sunshine and gay costumes beyond. For contrast, the next time we see Twelve Oaks it was in ruins, and in the steely grey-blue of dawn. The effects used for the mother's death were using the warm light of the wick low in the screen, deep blacks, and a blueish light on the dead face. The arrangement of light and colour values helped give it a strong angular and moving composition. The pre-dawn dramatized the effect of desolation and destruction. Not only the fences and ruins were painted black, but acres of grass were blackened. No attempt was made to make *Gone with the Wind* pretty: when unpleasant colours were required to enhance the drama, they were used. Red skies and indigo backings were planned for macabre, strong, and unhappy atmosphere. Times of the day were, I think, gone further into in colour study further than ever before.[43]

While Selznick's constant rewriting of the screenplay indicated that he was willing to revise narrative continuity as a matter of routine, he was unhappy when the Technicolor consultants raised objections to

Menzies' colour schemes.[44] One of the cameramen was fired because Selznick felt 'he was not capturing the richness of colour that Menzies had designed', and editor Hal Kern was tasked with trying to ensure that the colour balance of the exposed footage was in line with Menzies' designs.[45]

Of those scenes known to have been storyboarded, the lengthiest, most complex, and most widely reproduced is the sequence of 66 images depicting the burning of Atlanta. It was also the first to be filmed. On 10 December 1938, Menzies himself directed the scenes of the fire taking hold in the town – famously realised by burning some of the old sets on the studio's lot – with the conflagration forming a dramatic backdrop to the escape of Rhett and Scarlett. This gives a very clear reason as to why the sequence required the detailed storyboarding provided in the sequence of drawings. As Wilson remarks, to maintain narrative continuity and to heighten the dramatic action, 'close-ups of the principal actors filmed later would [have to be] seamlessly intercut with the long shots and wide shots' that were the first to be filmed. 'These close shots would be set up and filmed periodically over the course of the production, and Selznick worried until the end of filming about whether all the shots needed would be completed in time'.[46] Aside from a palette of greys and blacks, the only colour visible in the boards is the reddish orange of the fire. The frames show a range of aspect ratios, the majority being drawn in approximately the standard, Academy ratio of 1.33, but with others of two or three times this width **[Figure 3.2]**. Possibly this is due to the experiments that Selznick was considering for dramatic innovations in the screening of this sequence; alternatively, it may be explained as a combination of concept art (displaying the entire area of a set that would need to be covered by the cameras) with a more conventional storyboarding continuity designed to assist in the intercutting between long and close shots. Vertrees has discussed the relationship between the storyboards and the final edit in the film in two exemplary analyses, and here we need only note his conclusion that 'while a significant portion of the artwork does correspond to a specific script version, the linkage of shots that comprises this episode was revised subsequently with little influence from these production designs'.[47]

The storyboarding of the remainder of the film appears to have been more fragmentary, although provisos about the incomplete nature of the archived materials need to be kept in mind. There are surviving storyboards for only a handful of other scenes, and in each case this takes a much more abbreviated form, often only three or four images. Significantly, several of these storyboards bear signs of revision.

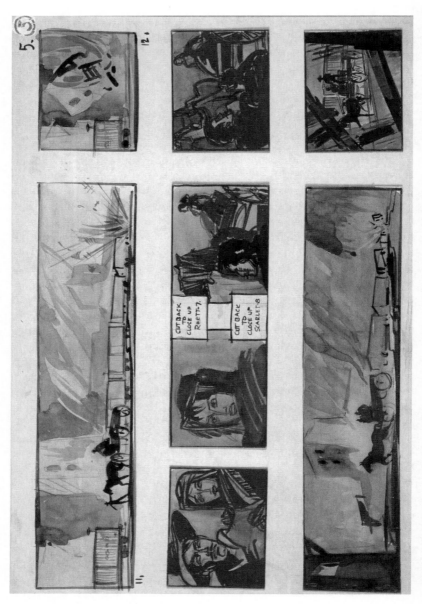

Figure 3.2 Storyboard 5 of the 'Burning of Atlanta' sequence in *Gone with the Wind*, #5. David O. Selznick Collection, Harry Ransom Center, The University of Texas at Austin.

For example, there are two different sets of storyboard images for the very first scene of the film, in which Scarlett flirts on the porch with the Tarleton twins. The first series, of four images pasted onto a pale backing card, shows intercutting between the three main characters on the porch; a view of them from inside a room in the house, seen with their backs facing the window, as servants eavesdrop on their conversation; and a shot of Scarlett standing next to Mammy. In the later version, comprising three images, these other characters do not appear. Instead, Scarlett and the twins are seen at the top of the stairs, lolling on the porch rather than seated at chairs as in the earlier drawings; dogs laze in the foreground, with all three images presented from the perspective of a camera at ground level (there is a characteristic Menzies touch in the peculiarity of the angle), looking up at the characters. Neither series shows a very close correspondence to the completed scene: in each of these versions Scarlett is wearing a green dress, for example, rather than the iconic white 'prayer dress' Vivien Leigh wears in the film. Moreover, as Katharina Henkel remarks, 'the representation of Scarlet O'Hara in a high-necked simple green dress with a severe, dark bun does not fit at all with the "whirlwind" of the film, who is very conscious of her attraction and aura and flirts with every man'.[48] Wilson notes that this opening scene was reshot on many occasions over a period of months,[49] but the precise dating of the two sets of storyboards is unclear.

Like the porch scene, the individual frames of most of the other extant storyboards are impressively detailed, and carefully completed in watercolour or gouache. Several of these are as restricted in the number of their images as the porch scene, again surviving as a grouping of frames mounted on a single board. Four paintings depict the aftermath of the killing of the Yankee deserter; another four show a conversation between Ashley and Rhett, including both a long shot of the two characters within the library setting and a medium shot of each character seen over the shoulder of the other, clearly envisaging a dialogue two-shot; four more depict the sequence of events as news of war reaches Twelve Oaks.

More extensive is the storyboarding of the scene in which Scarlett hides under a bridge to escape the Union soldiers, comprising twelve completed colour paintings on a single backing. Information identifying set and scene ('Set #26 – Ext. Bridge – Trek') has been affixed to the upper right-hand corner, but as Wilson remarks, between this conception and the version in the completed film '[t]he scene underwent numerous changes'.[50] The somewhat rougher series of storyboard drawings for the childbirth scene shows shots within the bedroom and others as Scarlet and Prissy converse on the landing. These images show

little stylistic consistency with the other storyboarded sequences; they are sketches, albeit sketches completed in watercolour, rather than the more fully realised paintings of the other storyboards. Outline frames for twelve images have been created on the single sheet, but only nine have been drawn, with a tenth just begun.

In almost all cases, Vertrees finds close correspondences between the illustrations and particular iterations of the screenplay, but less so between the drawings and the film as edited and released. 'Because of script revision, storyboarding of *Gone with the Wind* remained a tentative exercise', with most surviving drawings used 'not as continuity designs but rather as preparatory work for set construction and for the use of miniatures and of special-effects cinematography'.[51] The major exception concerns the continuity of the fire sequence – significantly, the sequence that is invariably adduced in arguments in favour of *Gone with the Wind* as a 'completely storyboarded' film. The available evidence suggests the opposite: the oft-reproduced burning of Atlanta sequence is if anything an exception to Menzies' method, not an illustration of it. Indeed, it is no small irony that on stylistic grounds Vertrees is inclined to attribute the images on the storyboards for this sequence not to Menzies but to Mac Johnson.[52]

In his new role of production designer, Menzies oversaw a conceptual approach to the settings, colour, mood, and architecture of each scene, but less to the action unfolding within them. This provided a degree of control over a method of film-making that was for much of the time essentially improvised, and within this framework storyboards were sometimes created as a means of addressing particular difficulties in the shooting of individual scenes. The ultimate failure of Selznick's hopes for a completely 'pre-cut' film should come as no surprise: Menzies' comparably grand conception for a fully storyboarded and technically designed adaptation of *Alice in Wonderland* had similarly foundered on the vagaries of film production. In addition, while Menzies was an artist of spectacular and eclectic talents, he was not especially adept at illustrating movement within a frame – a faculty which would later come to appear necessary to the work of the storyboard artist – and there was a direct contradiction between his predilection for unusual camera angles and Selznick's more hard-nosed understanding of what an audience wanted, with Menzies' aesthetic also conflicting with the original director George Cukor's talents for coaxing dramatically convincing performances within relatively long takes. Yet despite the inevitable discrepancies between the conception of any film and its execution, Menzies undoubtedly helped to bring to Hollywood a more developed,

design-oriented idea of how a narrative could be preconceived in cinematic terms. And meanwhile, in Bordwell's summary of Menzies' achievement in the area addressed in the present study: 'If he did not invent the storyboard, he surely popularized it, and along with it the new role of production designer'.[53]

4
Storyboarding, Spectacle and Sequence in Narrative Cinema

In 1993, Annette Michelson proposed that 'the last half-century of [cinema]'s development [is] the period in which production design was largely characterized by the adoption of the storyboard'.[1] This assertion sees the development starting in the late 1930s, if not a little later, and would tend to confirm the pivotal position of Walt Disney and William Cameron Menzies in the evolution of the form. As we have already seen, Menzies at least was already using similar methods long before this time, though this made him an innovator in methods of pre-production.

Perhaps more contentiously, Michelson affirms that

> in film cultures other than that of the United States, the convention was less highly developed and uniformly applied. In France or the Soviet Union, for example, its use was mainly reserved for large-scale historical and spectacle productions. One would not expect to encounter it in a practice such as Italian neorealism as it moved the camera, in the immediate postwar period, out of the studio and into location shooting. Nor do we find it represented in the practice of a filmmaker such as Godard, who, developing in the wake of that tradition, has now turned to electronically facilitated composition.[2]

There is some support for this view. Fionnuala Halligan remarks that 'the international marketplace did not immediately adopt storyboarding as an industry standard' for budgetary reasons,[3] while in a specifically French context, Raphaël Saint-Vincent similarly argues that adoption of the storyboard would have stifled the auteurist, New Wave fondness for improvisation and location shooting (in Jean Renoir's words, 'one must keep the door open'), and that consequently the storyboard is essentially non-existent in France between the 1960s and the early 1990s.[4]

This puts the storyboard in France on a similar footing to the screenplay in the post-New Wave era.[5]

There is certainly a difficulty when hunting for evidence of the practice outside the United States, one compounded by language barriers and the problem of access to materials, and for these reasons the present study is, again, more Hollywood-centric than would ideally be the case. But implicit in such arguments is a contrast to Hollywood, and an assumption that it was the industrialised practices of the Hollywood studios that helped to establish a position for the storyboard within film production. This allows for a more structured view of storyboarding than would emerge from a piecemeal survey of the innumerable different ways in which myriad different kinds of illustrative materials created for individual films could be regarded as storyboards. However, there are several problems in assuming that from the 1940s onwards 'production design was largely characterized by the adoption of the storyboard': there is no strong evidence that its adoption became widespread as early as this date, only very infrequently do entire films appear to have been prepared using this method, and, as noted in the Introduction, distinctions need to be kept in mind between production design in general and storyboarding specifically.

Spectacle and narrative in the classical Hollywood cinema

Storyboarding in the classical era never became anything like as pervasive as the use of screenplay forms such as the continuity script or the master-scene screenplay, at least as far as the planning of an entire film was concerned. At the microcosmic level continuity editing is designed to create the illusion of continuous action through the editing of footage shot discontinuously, and one function of the storyboard can be to assist in this process by pre-visualising the editing in advance. This certainly became an increasingly common practice, though in the early decades of the classical Hollywood cinema continuity editing followed clearly defined conventions, which were sufficiently well known to the directors and editors on a studio's roster that there is no particular reason to think that storyboards would be generally required in this aspect of pre-production.

Instead, their early development, in the work of Menzies at least, was bound up with the ideal of pre-planning a complete narrative film, especially one that aimed for a distinctive approach to mise-en-scène, camera angles, and other aspects of visual design. It is this kind of work that we see in *Alice in Wonderland*, and in Selznick's ambitions for the 'pre-cut

picture'. Yet the problems with *Gone with the Wind* indicate that this was likely to prove a very expensive procedure, appropriate only to prestige films, and one fraught with the dangers of excessive pre-planning. Alan David Vertrees notes that '[w]hile advanced planning of compositions and continuity of shots for action or musical sequences was not uncommon during the classical Hollywood period, the complete storyboarding of a script prior to filming was unusual', because '[g]enerally, principal authority was assumed by film directors only on the shooting set'.[6] Moreover, the storyboard artist did not yet exist as a specialised role, emerging relatively late in film history. As Kristina Jaspers remarks, even '[t]he responsibility for animation and special effects did not yet lie with one specialised profession in the 1920s. Often, the responsibility lay with the cinematographer, who would sketch the design of the special effect and discuss the necessary set or model construction with the film architect'.[7]

In the studio system, any one of a number of people within art departments could be assigned the task at any given time, especially given the understandable tendency to see storyboarding in terms of discrete sequences requiring localised forms of attention in order to solve particular problems, rather than as a function of overall narrative or design. Moreover, while specialist storyboard artists may become involved in a project it remains the case that boards are as likely to be created by a director, production designer, or other member of the team, since in Vincent LoBrutto's words, they need to be drawn 'by someone who can visually interpret a story and understands cinematic grammar'.[8] Again, there is an instructive contrast with the screenplay, which is ordinarily (and in Hollywood, must be) credited to specific writers.

The storyboarding of a film in its entirety became a more prudent option in the post-classical cinema. LoBrutto notes that '[o]n a low-budget film the production designer may storyboard the entire film',[9] which is partly because a completed storyboard might be created less as a direct anticipation of a film than as a selling document used for the purposes of securing financing: as John Hart writes, with a detailed live-action storyboard 'the producer can make a much better estimate of costs and therefore develop a realistic budget'.[10] In the classical studio system, however, this budgeting function was normally fulfilled by the screenplay or continuity script, which had the parallel purpose of organising all aspects of the narrative and structure of the story. Meanwhile, in the vertically integrated industry of the classical era, there was ordinarily no need to look for external sources of funding.

While the example of Menzies shows that it was certainly possible to conceive of planning a film in its entirety via storyboards, then, the surviving evidence suggests that this remained an infrequent practice at most. Storyboarding is notable by its absence from Thomas Schatz's exhaustive study of classical Hollywood film-making, *The Genius of the System* (1988), although this may in part be due to the deficiencies of the archival record that we have previously noted.[11] In the words of the curators of a Berlin exhibition in 2012 that attempted a survey of the practice from before the classical era to the present day, 'Storyboards are seldom drawn for the entire motion picture. Usually, they are used for complex key scenes of a film'.[12] Martin Campbell, who directed *Casino Royale* (2006), 'storyboard[s] all the action sequences, and also a lot of the other sequences', which indicates that some are not.[13] Peter Lamont, who worked on 18 James Bond films from *Goldfinger* (1964) through to *Casino Royale* – including four each as set decorator and art director, before taking on the mantle of production designer for the last nine – confirms that none of them was wholly storyboarded. Although the nature of the Bond films required storyboards to be used in certain specific ways for particular scenes, Lamont, who was also production designer on *Aliens* (1986), *True Lies* (1994), and *Titanic* (1997), asserts that the storyboarding of other films in their entirety is a rarity, and something he had not personally encountered.[14]

The possibility of seeing scenes or sequences as self-contained, rather than as links in a causal narrative chain, is perhaps genre-specific. Elizabeth Cowie, for example, notes that 'classical Hollywood included forms of storytelling which lack the "well made" qualities associated with classical narrative form'.[15] In the present context, it must be noted that entire films and even genres may be comprised of narrative stretches that require little if anything in the way of storyboarding, interspersed with action or spectacular sequences for which it becomes a requirement. Such sequences tend to require the work of a designer or specialist storyboard artist, and in these cases storyboarding will tend to take priority over the written text. The screenplay for a musical, for example, will frequently leave what is in essence a gap where musical numbers or choreographed sequences are called for, and simply indicate the need for such material to be inserted within the film. An early example is the work of Busby Berkeley, whose spectacular designs were arranged in more or less complete independence from the script.[16]

A somewhat later illustration from outside the Hollywood system is the work of the surrealist artist Hein Heckroth, assisted by matte painter Ivor Beddoes, in devising the 17-minute ballet sequence in *The Red Shoes*

UNIVERSITY OF WINCHESTER
LIBRARY

(1948). (Beddoes was to become an important figure in the pre-production of many later films, and storyboarded *The Empire Strikes Back* in 1980, as we shall see in Chapter 6.) Director Michael Powell believed *The Red Shoes* to be 'the first time a painter had been given the chance to design a film', with Powell editing the 120 paintings into a sequence that could serve as a storyboard.[17] Here the function of the designs has nothing to do with the demands of narrative. In the words of Katharina Henkel, these images 'do not show any unity in terms of the language of the images; quite the contrary, it is often only a varyingly large section of the colourful sheets which has stylistic unity. Especially visible is the change from sheets of narrative and character scenes to abstract-organic forms'.[18]

Even when a film is largely or entirely storyboarded, the number of frames produced may vary in accordance with the kinds of material within the verbal text of the screenplay: dialogue-intensive shot/reverse shot scenes may gain little from storyboarding, while conversely, action sequences may be rendered elliptically in the screenplay but require detailed storyboarding. Moreover, while the storyboard undoubtedly facilitates continuity *editing*, it often challenges the continuity of *narrative* by isolating particular sequences as semi-autonomous fragments. This offers a particular perspective on familiar debates about the interrelation of spectacle and narrative in Hollywood cinema. Controversy surrounds the question of whether or not a significant change in Hollywood film-making came about in the late 1970s as a result of what Tom Gunning refers to as the Spielberg-Lucas-Coppola 'cinema of effects'.[19] In this reading, what was until that point an essentially narrative storytelling form gives way to a cinema of spectacle, special effects, musical soundtracks, and so on. A counterargument proposes instead that the interest in narrative persists – albeit displaced, perhaps, into the simpler forms of storytelling in what William Goldman refers to as 'comic-book movies'.[20]

We shall examine aspects of this debate in relation to storyboarding in Chapter 6, but the presence and functions of storyboarding in earlier periods has significant implications for the discussion. It is important to separate matters of production from reception in this context. A film may appear to the viewer to have an integrated narrative, yet actually to comprise a series of sequences that were created in relative autonomy during the production process; indeed, this is perhaps usually the case. Put simply, the history of storyboarding suggests that from the 1940s onwards it was increasingly common, if not perhaps routine, for film-makers in Hollywood and outside to conceive of the production of narrative films in terms of discrete sequences with distinctive properties,

which may or may not have been directly involved in furthering the story. On the one hand, this may support the argument that the classical Hollywood cinema itself placed lesser emphasis on narrative development, and more on spectacle, than the emphasis on narrative and continuity in David Bordwell, Janet Staiger, and Kristin Thompson's *The Classical Hollywood Cinema* (1985) may suggest.[21] On the other hand, the widespread *absence*, or relative marginalisation, of storyboarding in the classical era, and the failure of prominent attempts to create a 'pre-cut picture', rather suggests the opposite.

What the multiple and fluid uses of storyboarding tend to indicate instead is that both classical Hollywood generally, and individual films locally, operated according to more varied mechanisms of production than the undoubtedly more centralised and industrialised uses of a final-draft screenplay would suggest. In the studio era the submission of a screenplay in this form functioned as a definable stage in pre-production. This facilitates the analysis of Hollywood in *The Classical Hollywood Cinema* as an essentially industrial set of practices. Storyboarding, by contrast, was not a routine part of the production process, and frequently emerged as a result of less formal, ad hoc arrangements between particular members of a production team. Perhaps partly as a result, many of the best-known or more intriguing uses of storyboarding arise in contexts that suggest a more flexible division of labour than is familiar in the history of screenwriters in this era. For this reason also, we can expect it to be contributing in different ways to different kinds of film.

Auteurs and others

For example, illustrations made by the director tend to receive particular attention, even when they cannot properly be regarded as storyboards, or (as is the case with Hitchcock) are not especially distinguished examples of the form, since they tend to contribute to a still-influential notion of the director as auteur. By contrast, we can trace the emergence of a canon of illustrators who were not themselves, or not primarily, directors. This offers a counter-attraction to the above, appealing to the view of film-making as a collaborative rather than an auteurist practice. Menzies again emerges as a crucial figure here, not only for his own work, but also because he worked directly with several other designers, such as Ken Adam, who subsequently forged significant careers within Hollywood. Such designers then tend to work with canonical directors, however, completing a kind of auteurist loop; examples include the work of Henry Bumstead and Robert Boyle for Hitchcock. A final

example of the kind of storyboard that tends to enter the developing canon is that designed for films in which the need for storyboarding is, as it were, visible in the texture of a film. Examples include films that foreground set-piece, usually non-narrative sequences which, as the audience registers consciously or otherwise, must require a form of preparation other than that of the dramatic verbal script. These include complex action sequences in adventure or thriller movies of the James Bond variety, choreographed sequences within musicals, and animation sequences within films that represent a hybrid of live-action and particular forms of animation, such as Ray Harryhausen's 'Dynamation'. In the remainder of this chapter we aim to give some flavour of this range of storyboarding artists, materials, and practices that developed prior to the significant changes of the late 1970s.

For reasons previously discussed the historical record of storyboarding is drastically incomplete, and, unsurprisingly, many of those storyboards that have survived were created for directors and films that have attained canonical status. In turn, this can create the misleading impression that the pre-production work carried out on what were often prestige productions was typical, at a time when it was still exceptional. Nevertheless, by the time of *Citizen Kane* (1941), just two years after *Gone with the Wind* and four years after *Snow White*, storyboards ('continuity sketches') had become more familiar in Hollywood. As Robert L. Carringer demonstrates, after a draft script had been completed, Orson Welles discussed the scenes with the art director Perry Ferguson as well as with the cinematographer Gregg Toland, but the storyboards themselves were prepared by illustrators from RKO's art department, and 'were turned out so quickly that they usually lacked individuality'.[22]

This was because, in Carringer's analysis, the storyboard has a place in the process of production that is distinct from, or at least more specific than, the blueprint status that is commonly claimed for it. The first stage in the art direction was to draw up a floor plan that would facilitate the shooting of the scene. The storyboarding came next:

> Storyboards were drawn very quickly, and the visual details were very crude. [...] The purpose of the storyboards was to illustrate the camera angles that would be needed for the action as envisioned, not to indicate elements of visual design. Because storyboards often correspond closely to the camera setups in completed films, some writing on art directors has tended to treat them simply as evidence of an illustrator's power to determine such things. Actually, the illustrators usually worked to specifications previously determined.[23]

In this account, the storyboards were simply one stage in a series of steps taken to establish the basis on which a scene would be shot, with the mise-en-scène of the set, including the possibilities for camera movement entailed by the set construction, taking priority. A charcoal sketch would be drawn to help to visualise the architectural space of the setting, following which 'miniature working models of the sets would be made' in order to anticipate the possibilities of character and camera movement; finally, 'the sketch artists would prepare elaborately detailed working drawings, usually thirty by forty inches, showing each scene as it might appear on the screen. The working drawings would then serve as the master plan and the basis from which construction would proceed'.[24] What is not entirely clear from this is whether the story-board's function in pre-visualising the camera angles was superseded by the models and working drawings, or whether they retained a separate function in assisting with the editing, though the latter must at least remain a logical possibility.

Meanwhile, although the evaluative comments are perhaps of secondary importance to establishing the role of the storyboards in production, Carringer's assessment of them seems harsh. For example, the 15 drawings that illustrate part of the film's opening montage capture much of the detail and lighting proposed for a complex sequence, while giving a strong sense of how the series of shots works both as a series of individual compositions and as a sequence of cuts and dissolves. Below each frame is a brief indication of the content of the shot: 'camera travels up to – window and as window – fills screen, light – goes out and we dissolve – to interior (note: see other card for treatment of this room) – dissolve to winter scene – pull back as (sic) disclose – glass ball in hand – which drops it and – we follow ball as – it bounces down steps', and so on to the end of the sequence.[25] This captioning is a developing prac- tice, which we have already seen in different forms in Menzies' work, whereby storyboards visualise the screenplay text to aid in the prepara- tion of complex sequences.

In Carringer's analysis the storyboards have a necessary, albeit it seems relatively minor, role in film production generally and in the making of Welles' acknowledged classic specifically. In addition, however, they may have uses in archival and reconstructive contexts, and here there is, perhaps, a missed opportunity with Carringer's reconstruction of Welles' next masterpiece, *The Magnificent Ambersons* (1942). The release print is a notorious studio hack-job that followed RKO's rejection of Welles' orig- inal cut. The eliminated footage was subsequently lost, and Carringer's book is an attempt to give 'as clear an impression of the original film

as is possible from the materials which survive'.[26] For these purposes, he understandably chose to use as his copy text the cutting continuity made for a preview screening of Welles' own version, before the studio took the axe to the print. This enables the reconstruction of the dialogue and much of the visual action, while a sense of the latter is enhanced by the reproduction of more than 60 continuity sketches, seemingly all by Joe St. Amon, alongside the corresponding passages in the text. 'These were found in the notebook containing Welles' personal copy of the shooting script',[27] a circumstance which simultaneously indicates the value they held for the director and their ephemeral status in a record-keeping system that has preserved so little of the artwork created during the years of the classical Hollywood cinema.

In contrast to his meticulous documentation of the written records, however, Carringer does not provide any clear sense of the extent of the storyboarding. A full set of storyboards could perhaps answer more precisely than the cutting continuity some of the questions that remain about the staging, framing, and continuity of particular scenes, especially since so many of the sketches that he does reproduce chime reasonably closely with the footage that RKO retained. In his *Kane* appendix, Carringer reproduces a number of storyboards that valuably illustrate scenes that were subsequently deleted,[28] but it is not clear whether the drawings in his *Ambersons* book comprise all that he was able to trace. Fionnula Halligan, however, reproduces some additional sketches, remarking that 'all that remains is Welles's script and some storyboards, unattributed'.[29] Formally, these resemble quite closely the groupings of four illustrations that we have seen in the making of *Gone with the Wind*, and include what are clearly continuity sketches for a scene in the Amberson mansion (scene 38) and another at the reception (scenes 53–54), the famous scene when the horse-drawn sleigh outperforms the new motor car in the snow (scene 72), and the following scene in which Lucy explains to George about car production in the factory (scene 74). Future scholarship may succeed in making further use of storyboards to help bring an additional sense of texture to reconstructions of what remains the great lost American masterpiece, but to date *The Magnificent Ambersons* is yet to receive the extensive multi-medial revaluation that the combination of archival research and commercial digital release has brought to so many other films of the classical era.

In contrast to Carringer's devaluation of the *Citizen Kane* sketch artists, there is a tendency in the history of storyboarding to place a high value on the practice of certain directors of illustrating a script by placing individual thumbnail drawings, at appropriate marginal places

within the screenplay, to help with visualising and preparing a shot. The 1993 exhibition *Drawing into Film: Directors' Drawings* at the Pace Gallery in New York, and its accompanying catalogue, offers something of a pantheon of director-illustrators. Annette Michelson's introduction to the catalogue sees such drawings as 'freer, more flexibly conceived plans' than storyboards; they 'have served as basic plans and points of reference, subject, where necessary, to modification or amplification'.[30] For example, while Federico Fellini's prodigious output of concept art for his films includes very little that could be formally described as storyboards, the films are to a significant extent defined by the scenic ideas the concept art expresses, raising the question of whether the paintings can fulfill the function of a storyboard in a different form. Another striking, storyboard-like work is Chris Marker's *La Jetée* (1962), a film constructed almost entirely of stills, which then comprise a kind of 'photomatic' analogous to the animatics of Disney and other animators. Certainly relevant to the present study is Fred Zinnemann, who would routinely annotate and illustrate his copy of a screenplay in advance of filming. Script pages for *The Wave* (1935) show extensive textual emendations, suggestions for shot type, and, most importantly for our purposes, detailed penciled drawings in approximately Academy ratio that visualise a shot, including in some cases arrow signs to indicate direction of movement. The script has already broken down the action into specific shots, and in those cases where Zinnemann has provided an illustration for each of them, the text becomes an approximation of a storyboarding continuity.[31]

As Menzies' work on *Alice in Wonderland* shows, the annotated screenplay need not be the province only of the director. An undated series of sketches by James Wong Howe for the 1934 film *Viva Villa!* represents what are recognisably storyboards that break down a sequence into a series of shots; they are characteristic of the period in suggesting a series of cuts from shot to shot, but do not directly indicate movement within the frame.[32] In an article he published on the film's release, Howe stated that he and art director Harry Oliver drew 'hundreds' of sketches after reading the script, working out several different possibilities for each scene. 'These sketches were incorporated in the final script of the picture: they served the dual purpose of simplifying both the production and pre-production problems, and of assuring better coordination between the director and director of photography'.[33]

Another fascinating example of someone other than the director illustrating the script is the work of Joe DeYong (also sometimes called Joe De Yong or Joe De Young), who was a historical adviser on many Westerns

from the 1930s through to the 1950s. In documentary film-maker Dan Gagliasso's words, DeYong was a 'compadre' of the artist Charles M. Russell, who had spent much of his youth living among both white trappers and Native Americans, and whose work subsequently influenced many of the film-makers who went on to establish the iconography of the Western. 'After Russell's death in 1926 De Yong became a highly valued member of the visual and historical production teams on many Hollywood classics',[34] receiving, for example, credit for costume design on several films directed by Cecil B. DeMille.

DeYong was a talented draftsman in addition to possessing extensive historical expertise, and these skills were deployed in assisting with the design and iconography of several key Westerns. He received a credit as 'technical advisor' on *Shane* (1953), and among director George Stevens' papers is a 190-page version of the script that according to the MHL index includes a 'storyboard drawing by Mr. De Yong'.[35] This entirely undersells the document. The first page of notes, to Stevens, is dated 22 July 1951: 'I expected to show all suggestions for dialogue and related bits of business at one time, but the wardrobe situation has prevented. [...] Balance to follow as soon as possible.' The annotated script accompanying this letter appears to comprise the whole of the 'balance'. This document, modestly described as 'technical material' on the title page, is essentially a form of production bible. While several directors have sometimes made use of this method – a text-intensive example is Francis Ford Coppola's 'Bible' for *The Godfather* (1972) – it has never become fully established within cinema to the extent that it has within theatre; partly, perhaps, because of the cautionary tales offered by previous attempts to pre-visualise a film at this level of detail.

This version of the *Shane* text has been constructed by cutting up a current iteration of the script and using the fragments as the basis for new pages, on which DeYong has supplied detailed commentary on all aspects of the production. The default is handwritten comments in lead pencil, including a few technically accomplished drawings; some of the revisions to the script pages themselves (also in De Yong's handwriting) are in red pencil. DeYong has supplied very extensive and detailed commentary, amounting in places almost to mini-essays, not only on wardrobe and general iconography but also on character. Moreover, these revisions include a large number of comments not only on the scene text but also on the dialogue, with the aim of heightening the authenticity of the speech. DeYong's influence remains largely invisible and unknown outside of the archive.

What we might think of as 'proper' storyboards were and are often created by the production designer, but these generally form only a relatively minor part of the role, and again tend to be created to address particular problems rather than as a means of designing the film as a whole. For example, in the course of a book-length series of interviews, the designer Henry Bumstead refers explicitly to storyboards only fleetingly and infrequently, with only a famous series for Hitchcock's *Vertigo* (1958) and another for *To Kill a Mockingbird* (1962) being reproduced in the book.[36] Like many designers, Bumstead tended to work repeatedly with individual directors, and the development of personal relationships between a small number of trusted collaborators means that where a designer is involved in storyboarding the process will often be more intimate and lack the industrial scale of the complete storyboard. Screenwriting, by contrast, has a dominant narrative of writing as an industrial craft that can be learned either within a studio's writing department or, later, by an individual using story templates derived from authorities ranging from Aristotle to Christopher Vogler, and following standard formatting templates. The practice whereby an art designer will work together with trusted collaborators and assistants gives the history of storyboarding an entirely different feel.

A related phenomenon is the often-seen mentoring relationship commonplace in storyboarding and art design, whereby one expert passes on his or her skills to assistants, who then carry the practice forward. The tradition continues in the work of an artist like Tony Walton, whose Hollywood career began by working for Disney on *Mary Poppins* (1964), and who still trains assistants at his home in New York today. Menzies, once again, is an emblematic figure: having learned some relevant techniques from Anthony Grot before arriving in Hollywood in the early 1920s, he in turn taught methods of continuity design first-hand to many of the key Hollywood designers of the 1950s who helped to storyboard scenes for Hitchcock and for the James Bond movies, among many others.

The James Bond films: storyboarding the sequence-based movie

It has been plausibly suggested that 'the [James Bond] series owes most to two men: Sean Connery and the production designer Ken Adam',[37] the latter of whom had previously worked with Menzies on *Around the World in Eighty Days* (1956). Speaking at the time of the release of *Moonraker* (1979), which would be the last Bond film on which he worked, Adam

remarked that '[t]he Bond films are done so loosely that the script isn't the Bible that it is in most films. It changes all the time and the whole process of writing it is like some democratic debating society'.[38] It is hardly surprising that Neal Purvis, writer on *The World Is Not Enough* (1999), would make a significant comparison in observing that 'Bond films are like musicals; the action scenes are like dance numbers. And although the action scenes are organic to the plot, they're a slice of entertainment'.[39] It is possible to overemphasise this notion: the successive drafts of the screenplays for *Goldfinger*, for example, reveal writers Richard Maibaum and Paul Dehn focusing their attention on plausible motivation of plot and character.[40] Nevertheless, the films are clearly structured as a series of often action-based sequences in a way that many other kinds of crime thriller, for example, are not.

Several contributors working on different aspects of pre-production for the Bond films have commented on the relationship between screenplay and sequence, with the latter becoming central at relatively early stages of the planning. Christopher Wood, who worked on the script of *The Spy Who Loved Me* (1977), compares the process to 'putting together a jigsaw puzzle',[41] while director Michael Apted recalls that '[w]hen we were laying out the script for *The World Is Not Enough*, we did a diagram, and you knew exactly when we had to have the action sequences',[42] which involved the use of storyboards. For *Die Another Day* (2002), Vic Armstrong 'devised this sort of ballet on ice between the two cars. I did a diagram, as I always do, and looked for highs and lows, the build-up and the climax. Each action sequence had to have a structure – just like a story'.[43] In this way, the storyboarding of an action sequence starts to resemble a theory of screenwriting that emphasises the internal structure of the scene or sequence, as much as the contribution of the individual sequence to the overall structure of the narrative.[44]

This relative looseness is apparent also in the variety of work that a designer may carry out in helping to prepare the film. Adam is perhaps most famous for his creation of spectacular sets, such as Blofeld's fortress volcano in *You Only Live Twice* (1967) and the spider-like Atlantis den of the villain in *The Spy Who Loved Me*. A different kind of spectacle is seen in the action sequences, which frequently required storyboarding. Adam would occasionally do this work himself: for example, he storyboarded the scene in which Bond escapes through a tunnel in the first Bond film, *Dr. No* (1962).[45] Meanwhile, although we have attempted throughout this book to maintain a distinction between storyboarding and set design, some of Adam's work reveals certain formal connections and resemblances between them. Léon Barsacq remarks that 'the

designer must give concrete shape to his vision of the framework for the film by drawing the set from the most interesting angles. He begins by making countless thumbnail sketches'.[46] In consequence, these sketches can take on the visual appearance of a storyboard, as is apparent in Adam's series of studies for a B-52 bomber base for *Dr. Strangelove* (1964), and for the billiard room in *Sleuth* (1972).[47] While these lack the narrative continuity of his storyboards for the earthquake in *Sodom and Gomorrah* (1962), or for a bomb-release sequence for *Dr. Strangelove*,[48] a storyboard, as noted, need not have continuity as its focus; it may instead, as here, present a series of perspectives on a static set. This can produce problems in determining the status of a series of illustrations in the absence of further evidence, as when Vertrees, hunting for evidence of storyboarding in the classical Hollywood era, debates whether a series of drawings for *Juarez* (1939) is a storyboard or concept art.[49]

For the most part, however, storyboarding in the Bond films was conducted in order to plan spectacular action sequences. A selection of such boards from a range of Bond films has recently been on display as part of the 'Bond in Motion' exhibition at London's Film Museum, dedicated to the cars, boats, helicopters, planes, and other modes of transport seen in the films. Despite this relatively narrow focus, the display is very revealing of important aspects of storyboards, such as their relationship to the screenplays, their materiality, and their uses as a medium of communication between different members of a production team. Chris Baker's 'AW101' sequence for *Skyfall* (2012) provides a sequence of dozens of images to depict the attack of the helicopter fleet on Bond's eponymous Scottish home. A corresponding page from the screenplay ('2nd Green Revisions') breaks the action into a series of scenes, and follows the master-scene screenplay convention whereby a change of location occasions a new scene. While the imagery of the script is occasionally vivid (the helicopter looks 'Like a great prehistoric beast'), inevitably the storyboard images convey much more powerfully than the screenplay the impact of such moments as when 'The helicopter soars overhead and then dramatically begins to circle the house'. Other examples in the exhibit show a similar, seemingly unavoidable discrepancy between the detailed shot specification and movement depicted in the storyboards, and the flatness of screenplay prose that is obliged to break down the action into a series of shots.

Fascinatingly, many of the storyboards have a home-made look to them. For the *Skyfall* sequence, six frames of approximately the 2.35:1 aspect ratio used for the film have been drawn in ink onto each page, with the illustrations themselves drawn in pencil, accompanied by

handwritten comments, descriptions, and shot specifications in the margins. For a boat-chase sequence for *The World Is Not Enough*, the images have been variously stickered, sellotaped, or glued onto the pages, this time four to a page, and those for the much earlier *Diamonds Are Forever* (1971) have been affixed using similar means. These material properties of the storyboards indicate a tendency for them to be created in forms and environments that are more craftsman-like and improvised, and less fully industrialised, than the more generic forms that tend to be taken by screenplays in the studio context.

The 'Bond in Motion' exhibition typifies the current vogue for displaying the storyboards of popular films in a range of media. Recent book publications include *The Art of Bond: From Storyboard to Screen: The Creative Process Behind the James Bond Phenomenon* (2006), compiled by Laurent Bouzereau, and *The James Bond Archives: 007* (2012), edited by Paul Duncan.[50] Inevitably, the storyboards have also taken their place amongst the 'extras' packages on Bond reissues. The 50th Anniversary Blu-Ray collection, for example, features a version of the climactic speedboat chase at the end of *From Russia with Love* (1963) that differs significantly from the final version of the film; a plane crash sequence in *You Only Live Twice*; two alternative storyboarding sequences for a cable car chase in *Moonraker*; and a storyboard for a chase scene in *For Your Eyes Only* (1981) that uses snowmobiles, which were changed to motorbikes for the film. What is immediately noticeable is that the same storyboards tend to recur regardless of the mode of presentation: there is very substantial overlap between the two aforementioned books, and between them and the Blu-Ray set, with a lesser though still substantial number of those in the exhibition also having been published in these other forms. The recycling of selected storyboards in so many different media gives the viewer a glimpse into the pre-production process, but perhaps risks giving a partial or misleading impression by tending to abstract individual sequences from any wider context; although this is, perhaps, precisely how the films themselves approach the relationship between sequence and narrative, in both story development and production.

Indeed, it would be misleading to draw too many wider conclusions from the storyboarding of the Bond films. While they tend to support a sequence-based view of film-making, this essentially modular form is part of their very appeal, like that of some musicals. Moreover, the sheer scale and cost of the films, especially regarding the action sequences that most heavily draw on the skills of the storyboard artist, make them exceptional; and although some earlier Bond films can

be seen to anticipate in this way and others some of the blockbuster movies of the 1970s, to which we shall turn in Chapter 6, they remain very much a subgenre unto themselves. It is instructive, for example, to contrast storyboarding in the Bond films with that for a quite different, but equally sequence-based and (on a much smaller scale) spectacular kind of movie: those associated with animation innovator Ray Harryhausen.

Ray Harryhausen's 'Dynamation'

Harryhausen provides a striking example of an individual film-maker who has made use of the storyboard in a range of different ways to plan specific sequences of action. Famed as the person responsible for bringing fantastical stop-motion spectacle to what would otherwise have been fairly conventional live-action adventure films, the story-board became an important – and necessary – document to facilitate the communication of his ideas regarding the stop-motion set pieces to the individuals responsible for directing and producing the film's overarching live-action elements. Although it might be tempting to view Harryhausen's contributions to the live-action films in which his stop-motion works appeared along the same lines as Busby Berkeley's previously noted choreographic contributions to musical films, this would be misleading. Berkeley's sequences were constructed as largely autonomous or self-contained non-narrative elements within the films in which they appeared, whereas Harryhausen's control over the stop-motion spectacle extended well beyond the pro-filmic event, with the animator often exercising significant control over the pre-production development and decision-making process.[51]

Harryhausen's preliminary concept drawings often served as key documents during pitching sessions with studio executives. Despite the popular appeal of his trademark 'Dynamation' spectacle – the term was coined by Charles H. Schneer, who produced many of Harryhausen's films, to describe the animator's particular combination of live action and stop motion – even at the peak of his career, studios remained cautious when considering projects to which he was attached.[52] For example, he attests that when pitching *Clash of the Titans* (1981), a film that would ultimately contain some of Hollywood's finest stop-motion animation, a charcoal and pencil illustration of Medusa (seen in **Figure 4.1**) was one of the key 'presentation pieces that sold the picture to MGM'. The drawing had such an impact that, '[a]part from the addition of a "boob-tube"', it captured 'almost exactly how she appeared in

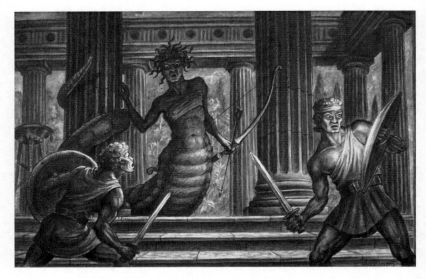

Figure 4.1 A Ray Harryhausen charcoal and pencil illustration of Medusa from *Clash of the Titans* (1977). Images copyright © The Ray and Diana Harryhausen Foundation

the film',[53] with the fine detail and shading of Harryhausen's illustration capturing the cinematic drama of this particular sequence.

When storyboarding, however, Harryhausen was concerned less with this degree of precise detail, and much more with the ability rapidly to capture and communicate an idea. This desire to work quickly when planning a sequence led him to develop a novel technique whereby he would draw directly onto location photographs. Only used in selective instances, when the location had already been firmly agreed, this approach provided a logical development of the standard storyboard form. Many live-action storyboards follow a design aesthetic frequently advocated in the standard how-to manuals, whereby background detail is frequently omitted, or provided in rough form only. By contrast, Harryhausen's stop-motion characters needed to be precisely integrated with the surrounding live-action setting, and consequently capturing useful spatial information becomes a feature of his approach to storyboarding more generally. Therefore, having the chance to work directly from photographic representations of what we might call the 'pro-filmic-space-to-be' would have been a deeply attractive prospect.

Although Harryhausen adopted this technique intermittently during the storyboarding process on a number of films, the benefits of the approach are most visible in the storyboards produced for the films *Earth vs. the Flying Saucers* (1956; **Figures 4.2–4.3**) and *One Million Years B.C.* (1966; **Figure 4.4**). These examples demonstrate the inter-action between the elements to be animated and the surrounding live-action environment. **Figures 4.2–4.3** use images of Washington, DC, including several images of the Capitol Building, the Lincoln Memorial, and the Washington Monument, as its background. Here Harryhausen clearly illustrates how the animation will not just take place in this iconic arena, but how the intended animation will in fact reshape the landscape, the destructive attack launched by the flying saucers culminating in one spacecraft crashing into the domed roof of the Capitol Building.

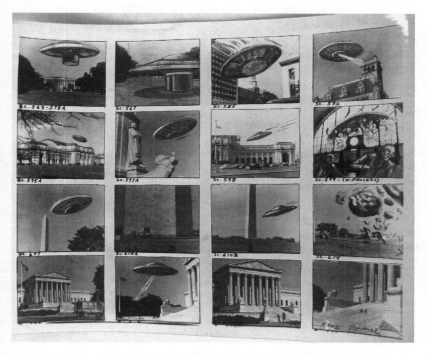

Figure 4.2 A Ray Harryhausen storyboard produced for *Earth vs. the Flying Saucers* (1956). Images copyright © The Ray and Diana Harryhausen Foundation

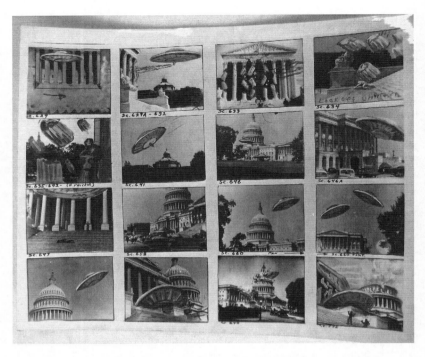

Figure 4.3 A continuation of the Ray Harryhausen storyboard seen in Figure 4.2 produced for *Earth vs. the Flying Saucers* (1956). Images copyright © The Ray and Diana Harryhausen Foundation

In **Figure 4.4**, the implied dynamic between landscape and animated objects (in this instance dinosaurs) is equally important, but rather than the animated objects reshaping the landscape, as is signalled in the *Earth vs. the Flying Saucers* storyboard, here it is the landscape that shapes choices relating to the proposed staging of the animation.[54] Discussing the pre-production of *One Million Years B.C.*, Harryhausen observes:

> On a recce in Lanzarote I spotted this location where the rock formation and the cleft in the rocks were perfect for the battle of the dinosaurs. To save time and to show how the scene would work and be cut together, I made up this photographic storyboard, sketching the action that would appear in the scene over some of the shots.[55]

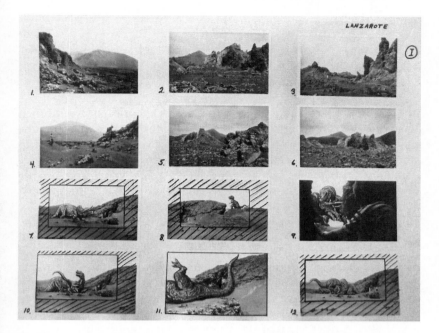

Figure 4.4 A Ray Harryhausen storyboard produced for *One Million Years B.C.* (1966). Images copyright © The Ray and Diana Harryhausen Foundation

In the panels numbered seven through nine, Harryhausen uses the landscape to exaggerate the action and tension. Establishing the scale and position of the human characters that were to feature in this sequence in the final film (Tumak/John Richardson and Loana/Raquel Welch) by photographing himself in extreme long shot in panel four, Harryhausen then adds a triceratops in the foreground of panel seven. Following the introduction of the triceratops, which roars loudly upon being disturbed, shot 475 in the script shows a 'PETRIFIED ROCK AREA'. In what follows, the contrast between script and storyboard is illuminating. The screenplay describes the action as follows:

476 TWO SHOT: TUMAK, LOANA

As they react to the frightening sight and sound ... led by TUMAK they turn and run.

477 RESUME FULL SHOT: AREA

Same as 475 [Handwritten notation]

> As TUMAK and LOANA run to the right on the nearside of the rock outcrop, the TRICERATOPS moves swiftly in the same direction on the other side of the rocks.[56]

Although Tumak and Loana's encounters with the triceratops and then the ceratosaurs are described in the script, the textual description of the staging of this encounter remains limited, and it is only in Harryhausen's storyboard that the scene really begins to take shape.

To illustrate the feeling of 'jumping out of the frying pan and into the fire' that characterises the sequence, as Tumak and Loana flee the agitated (yet herbivorous) triceratops only to come face to face with the hungry (and carnivorous) ceratosaurus, in panel eight Harryhausen depicts the ceratosaurus lurking in the background behind a rocky outcrop, and therefore not immediately visible from Tumak and Loana's foreground position. This heightens the tension by implicitly restricting the spatially related diegetic information available to the human characters positioned in the foreground. Once the dinosaurs meet and engage in battle as a result of the triceratops having chased the human characters, the tension is amplified further through Harryhausen's opportunistic and inventive use of the photographed location as the basis for his storyboard. Having photographed the location from within the cleft in the rocky outcrop, with Harryhausen himself posed in the foreground looking outwards and away from the camera, this image closely anticipates how the dinosaur battle is seen in the final film: over the shoulders of Tumak and Loana as they shelter within the rock formation. However, this is no guaranteed safe haven: Harryhausen draws the dinosaurs in such a way as to fill the slice of background that is visible from within the cleft, suggesting the close proximity of the battle. Much like the aforementioned *Clash of the Titans* illustration, these photographic storyboards served a function beyond their initial purpose in providing a practical reference point for Harryhausen when planning his animation, since they would also have provided a useful point of contact for producers, directors, and editors seeking to get an accurate understanding of what Harryhausen had in mind before the actual animation process was complete.

While the novel form of these photographic storyboards makes them of particular interest to the present study, they are very much the exception rather than the rule in Harryhausen's storyboarding practice as a whole. In most instances, he favoured rough, sketched lines, focussing predominantly on character action, rather than excessive background detail. Again, however, they differ significantly from most of the other animation-specific storyboards discussed in this book. The Disney storyboards

that we have previously examined offer more coverage than is typically the case in live-action storyboards, so as to provide a better basis on which to judge both the economy and aesthetics of a given sequence. A comparable level of detail, albeit in completely different form, characterises the digital storyboards discussed in Chapter 7, which overlap with other forms of pre-production development such as previs to allow for greater moment-by-moment planning, with the computer being able to plot much of the visualisation process relating to three-dimensional space. Harryhausen's storyboards instead follow patterns more commonly associated with live- action film-making in terms of how much information they provide per storyboard page. Falling somewhere between key frames and intended shot setups, many of the panels in his storyboards provide enough specific information to serve as a useful starting, middle, or ending point to guide the animation, while being sufficiently unspecific to enable him to improvise his way through a sequence and exploit any opportunities that might arise throughout the animation process.

Figure 4.5 shows a panel from Harryhausen's *Jason and the Argonauts* (1963) storyboard, depicting a moment from the encounter between Jason (Todd Armstrong) and the skeleton army.

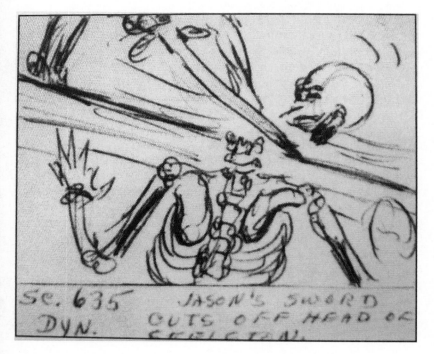

Figure 4.5 A Ray Harryhausen storyboard panel produced for *Jason and the Argonauts* (1963). Images copyright © The Ray and Diana Harryhausen Foundation

In the storyboard sequence it is preceded by a panel detailing Jason as he swings his sword, and followed by another that cuts to a wide shot showing Jason fighting several skeletons, one of which is now headless, from atop a plinth. The image in **figure 4.5** serves as a useful key frame in what would certainly have been a complex sequence to animate. Harryhausen remarked that he frequently relied heavily on memory when working on a sequence, with the storyboards serving as a useful aide-mémoire in the absence of more logistically detailed planning documents – a workflow that required him to avoid distractions (such as telephones and door bells) as much as possible.[57] The only explicit mention of the animation process in this panel, and in this storyboard sequence more generally, comes in the form of 'DYN' in the bottom left-hand corner of the panel, which is a shortened reference to Harryhausen's Dynamation process. This limited use of written production information means that as he animated his way through the sequence, Harryhausen worked out the details of how the skeleton armature was to be replaced by another armature without a head, the means by which the arc of the decapitated head was to be controlled as it fell to the ground, and how all of this animation was to correspond with the movements made by Jason.

It could be argued the very absence of detailed technical information in Harryhausen's storyboards presents a professional narrative in itself, one that gives a sense of the natural mastery of the artist over his chosen medium. It is tempting to extend this further still, and to consider the storyboard as a document capable of recording interlinking creative histories. A good example of this involves Harryhausen's adoption of visual ideas originally devised by Willis O'Brien during the pre-production of an ultimately un-filmed version of 'Gwangi' in the early 1940s – a project that would eventually be released by Warner Bros. in 1969 as *The Valley of Gwangi*, with Harryhausen responsible for the Dynamation set pieces. Working from a 'Revised Estimating Script', dated 6 October 1941 and written by Harold Lamb and Emily Barrye, O'Brien produced a detailed storyboard. For whatever reason, the project was shelved; perhaps a film featuring cowboys fighting with dinosaurs was considered too frivolous at a time when the horrors of war were permeating everyday life. It is also unclear exactly how Harryhausen came to possess O'Brien's storyboard and the 1941 screenplay, but it is likely that O'Brien gave these documents to Harryhausen, identifying him as his natural successor in stop-motion form, and in the hope that at some point in

the future he might have more success getting the 'Gwangi' project made.[58]

In 1969, Warner Bros. released *The Valley of Gwangi*, with Harryhausen responsible for the Dynamation set pieces. What is remarkable about this film is the degree to which certain sequences echo the story-board drawings penned by O'Brien almost 30 years earlier. The film's central action set piece, for example, which sees a gang of horse-riding cowboys attempt to lasso an allosaurus (**Figure 4.6**) repeats in almost identical form the staging proposed in O'Brien's original storyboard (**Figure 4.7**). Clearly, practical decisions will have heavily dictated the staging, which follows a convention characteristic of much of Harryhausen's stop-motion animation, whereby live-action performers occupy the sides of the screen and the stop-motion element is contained centrally within the frame, with the elements occasionally crossing and overlapping.

Beyond such practical considerations, it is important not to under-estimate the potency of the image proposed by O'Brien in panel 226 (**Figure 4.7**), which Harryhausen closely replicated in his own story-board for *The Valley of Gwangi* (**Figure 4.8**) in panel 405. This image of

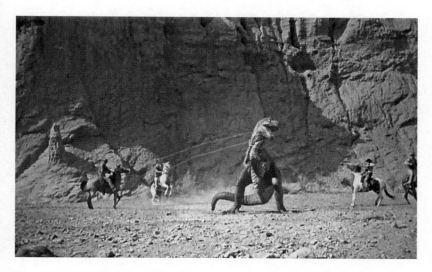

Figure 4.6 A still from the finished film *The Valley of Gwangi* (Warner Bros. 1969)

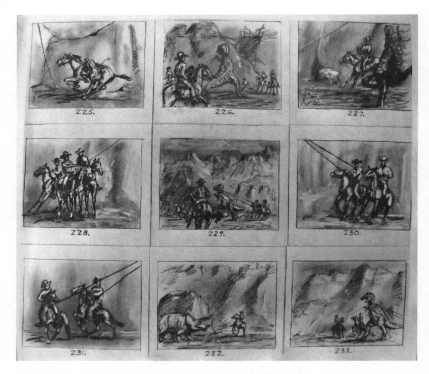

Figure 4.7 A Willis O'Brien storyboard page for the un-filmed project 'Gwangi' (c. 1941). Images copyright © The Ray and Diana Harryhausen Foundation

the allosaurus being lassoed by cowboys that flank the dinosaur on all sides serves as, and has become, a shorthand visual signifier of the film as a whole. Present in two storyboards produced almost three decades apart, it is positioned prominently in the film, while also forming a spectacular visual refrain in the theatrical trailer and featuring as the central image on many of the posters produced to advertise the film at the time of its release. In this context Harryhausen's storyboard, and subsequent Dynamation, serve as vehicles for O'Brien's original image, and the storyboards of both O'Brien and Harryhausen, which circulated in a predigital creative environment, prove instrumental in the propagation of an image that contributed in a significant way to the construction and production of *The Valley of Gwangi*. The storyboard thereby becomes the key document through which visual design choices might be transmitted across generational divides, which might otherwise prove terminal to shared creative practice.

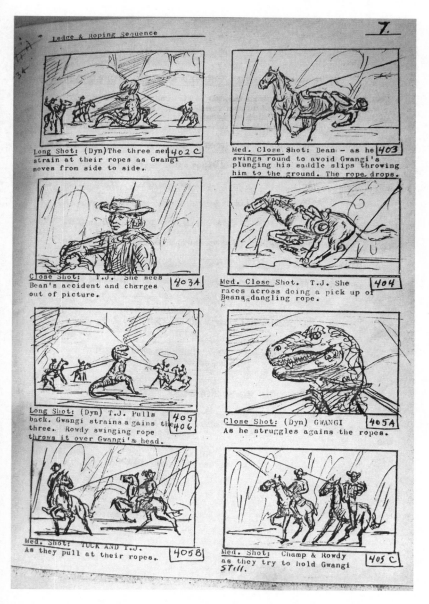

Figure 4.8 A Ray Harryhausen storyboard page for *The Valley of Gwangi* (c.1969). Images copyright © The Ray and Diana Harryhausen Foundation

This chapter has aimed to give some sense of the kinds of storyboards and storyboarding practices that emerged after *Snow White and the Seven Dwarfs* and *Gone with the Wind* had brought this approach to pre-production to wider attention. We have also attempted to show how storyboarding is enmeshed with wider debates about narrative cinema: the extent of pre-production planning in the creation of a film; the role of the auteur director in relation to other, less widely known collaborators; and the degree to which particular kinds of film are structured as integrated narratives or as a series of spectacles. In Chapter 5 we turn to storyboarding in the films of a director whose work encapsulates all of these questions, and who lies at the centre of the most widely debated controversy in the history of storyboarding: Alfred Hitchcock.

5
Hitchcock and Storyboarding

Alfred Hitchcock in many ways presents a comparable case to that of William Cameron Menzies. Indeed, the careers of the two men were intimately connected: Menzies worked with the director on *Foreign Correspondent* (1940), and took particular responsibilities in designing aspects of the surrealistic dream sequence in *Spellbound* (1945), for which Salvador Dalí was the more visually obvious collaborator. Several of the designers who subsequently achieved success with Hitchcock, such as Dorothea Holt, learned much of their craft under the tutelage of Menzies. Each man is at the centre of one of the major controversies that has helped to bring the role of storyboarding into critical prominence: Menzies as purportedly the creator of a complete set of storyboards for *Gone with the Wind*, and Hitchcock for the still-complex debate about the storyboarding of the shower scene in *Psycho* (1960).

Both Menzies and Hitchcock positioned themselves at the forefront of modes of film-making that, at least in theory, separated the advance planning of the film via screenplay and storyboard from its realisation in the shooting and editing. Yet as we have seen, although Menzies certainly did use continuity sketches, among other forms of visual artwork, in an attempt to plan more than one film in its entirety, in practice his efforts were compromised by the serendipity and uncertainty that film-making inevitably entails. *Gone with the Wind* represents this contradiction in its clearest form. Hitchcock, by contrast, and despite his many pronouncements on the matter, appears to have been a fully practical director who accepted the need to make changes, and saw storyboarding as simply one possible means to an end.

In his groundbreaking study *Hitchcock at Work* (2000), Bill Krohn summarises many of the widespread assumptions about the director: 'The Hitchcock I had heard about was a control freak who pre-planned

every shot of his films and was fond of saying that once the screen-play was finished, the actual making of the film bored him. [...] All this was made possible by rigorous pre-visualization techniques centring on the famous Hitchcock storyboards, a veritable film-before-the-film'.[1] As Krohn points out, this presents the pre-production stages as a kind of Platonic ideal of the film. Like David O. Selznick's dream of a 'pre-cut' picture, this would be an extreme version of the conception/execution model that, as we saw in the Introduction, has come under sustained critiques in recent scholarly studies of screenwriting. Krohn convinc-ingly draws on a wide range of documentary evidence, mostly held in Hitchcock's own papers at the MHL, to demonstrate that in practice he was a very different kind of director. In *Notorious*, (1946) for example, '[u]nscripted choices made during production grew out of details already written into the script, in the process creating rhymes as one shot or sequence suggested another falling into the same paradigm', a para-digm which 'did not exist before the film in some Platonic heaven, but evolved in the director's mind while it was being written, and particu-larly while it was being filmed'.[2]

None of the scripts in Hitchcock's own collection at the MHL show any evidence that he would either storyboard an entire film himself, or illustrate his copies of a shooting script with drawings that performed the same function. What are found repeatedly, however, are single sketches, or short sequences of sketches, apparently improvised in response to local questions surrounding a particular scene. Several folders for *Torn Curtain* (1966), for example, contain miscellaneous drawings that are certainly by Hitchcock, some on dedicated storyboarding paper with a three-image-per-page printed template.[3] Hitchcock seems to be using the frames to improvise solutions that may not have been solved in the scripts or in other storyboards by dedicated artists.

Even where he was working closely with such an artist, the idea that this then formed an inflexible blueprint for the production is contra-dicted both by many of his collaborators and by the documentary evidence. For *Saboteur* (1942), for example, he employed Robert Boyle, who recalls that Hitchcock 'wanted to have somebody who could do the continuity drawings, the storyboards. [...] [At] my first meeting with Hitchcock [...] we were working out some sequences, and he was making his little drawings. [...] Of all the directors that I had worked with, this was the first time somebody not only told me what they wanted, but showed me'.[4] This does not mean that Hitchcock storyboarded the entire film in advance, or expected Boyle to produce a 'Platonic' version either. Discussing the same film, actor Norman Lloyd recalls Hitchcock

producing a scroll which contained the Statue of Liberty sequence: 'In all the film schools they talk about the fact that he always did all these drawings and laid out the shots. It's not true. He did many. [...] But this sequence on the statue, he drew. For obvious reasons he had to, because it involved some very special technical work.'[5]

Ordinarily, then, individual scenes required storyboarding for specific reasons. Another example is Harold Michelson's storyboarding of *The Birds* (1963): this was confined to the sequences of the bird attacks, which demanded particularly complex matte and special effects work. A particularly telling case is Krohn's demonstration that the storyboarding of the crop-dusting scene in *North by Northwest* (1959) was actually a retrospective construction produced for publicity purposes.[6] And even where a scene was fully storyboarded, the sequence as sketched might be altered during production for any number of reasons, or altered at the editing stage, the sequences in the film as released consequently demonstrating marked differences from their storyboarded versions.[7]

Hitchcock's career presents a large number of possible approaches to storyboarding, but one that it does not demonstrate, on the available evidence, is a commitment to the pre-cut picture of the type that Selznick had been hoping for on *Gone with the Wind*. The dream of finding a precise correspondence between the pre-production work on storyboards and screenplays on the one hand, and Hitchcock's completed version of a film or scene on the other, has tended to bedevil analysis of his work, and this is nowhere better illustrated than in the sequence that has provided the longest-lasting and most complex debate in the history of storyboarding.

The shower scene in *Psycho*

Psycho offers one means of addressing some of the most important questions about both Hitchcock and storyboarding more widely. Given the centrality of the film in debates surrounding Hitchcock and authorship, and the expansive range of visual materials otherwise reproduced in Krohn's exemplary account, it is a little surprising that Krohn does not reproduce the Saul Bass storyboards for the shower scene, since Bass in many ways exemplifies Krohn's case for seeing Hitchcock as a more collaborative film-maker than had hitherto been accepted. Equally, and conversely, it is ironic that Bass should have weakened that very case by (apparently) claiming to have 'directed' the shower scene – a claim that the defenders of Hitchcock's status as an auteur director have had little difficulty in demonstrating to be false.

In the words of Philip J. Skerry, '[i]t is no exaggeration to say that the shower scene is *the* most analyzed, discussed, and alluded-to scene in film history',[8] and Skerry's own, invaluable book-length 2009 study, *Psycho in the Shower: The History of Cinema's Most Famous Scene*, adds considerably to this weight of commentary. Of the many reasons for this, two connected but separable claims are especially pertinent in the present context. The first is that Bass directed it; the second is that, irrespective of the identity of the director, the storyboards – which were undoubtedly drawn by Bass – anticipate so precisely the form and appearance of the scene in the film that its construction cannot be attributed solely to the director and editors, but instead provides one of the strongest pieces of evidence for the storyboard as a blueprint for a specific scene.

The Killing of Marion continues to shock, partly of course because it comes as an unprecedentedly brutal attack on the protagonist, and occurs at a startlingly early point in the narrative. More important for present purposes, however, are those qualities of the scene that visually, emotionally, and aesthetically separate it from the design of the rest of the film. The shots are organised via a kind of Eisensteinian montage, following a logic dictated not by narrative but by the arrangement of angles and planes. This gives the scene something of the feel of a modernist artwork, and contributes to its recycling via innumerable parodies and homages that have lent it a creative afterlife in relative independence from the rest of *Psycho*. [9] This tends to prompt the recognition that the planning of the sequence must have taken a different form from that of the rest of the film, leading to the discussion of the possible role of others in its conception; and Bass can certainly be credited, to an extent that remains open to debate, with assisting in this respect.

A second, related effect is that the vertical and diagonal slashes of the knife as it plunges towards the camera, accompanied by the screechingly staccato violins, represent an attack on the spectator – and even, perhaps, on the audience's understanding of cinematic representation itself. This is anticipated in remarkable form in Joseph Stefano's screenplay, in a way that the storyboards do not quite capture. As Marion (Mary in the screenplay) stands with her back turned to the curtain, 'we see the shadow of a woman fall across the shower curtain. Mary's back is turned to the curtain. The white brightness of the bathroom is almost blinding. Suddenly we see the hand reach up, grasp the shower curtain, rip it aside.' As the attack begins, 'The flint of the blade shatters the screen to an almost total silver blankness. [...] An impression of a knife

slashing, as if tearing at the very screen, ripping the film.' The sounds of the knife shredding through curtain and flesh in the film, mimicked and augmented by Bernard Herrmann's unforgettable musical score, entirely capture the screenplay's prescription for a kind of metacinematic assault; the storyboards, for all their radical angles and implicitly rapid cuts, cannot achieve the same effect. The end of the sequence as described in the screenplay, too, is strikingly similar to the film, with Mary ['l]ying half in, half out of the tub, the head tumbled over touching the floor, the hair wet, one eye wide open as if popped, one arm lying limp and wet along the tile floor', the blood draining away as the camera, in a movement followed in the film but only partially in the storyboards, 'MOVES away from the body, travels slowly across the bathroom, past the toilet, out in to the bedroom'.[10]

If the argument about direction really concerns authorship, or rather of the use made in the final cut of the materials created in pre-production, then we might well want to accord Stefano's screenplay at least as much weight as the storyboards. Because Bass was closely involved in the project from an early stage, he received each section of the script as Stefano composed it, in chronological narrative sequence, with Bass then working directly from the screenplay.[11] And while it must be stressed that Bass's storyboards perform a classic function of such artefacts in mediating between the words of the screenplay and the images into which they are to be transformed, the simple point made by Janet Leigh (who played Marion) is telling: 'He couldn't have done the drawings had Mr. Hitchcock not discussed with him what he wanted to get'.[12] This cuts both ways, however, with all of the evidence from the screenwriting and storyboarding indicating that there was extensive collaboration in the preparation of the film.

It seems that it may have been Hitchcock's reluctance to acknowledge this that prompted the counter-claim that Bass directed the shower scene. Despite Bass' important title sequences for *Vertigo* (1958) and *North by Northwest*, as well as *Psycho*, Hitchcock mentions Bass only once in François Truffaut's book-length interviews (first published in 1966), when he acknowledges that he made use of Bass' drawings for a different scene in *Psycho*, that in which the detective Arbogast climbs the stairs prior to being killed.[13] Nowhere is Bass' contribution to the shower scene mentioned. A similarly auteurist notion of film creation, especially regarding Hitchcock, may perhaps explain the strange omission of Bass from a number of other prominent sources, such as Dan Auiler's *Hitchcock's Secret Notebooks* (1999) and the catalogue publication *Casting a Shadow: Creating the Alfred Hitchcock Film*, published

in 2007 to accompany an exhibition of visual materials relating to Hitchcock's films. Yet Hitchcock certainly paid Bass $2,000 to story-board the sequence,[14] rather than assign the task to art director Joseph Hurley, because – as Hurley's co-designer Robert Clatworthy puts it – 'Joe could have storyboarded the whole thing, but Saul wouldn't fall into the cliché as we might readily do'.[15]

On several occasions Bass mentioned feeling the slight, most influentially in a 1973 article in the *Sunday Times Magazine*, which reproduced the storyboards and drew on an interview with Bass to support its sensational scoop in claiming that he had actually directed the scene.[16] This claim has been categorically denied by many others involved in the film, including some who were on the set during the filming and recall the minutiae of Hitchcock's direction,[17] and Krohn's study of the documentary, archival evidence provides no grounds for supposing that anyone other than Hitchcock was in overall command of the filming.[18]

In fairness, not only is the wording of the original *Sunday Times* article a little ambiguous, but Bass also subsequently rowed back from the specific claim, instead registering disappointment that his credit (he receives on-screen credits for title design and 'pictorial consultant') had been too easily taken to refer to the abstract title sequence only.[19] He denied having made the statements attributed to him in the article, and stated to Pat Kirkham that Hitchcock merely allowed him to set up the shots, working from the storyboard, and to call 'Action!', with Hitchcock himself always present and guiding events.[20] This makes his assertions considerably less presumptuous. Moreover, Bass *did* shoot test footage of a stand-in on 10 December, partly to find ways around the problem of nudity,[21] and appears to have produced a rough demonstration version of the scene, using his storyboards, a borrowed camera, and Janet Leigh's stand-in Marli Renfro. Bass and editor George Tomasini then edited the footage before showing it to Hitchcock.[22]

Nor does it quite follow that in the wake of the controversy '[t]he myth of the storyboard was threatening to rob Hitchcock of credit for one of his most impressive achievements', as Krohn puts it.[23] It was no myth that Bass had storyboarded the scene, or that some of the images he drew bore a striking resemblance to the version in the released film. Stretching our terms a little, there is clearly a sense in which the design of a scene is in itself a form of direction: as we saw earlier, David Bordwell has analysed Menzies' contributions to the films of Sam Wood in this light,[24] although it must be said that Hitchcock was much more visually proficient than Wood. The evidence strongly

indicates that Bass played a significant role in designing the shower scene and, in this loose sense, pre-directing it via the storyboards. As the British film reviewer Mark Kermode put it as recently as 2010, '[d]esigner Saul Bass's preparatory storyboards so closely detail every moment of the sequence that some have suggested he should share directorial credit with Hitchcock'.[25] For present purposes, however, the controversy is significant for the light it throws on more general questions surrounding storyboarding, in particular concerning the ways in which a director may make use of the boards: for example, as an indication of possible ways of shooting and editing a scene from which s/he may then depart. In order to answer this, the evidence needs to be examined closely, yet again.

Discussions of the storyboards for the shower scene tend to start from the assumption that Bass created a sequence of 48 images that functioned as a blueprint for the filming. These images have been widely reproduced on the Internet and in several recent publications, including Jennifer Bass and Pat Kirkham's *Saul Bass: A Life in Film and Design* (2011),[26] an authorised pictorial survey of the designer's career; and on the latest Blu-ray release of the film, issued by Universal in 2010. Not infrequently, only the first 24 frames are reproduced, as in Fionnula Halligan's 2013 anthology of storyboard images,[27] although Halligan does refer to a sequence of 48 frames, as do many other publications that do not reproduce all of the images, including Krohn[28] and Joseph W. Smith.[29] A possible explanation for this peculiarity is that at time of writing it is still the case that a thumbnail of only the first 24 appears on the Web pages of the MHL's Production Art Database, where they are described as 'a series of twenty-four images showing the shot sequence of the shower scene'.[30] However, copies of all 48 are held in the MHL's Saul Bass papers, though the remaining 24 have not (as of June 2015) been reproduced as an image viewable online.[31]

Unquestionably, the scene as Hitchcock directed it drew closely and directly on storyboards drawn by Bass. Janet Leigh told Stephen J. Rebello that 'Mr. Hitchcock showed Saul Bass's storyboards to me quite proudly [...] telling me in exact detail how he was going to shoot the scene from Saul's plans. The storyboards detailed all the angles, so that I knew the camera would be *there*, then *there*. The camera was at different places all the time'.[32] The on-set costumer Rita Riggs recalled that '[t]he storyboarding, particularly for that sequence, was so innovative, I only had to look at the boards to realize what we *had* to see'.[33] Bass' work was also undoubtedly helpful in anticipating the *rhythm* of the scene: something

that is rarely apparent, and probably unnecessary, in storyboard practice prior to this. As Bass remarked,

> After all, all that happens was simply a woman takes a shower, gets hit, and slowly slides down the tub. Instead, [we film] a repetitive series of motions: 'She's taking a shower, taking a shower, taking a shower. She's hit-hit-hit-hit-hit. She slides-slides-slides. She's hit-hit-hit-hit. She slides-slides-slides.' In other words, the movement was very narrow and the amount of activity to get you there was very intense. That was what I brought to Hitchcock. I don't think that shower sequence was a typical Hitchcock sequence, in the normal sense of the word, because he had never used that kind of quick cutting.[34]

Bass notes that this kind of 'staccato' rhythm in the editing later became much more prevalent, whereas at the time it was 'a very new idea stylistically. As a title-person, it was a very natural thing to use that quick-cutting, montage technique to deliver what amounted to an impressionistic, rather than a linear, view of the murder'.[35]

Yet Hitchcock did not simply copy the storyboards, as becomes very clear if we compare the canonical sequence of 48 frames, described in the MHL's Production Art Database as the 'storyboard cut version' **(Figures 5.1 and 5.2)**, to the images seen in the film. This reproduction of the sequence arranges the images on two boards, with the first 24 (those mentioned above as appearing on the Production Art Database) positioned on the top half of our page (figure 5.1), and the second 24 on the lower half (figure 5.2). The images are arranged vertically, so that frames 1–6 appear in the upper left-hand column of 5.1, frames 7–12 in the second column, and so on.

Frames 1–3 show Marion in the shower, seen first from the front, then facing right in extreme close-up, and then in medium close-up with her head filling the screen. Medium shots 4–6 show her occupying one half of the frame as a threatening shadow becomes progressively more visible in the other, pulling aside the curtain (6) before Marion screams in close-up (7) as the face of her attacker, in shadow yet with its eyes, nose, and mouth clearly visible, pulls aside the curtain (8). After a further close-up of Marion (9) she raises her arms to defend herself (10–11) against the knife-wielding hand that descends in extreme close-up in frames 12–14. An extreme close-up on Marion's mouth screaming (15) is followed by a close-up on her hand clutching the shower curtain (16), which due to the downward force exerted by Marion becomes partially detached from the rings on

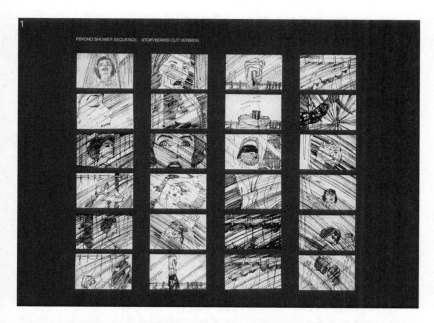

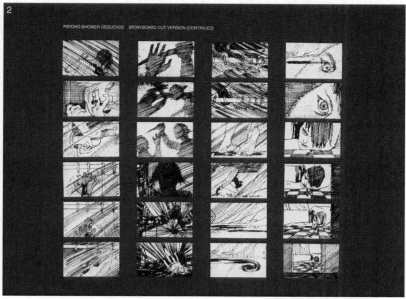

Figures 5.1 and 5.2 Psycho shower sequence: storyboard cut version. Saul Bass papers, production files of the Margaret Herrick Library of the Academy of Motion Picture Arts and Sciences. Courtesy Universal Studios Licensing. © 1960 Shamley Productions, Inc

the rail, seen in close-up in frames 17–19. A shadowy arm holding the knife aloft is foregrounded against a background of the shower nozzle spraying water in frame 20; the logic of the composition thereby indicates that the nozzle is seen from the front, with the arm and knife descending in front of it, although we shall discuss this point presently. In close-up, Marion holds her right hand in front of her face (21), then in medium shot holds her right arm aloft, clear of her face (22) in an ambiguous gesture that shows her either falling away from the curtain, or reaching out to it in an attempt to grasp it again; alternatively, we may read it as an intransitive gesture of submission and despair. In frame 23 she has turned her back, looking over her right shoulder in medium close-up, before in frame 24 the assailant's knife penetrates the skin of her back.

The second board commences at frame 25, with Marion either lying or falling, face-down and away from the viewer, as blood pours from a wound in her neck. She holds her bloodied hands to her throat in frame 26. Frame 27 is a slightly obscure composition that shows a hand, presumably Marion's, clutching what appears to be the shower's safety handle. Another hand – again, presumably, Marion's, although it is in shadow – rips the top of the curtain free from the rail in frames 28–30. The next several frames are all in shadows: in close-up, the knife comes down against a hand (31); then in medium shot we see Marion attempting to defend herself but beginning to slide down, her descent indicated by the fact that she occupies a clearly lower position in frame 33 than in frame 32. A close-up of the attacker's face, its features wholly indiscernible in the shadow, occupies frame 34. Frame 35 is very similar to frame 20, the arm, hand, and knife now a little lower against the background of the nozzle. Marion's defensive hand is seen from above (36) as the curtain finally comes free from the rail (37–38). A close-up on Marion's feet (39) is followed by a shot of her body, lying prostrate on the left side of the frame. Only her back, right arm, and hand are visible; blood streams from the wound in her neck (40) across the floor of the shower basin (41) and whirls in an anticlockwise motion around the plughole (42). In frame 43 the blood on the floor forms a backdrop to a close-up of Marion's eye, which then in extreme close-up occupies almost all of the frame (44), with the background only shadow. Finally, frames 45–48 occupy a fixed point in space but move progressively further away: beginning with a close-up of Marion's face as she lies dead on the shower floor, we retreat to see that she is lying over the side of the shower basin (46–47) in a scene that is finally framed by the doorway of the bathroom (48).

Clearly, several arresting images and effects of editing in the film are directly anticipated in the storyboard: the appearance of the dark

shadow of the intruder to the left of the frame as Marion, showering in the other half of the frame, looks off unawares to the right; the darkened face of the killer as s/he pulls the curtain aside; the hand holding the knife viewed from below as it stabs downwards; the rings giving way on the shower rail as Marion pulls at the curtain in desperation; the blood swirling around the plughole in an anticlockwise motion; the immediately following cut to the dead stare of Marion's eye; and finally the pull away from the eye to reveal Marion's dead face lying on the square tiles of the bathroom floor. It would be idle to contest Vashi Nedomansky's conclusion, demonstrated via a split-screen parallel video he placed online in 2014, 'that the Saul Bass storyboards were followed explicitly to create the indelible images that made this spectacular scene'.[36]

Explicitly; but not precisely or completely. Equally important are the differences. The progression of storyboard images that Nedomansky presents on the left-hand side of his screen, with the film sequence playing in real time on the right, significantly departs from the series of 48 images in the 'storyboard cut version', which Nedomansky has reproduced on the same Web page on which he has embedded the video. To begin with, his recreation of the scene via the storyboards includes not 48 but 49 images, yet only 34 of these are unique, with several being repeated more than once. For example, each of the first two images shown in Nedomansky's sequence is a reproduction of the first frame of the storyboard, with Marion's face seen from the front and slightly from below as she luxuriates in the rejuvenating sensations of the water splashing down upon her. In the film, however, a shot of the shower head spraying water towards the camera has been edited into an otherwise apparently continuous shot of Marion's ecstatic face. The image of the shower head does not appear in the storyboard, which explains why, in Nedomansky's sequence, the first frame of Bass' storyboard is immediately repeated, with simply a blank where the shot of the shower appears in the film. Frame 9, a reaction shot showing Marion's shocked expression as the attack begins, is used no fewer than six times in Nedomansky's film, while the image of the attacker in complete shadow (frame 34) is used four times. These frames need to be repeated because it is the only way to approximate the intercutting between Marion and her attacker, where there are significant differences between the film and the canonical storyboard. Nedomansky's technique – of using an identical storyboard frame to approximate two different shots – is akin to the 'Kuleshov effect' championed by Hitchcock, whereby the same piece of exposed footage will generate different meanings depending upon the image against which it is juxtaposed.

While some frames are used repeatedly in Nedomansky's construction, many others do not appear in his version at all, because they do not appear in the film. These include several images of the curtain being pulled from the rail, which is shown at three different points during the attack in the storyboard but only once in the film, after the attacker has fled, as Marion grasps it before her head falls to the floor. Most of the 14 images Nedomansky omits are shots of the knife, shower rail, and curtain, as well as the hand holding the wall-mounted handle, which does not appear in the film at all. Conversely, many images that do appear in the film are not present in the storyboards. These include several shots of the shower head from different angles, spraying water diagonally from the upper left to the lower right, or directly towards the camera from above. These memorable shots are perhaps anticipated in storyboard frames 20 and 32, but the effect is entirely different due to the presence of human figures in Bass' drawings, where the shower head is seen behind the killer's arm, hand, and knife, which are placed prominently in the foreground and dominating the frame.

Bringing the storyboard into alignment with the film also requires, in addition to these omissions, repetitions, and substitutions, a more radical kind of intervention whereby images are reversed to match more closely the orientation of characters and objects within the shot. An example is frame 20, which has to be inverted to show the knife descending from right to left, as in the film. Also reversed is the sixth frame, allowing Nedomansky's version to show the intruder pulling aside the shower curtain on the left-hand side of the screen – as one would expect, since this is where s/he appears in the preceding frame. In the canonical Bass frames, however, the figure has inexplicably moved from the left in frame 5 to the right in frame 6. This may be an error either in conception or in reproduction, but if so it is an error repeated on Nedomansky's own web page, where he presents a common version of the sequence as a still image prior to altering it for his parallel-text video comparison of storyboard to film. A total of seven of the 34 images that he uses have been inverted in his sequence to match the effect of the film.

The most striking thing about Nedomansky's invaluable parallel-text presentation, then, is that it reveals how extensively the canonical Bass storyboards have had to be re-edited and rearranged to bring them into a sequence that can approximate the film. The first six frames, before the attack, appear in the same order on the storyboards and in the film; aside from the omission of frame 43, the final eight images, showing the aftermath of the killing as the blood flows away from Marion's dead body, also appear in the same order. The depiction of the attack itself, however, shows such extensive rearrangement of the images that there is not space to detail all the changes here. What Nedomansky has done

is to use the canonical frames as raw material, selecting from, repeating, rearranging, cropping, and panning within individual frames and within the series to create an effect that most closely approximates that of the scene as edited in the film as released. This eliminates elements of incoherence, repetition, or redundancy within the storyboard sequence itself, and if we are to imagine the director and editor of the film to have been working directly from the 48 storyboard images, this is precisely what they have done also, intervening within and juxtaposing different elements before arriving at a final sequence of shots.

Nedomansky's approach illustrates what has already become a conventional editorial process in parallel-text analyses of storyboards in relation to finished films. Videos of this kind were a feature of the 'Zwischen Film und Kunst: Storyboards von Hitchcock bis Spielberg' exhibition staged at the Deutschen Kinemathek in Berlin 2012. Like the Nedomansky edit, cropping and panning was used to amplify the visual matches between storyboard illustration and the film in question. The advantages and disadvantages of this kind of editorial intervention are clear to see in Nedomansky's analysis of *Psycho*.

Moreover, it is not necessarily the case that Bass supplied Hitchcock with the images in this precise sequence. The MHL's online notes on the first 24 images state:

> This storyboard includes original drawings that were first mounted on smaller black cards before they were remounted together on this single board. These original drawings were created before shooting and mounted on individual cards as Bass often did with his presentations. The drawings were removed from these cards and then reassembled together on one board sometime after the sequence was shot.

It is in the nature of storyboarding that the original images can be rearranged at will; this is one of the advantages of the process in the first place, approximating the possibilities presented of editing exposed film in post-production. It is possible that the 48 frames were presented to Hitchcock in the canonical sequence; it is at least equally possible that this sequence is a retrospective reconstruction.

In any case, Hitchcock clearly did not simply follow the Bass images. Assistant director Hilton Green felt that shooting the shower scene 'was not that difficult because it was laid out. We knew shot for shot and setup for setup where the camera would go ahead of time'. This appears to confirm the familiar notion that Hitchcock was copying the storyboards, yet the real import of Green's observation lies in the next sentence: 'It only took time because of the many different angles we had to get'.[37] Several crew and cast members have commented on the difficulties of filming

the scene within the confined space of the shower set. In keeping with his recent experience of filming some of the *Alfred Hitchcock Presents* television episodes, Hitchcock used a multiple-camera setup, which enabled him to select from several different angles in the exposed footage, partly to avoid later difficulties with the censor regarding the nudity. It is highly likely that some of the differences of angle and sequence between the drawings and the film result from these more practical considerations. As Green recalls, 'Shooting the shower scene was never seen by us as more than getting the bits and pieces together purely for shock effect. The fragments that we photographed were sort of stored away, but Mr. Hitchcock had a general idea of how he wanted to make the idea progress'.[38] Just as, in editing the scene, Hitchcock was selecting from and rearranging pieces of exposed film, so, too, was he selecting from, and adding to, the storyboards that Bass created.

Still more problematic for the standard reading of the canonical storyboards is the existence in Bass' own papers of two sets of unused images, comprising a total of 46 images.[39] In the Bass collection at the MHL these are arranged on two separate boards that reproduce these 'excerpts from storyboard studies of components', as the MHL labels them. One of these, containing 25 images, we reproduce here [**Figure 5.3**]. The MHL's description of these artefacts is revealing: 'The drawings on this board include original drawings that were removed from individual cards and reassembled on boards after the fact. This board includes components that were not included in the final edited scene. It is believed that the drawings on this board were created before shooting occurred and these unused components were edited out.' This makes clear that the canonical Bass sequence is a selection and arrangement of images from a larger number of images that the designer created, and one that produces an arithmetical and geometrical arrangement on the page that is pleasingly – perhaps suspiciously – elegant.

Only four frames (identified above as frames 6, 7, 8, and 28) appear both in the canonical sequence and among the 'unused' 46 additional images. This means that the four boards of extant drawings in the Bass archive comprise a total of not 48 images, but 90. It is not clear who has arranged the two additional boards, or if there is a deliberate logic to the sequencing. The images this time appear to be arranged not in vertical columns but in horizontal rows; they do not seem to have been positioned in any particular *narrative* order; and there appears to be no direct connection between the two images on the fifth, bottom row (one a direct reproduction of canonical image 8, which shows the killer's shadowy face, and the other a close shot on a wound to Marion's neck).

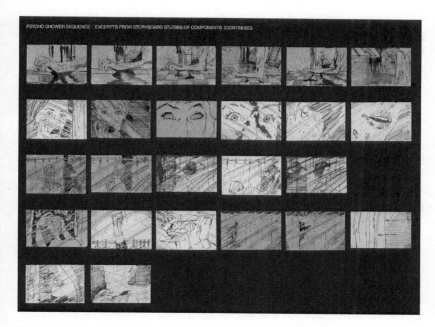

Figure 5.3 A series of twenty-five unused images from the shower scene in *Psycho*. Pen and ink on paper and photocopies mounted on mat board. Saul Bass papers, Margaret Herrick Library of the Academy of Motion Picture Arts and Sciences. Courtesy Universal Studios Licensing. © 1960 Shamley Productions, Inc

With the exception of this row, however, each of the remaining four horizontal rows of images in **Figure 5.3**, and all of the five rows in the remaining board (which we have not reproduced here), show Bass experimenting with variant approaches to a particular moment or kind of shot, or possibly attempting to depict particular sequences of action in motion. The six frames on the top row of **Figure 5.3** offer alternative close and medium shots of Marion's hand, arm, and face as she lies motionless on the shower floor in the aftermath of the killing. The second row presents various close-ups of the shocked expression in Marion's face, eyes, and mouth; here Bass seems to be experimenting with angle and shadow, with the first of the six appearing as frame 8 of the canonical sequence.

A remarkable series of five images on the third row captures the moment at which the killer approaches and pulls back the curtain. Of these, the fourth is reproduced in the familiar series as frame 6, which we have previously noted to be problematic due to the inexplicable emergence of the shadowy figure at the right of the frame, having appeared at

the left in the preceding image. What we might think of as the 'outtakes' in **Figure 5.3** show that Bass conceived a range of possibilities here. The first and second of the five frames in the row show the curtain opening slightly right of centre – not at the extreme right, as in the commonly reproduced image. The fifth frame in the row, however, is very similar to image 5 of the canonical sequence, with the shadowy assassin appearing instead at the left of the frame before pulling the curtain aside. That moment is captured in the third image of the outtakes row, which indicates with an arrow movement that Marion turns her head towards the left as the attacker pulls the curtain aside at the extreme left of the frame. (The image of Marion clutching her hair that appears at the beginning of the following, fourth row appears a little anomalous, although since the curtain is fully opened it may be visualising the same moment of attack, but a fraction of a second afterwards.)

This explicit indication of movement within a shot is seen also in several images on the fourth row, most of which focus on the knife, and the second of which is extremely similar to canonical frame 12. The last image on the row has arrow signs pointing from the right of the frame towards the curtain on the left, indicating the direction of the attacker's approach within the shot, while the fourth and fifth present the perspective from inside the shower as the knife cuts through the curtain. The remaining image in this row intricately presents a downwards movement of the knife via three superimposed images as its cuts the flesh of Marion's hand.

The other outtakes board at the MHL is less varied, concentrating for the most part on different angles of the shower spray and of the curtain rings giving way as Marion falls. Again, while they appear to have been grouped thematically, they do not follow a narrative sequence: another series of variant images of Marion washing occupies the bottom row, yet the rows above show different moments from the knife attack that should logically come afterwards. What these 'studies of components' collectively reveal is that Bass created several alternatives for many of the key shots in the sequence, and that the canonical series of 48 images represents a selection from the range of possibilities. The contradiction between frames 5 and 6 of that canonical sequence, as the attacker appears first on the left of the frame and then, confusingly, on the right, may perhaps be explained as either an accidental or an unavoidable consequence of choosing from images which can be arranged with either of two possible uses of a storyboard in mind: to form a narrative sequence (the 48), or as a means of focusing attention on particular aspects of framing, angling, shading, movement, and so forth, which

is more readily apparent in the 'studies'. The desire to present a narrative storyboard – possibly retrospectively – may have outweighed the occasional illogical juxtaposition, or Bass may simply have been experimenting with different ways of positioning the characters.

Memories are fallible; production records are less so, although even they cannot reveal everything. *Psycho* was a comparatively rushed production, with just 30 days scheduled for shooting. There is no documentary record to prove exactly what role Bass took on set, but it seems certain that there was a measure of verbal discussion between the collaborators as the shower scene was being planned and executed. The evidence proves that that Bass did not direct the scene; it also proves that Hitchcock did not plan and shoot it without assistance. Instead, the shower scene exemplifies the collaborative nature of film-making, with both Stefano and Bass playing key roles, albeit under the final authority of Hitchcock, who, importantly, was both producer and director on the film.

It also illustrates another general principle, which is that the separation of pre-production from production is rarely straightforward. The blueprint theory of a film conceived fully in advance, with the filming merely the execution of the plans, has attached itself with peculiar force to Hitchcock; but as the documentary record shows, for Hitchcock as for others film-making is usually a messier affair. Bass prepared the storyboards in advance, but there was room for selection from them, for departure from them during the filming, and for reinterpretation of the scene in the editing. The shooting of the scene with several cameras gave options in the editing room, while Hitchcock also took the opportunity to reconceive aspects of the scene via the shooting and insertion of additional shots after the main filming had been completed. It seems certain that Bass was making allowance for these imponderables while working on the storyboards, providing a palette of options from which the director could choose.

A detailed analysis of Hitchcock's use of storyboards places the director in a more ambivalent position than is commonly assumed. He did not pre-cut all of his pictures using this or any other method; nor is his use of storyboards a myth. Instead, they were for Hitchcock one of several methods of planning a film from which he was willing to deviate at any point for practical or artistic considerations. It is with this flexibility in mind that we turn to the films of some of the directors of the following generation whom Raphaël Saint-Vincent termed 'Les héritiers d'Hitchcock': the heirs of Hitchcock.[40]

6
Constructing the Spielberg-Lucas-Coppola Cinema of Effects

In his 1986 article, 'The Cinema of Attraction[s]: Early Film, Its Spectator and the Avant-Garde', Tom Gunning suggested that American cinema of the late 1970s and early 1980s had 'reaffirmed its roots in stimulus and carnival rides, in what might be called the Spielberg-Lucas-Coppola cinema of effects'.[1] This brief remark proposes a very real continuity between early cinema and Hollywood cinema of the time in which Gunning was writing: the cinematic desire to privilege spectacle over narrative. However, Gunning's article is primarily concerned with film production and exhibition before 1906, and does not directly engage with either the cinema of the late 1970s and early 1980s generally, or the film-making practices of Steven Spielberg, George Lucas, and Francis Ford Coppola specifically, and the comparison risks eliding some crucial distinctions.

As Janet Staiger describes in *The Classical Hollywood Studio Cinema* (1985), film production at the turn of the twentieth century relied upon a cameraman system, which, for a brief time, became the common arrangement for film production. Crucially, this cameraman system, which underpinned much of the work discussed by Gunning, enabled individuals to 'select the subject matter and stage it as necessary by manipulating setting, lighting, and people; they would select options from available technological and photographic possibilities (type of camera, raw stock, and lens, framing, and movement of camera, etc.), photograph the scene, develop and edit it'.[2] Consequently, the need for detailed pre-production documentation, such as scenarios, screen-plays, or storyboards, would have been minimal, given the cameraman's ability to both plan the film mentally and improvise when necessary. Furthermore, many of the individuals working in this manner were

producing short films specifically for exhibition on the vaudevillian stage: 'Until the advent of the nickelodeon around 1906, American vaudeville provided the embryonic motion picture industry with hundreds of exhibition outlets across the country and an audience of millions of middle-class spectators'.[3] Again, given the modular nature of these early vaudeville shorts, which emphasised spectacle squarely over narrative complexity, there would have been little need for an experienced cameraman to spend much time planning the work in advance. Compared to the cameraman system, it becomes clear that while the creation of spectacle does indeed connect these two very different film-making periods, the Spielberg, Lucas, and Coppola cinema of effects demanded – and relied upon – far greater levels of pre-production preparation and creative collaboration.

While many other filmmakers shared similar ambitions during the 1970s and 1980s, such as James Cameron, John Carpenter, Wes Craven, Ray Harryhausen, and Sam Raimi, Gunning's decision to single out Spielberg, Lucas, and Coppola to represent this shift towards a more effects-heavy form of cinema is fitting in at least one important respect: no other triumvirate can lay claim to having directly expedited the demise of the New Hollywood movement of the late 1960s and 1970s, whilst also laying the foundations for a fresh period of studio domination to which spectacular film-making became key. This is not to cast the trio as a unified or revolutionary group; rather, it recognises their position in the eye of a perfect storm. With economic recession deflating U.S. finances for much of the 1970s, the rate of film production in Hollywood declined sharply by the end of the decade. With the studios able to finance fewer and fewer films, executives became increasingly cautious, naturally searching for ways to ensure a financial return on their investment.[4] Speaking in 1982, Spielberg candidly captured this sense of desperation and the consequences that it carried for film-making:

a lot of people who run the studios seem to have an attitude that if a film can't at least reach third base, let alone home, then we don't really know if we want to make this picture, and that's the danger. The danger is not from filmmakers, the danger is not from the producers or the writers, it is from the people who are in control of the money, who essentially say I want my money back, and I want those returns multiplied by the powers of ten. So I'm not really interested in sitting here and seeing a movie about your personal life, your grandfather, what it was like to grow up in an American school, what it was like to masturbate for the first time at thirteen, or whatever. I want a picture

that is going to please everybody, in other words I think Hollywood wants the ideal movie, with something in it for everyone, and of course that's impossible.[5]

In different ways, all three directors played a part in accelerating Hollywood's shift to the idealised, high-concept, sequel-minded business model that has become so familiar, with the big-budget failure of Coppola's *Apocalypse Now* (1979) standing in opposition to the lucrative franchise-building evident across Lucas' *Star Wars* instalments, Spielberg's *Jurassic Park* series, and the pair's *Indiana Jones* films.

Emerging in a concentrated manner throughout the 1970s and 1980s, this cinema of effects arguably encouraged a shift in Hollywood away from the narrative continuity of the Studio Era and the character-driven intensity of New Hollywood, towards a film-making attitude that privileged spectacle over narrative. (See Chapter 4 for a discussion of the critical debate surrounding this issue.) An associated and, for present purposes, more significant development was that on a practical level the storyboard started to challenge the role traditionally occupied by the screenplay as *the* principal pre-production and production document, by virtue of it being a fundamentally visual text, and thus better suited than the screenplay to plan for spectacle. In addition to bringing detail to this pre-production dialectic, between screenplay and storyboard, this chapter will challenge the narrow authorial emphasis present in Gunning's equation by highlighting the contributions of those storyboard artists who supported – if not guided – the Spielberg-Lucas-Coppola cinema of effects.

Storyboarding and Spielberg

Gunning lists Spielberg first in his tripartite expression, perhaps reflecting the director's already-acquired reputation by the mid-1980s for effects-laden, event filmmaking. If we were to reformulate Gunning's directorial equation based on storyboard usage, Spielberg would retain the primary position, with Lucas and Coppola relatively interchangeable behind him. Both comprehensive and versatile in his use of storyboards, Spielberg's seeming dependence on them has drawn criticism in some quarters. John Baxter comments on the use of storyboards by the 'Movie Brat' generation in terms that recall familiar critiques of the alleged shortcomings of these directors in comparison with the work of their predecessors:

Though they didn't invent them – Hitchcock, among others, used them all the time – storyboards became a major weapon of the Movie Brats. Men like Spielberg's regular artists Ed Verreaux and George Jenson were adept at generating hundreds of pages of graphic art, complete with framings and camera movements, from the director's stick-figure diagrams. Storyboards dictated a two-dimensional style, reducing narrative to a handful of poses. Following style, dialogue was scaled down to the two or three lines needed to fill a talk balloon. Teenagers raised on the same visual conventions loved the result but, applied to a serious subject, it imposed a *Classics Comics* glibness. Coppola, Scorsese and many others abandoned this crutch as they embraced the multivalent possibilities of film, but Lucas and Spielberg clung to it. Many would credit the failure of *Empire of the Sun* in part to storyboarding, and the success of *Schindler's List* to the fact that Spielberg abandoned it for that film.[6]

In some respects Baxter's account recalls screenwriter William Goldman's comments in his influential part-manual, part-autobiography *Adventures in the Screen Trade* (1983) concerning the prevalence of the 'comic-book movies' of the period. Goldman associates such movies with melodramatically clear distinctions between good and evil, 'a lack of resonance', and an over-reliance on other movies, rather than 'life as it exists', for their points of reference.[7] In a chapter entitled 'The Ecology of Hollywood: or, George Lucas, Steven Spielberg, and *Gunga Din*', Goldman sees Spielberg's *Jaws* (1975) and Lucas' *Star Wars* (1977) as initiating a shift in the 'ecology', or balance, of Hollywood, whereby at the time of writing (mid-1982) 'comic-book movies' were almost the only films being made in Hollywood. He contrasts this situation not only with that just ten years previously, a time that might be regarded as the high point of the 'New Hollywood', but also with the oft-cited year of 1939, for example, in which the studios could already be seen to be investing in a remarkable range of different kinds of film.

Like the discussion surrounding narrative versus spectacle that we considered in Chapter 4, the initial critical basis for such a view of post–New Hollywood film-making lies in reception: that is, in an informed critical response to the movies themselves. Placing this argument to one side for the moment, however, what we shall see in the present chapter is that a production-oriented approach to the films reveals them to be 'comic-book films' in the more literal sense. Seen in this light, Baxter's analysis seems more concerned with mourning the loss of New Hollywood's brief promise, rather than offering a balanced consideration

of the multivalent pre-production opportunities afforded by the story-board, or similar drawn documentation.

Spielberg's directorial debut *Duel* offers an illustration. The final revision of Richard Matheson's 91-page *Duel* teleplay, dated 1 September 1971, provides a very clear picture of the vehicular combat between protagonist David Mann and the anonymous truck driver who relentlessly pursues him throughout the narrative. In fact, Matheson's description of Mann's actions within the car, his car's relationship to the truck, and Mann's perpetual interior thoughts begin to feel equally relentless as the teleplay unfolds. Yet this almost forensic detail comes at the expense of a consistent sense of space and geography. During one climatic sequence, which evolves over several pages, the description of location never ventures beyond the generic:

128 HELICOPTER SHOT – CAR AND TRUCK

The pursuit continuing down the slope. Retaining the two vehicles in the frame, the camera slowly draws around until we see the valley ahead. In the distance is a low building surrounded by open ground, two trucks, one large, one a pick-up, and two cars parked in front of it. Mann's car reaches the base of the slope.[8]

This stunted spatial description, which is typical of the teleplay, was perhaps intentional, with Matheson working to a studio brief that was probably based on an expectation that the film's landscape would be constructed artificially, through a combination of rear-projected sequences shot on an available sound stage and stock footage.

However, once hired, Spielberg made it clear that he wanted to shoot on location. With this ambition in mind, and working from Matheson's teleplay, Spielberg needed a practical way to plan *Duel*'s visual construction. Although traditional storyboards played a minimal part in the pre-visualisation of *Duel*, the director's comprehensive hand-drawn map of the film proved critical during production. Spielberg described this map as a kind of 'menu', which allowed him to plot his camera set-ups, in terms of location, for the entire film. Given the relatively consistent mise-en-scène (comprising mostly of tarmac road, sandy canyons, a car, and a truck), this approach would have also meant that any storyboards that were in use could be understood easily by all involved, as long as they corresponded to a point on the map.[9] The manner in which Spielberg used this document, wrapping it around his 'entire motel room', evokes comparisons with how storyboards have been used during the production of animated features (see Chapters 2 and 7), whereby they are often wall mounted to encourage analytical and

reflective story development.[10] Crucially, this method allowed Spielberg to consult Matheson's teleplay when required, but also enabled him to plan more intricately the visual set pieces that would make use of the real-world environment. Released at the time of writing, *Furious Seven* (2015) presents an unusual and irresistible comparison. For James Wan, the film's director, having the luxury of being able to manipulate his practical car stunts in digital post-production afforded alternative pre-production strategies:

> That scene – after the cars drop out of the sky, land, and assault the military motorcade in the mountains of Azerbaijan – that whole sequence was basically storyboarded and then pre-vized. And then, literally sitting around with my entire team. Second-unit group, with my stunt group, with my specials effects team, and with my visual effects team, trying to make this thing work. And literally there were days when it would be just like you and me sitting across a table, a whole group of us, just playing with little toy cars. 'Then the car comes and hits it like this, and then bangs over this way, and then the car come up, shoots the harpoon...'[11]

For Spielberg, perhaps the greatest consequence of approaching *Duel* in the manner that he did was that it revealed, at a formative stage in his career, both the potential usefulness and versatility of pre-visualisation.

Jaws (1975), Spielberg's big-screen breakthrough, endured difficulties during both pre-production and location shooting. The challenges faced by Spielberg and his crew on location have become the stuff of film legend, with the bespoke mechanical shark proving difficult to operate and film, but the trials faced during the adaptation of Peter Benchley's source text are less widely known. Although Benchley was initially chosen to rewrite his novel for the screen, further drafting was required, which resulted in several other writers being employed throughout the scripting process: Howard Sackler 'spent five weeks rewriting the script of *Jaws* but requested no credit'; John Milius, a World War II aficionado, was brought in to imbue Quint's USS *Indianapolis* monologue with a greater sense of authenticity; while, ultimately, Carl Gottlieb brought a final polish to the screenplay in close collaboration with Spielberg himself.[12] Given the script's fragmented development, the storyboard, produced by Spielberg and Joe Alves, gained added importance, serving to bind the production together in the absence of a settled screenplay.

Reminiscent of *Duel*'s pre-visualisation, during the production of *Jaws* 'Spielberg sequestered himself in a house overlooking the ocean, which he papered with thousands of storyboard drawings; four hundred for the

final sequence alone'.[13] However, while the drawings made during the planning of *Duel* remained fixed to the director's motel walls, the *Jaws* storyboards travelled with him. Reflecting on Spielberg's daily approach to the *Jaws* shoot, Baxter notes how the director would be up at '6 a.m. with a cup of tea, memorising the day's pages – he never, on this or any later film, took a script onto set, though he was seldom far from his storyboards – before setting out in the shivering dawn to chivvy four hundred extras into pretending it was July'.[14] As a working document, on a film set where morale ebbed more than it flowed, the storyboard took on added symbolic value – it became a document with the power to refocus individuals around a difficult creative idea worth striving for. Alves captures the significant position occupied by the storyboard, noting how during the production 'the shots needed to be meticulously planned so that everyone knew which shark was to be used and how the shot would be achieved (sled, left to right and right to left). Since it took literally a day per shot each storyboard drawing had to be precise'.[15] Spielberg's approach to pre-production on both *Duel* and *Jaws* provides an early example of the director's willingness to place the storyboard on an equal footing with the screenplay when pursuing spectacle. While Spielberg's workflow on *Duel* and *Jaws* reveals the extent to which the storyboard was able to occupy a prominent – if not parallel – position alongside the screenplay, the storyboard gained even greater importance for Lucas, becoming *the* document in which the varied demands of special effects film-making could be planned, reviewed, and recorded.

Storyboarding and Lucas

The Empire Strikes Back also evolved incrementally, with Lucas initially working with veteran Hollywood screenwriter and pulp science fiction writer Leigh Brackett, before hiring Lawrence Kasdan to help finalise the screenplay. However, being an effects-heavy film, responsibility fell to the storyboard artists when shaping the more spectacular sequences. Following Ralph McQuarrie, who worked closely with Lucas during early concept development for the films, Joe Johnston's storyboarding proved particularly useful during the digital effects production process at Industrial Light & Magic (ILM), while Ivor Beddoes served as the principal storyboard artist for the UK-based production unit alongside director Irvin Kershner.

Understandably, ILM relied heavily on storyboards to plan the film's digital effects. Given the time and money required to produce such effects at that time, storyboards provided an essential tool for ILM to coordinate

production in a controlled fashion. Frequently wall-mounted, these storyboards established a space in which large-scale pre-visualisation could take place; and, as is often the case where animation is concerned, they remained subject to constant revision and removal throughout production. Although ILM worked with a degree of autonomy, Lucas' 'ideas were transferred into storyboards so everyone could understand what he was thinking [...]. Joe Johnston drew the storyboards, but Lucas designed the shots, giving *Empire* his visual imprint as well as Kershner's.'[16] In this production context, where the visual construction of the image was of the utmost importance, the storyboard became an ideal working document.

By contrast, Beddoes' work with the live-action production unit reveals a persistent dialectic between storyboard and screenplay. From the outset, Lucas sought to share the writing responsibilities, with Brackett developing a script based on his scene-by-scene treatment. Looking at Brackett's original script now it is easy to see ways in which the visual spectacle of the film evolved beyond her written version, but it is equally possible to see how her draft 'gave some of the dialogue, particularly the exchanges between Skywalker, Solo and Leia, a sharp wisecracking thirties quality'.[17] Unbeknownst to Lucas, Brackett had been working on the script whilst battling with cancer, and died shortly after filing the script. To replace her, Lucas turned to the inexperienced Kasdan. Having recently employed him to help develop a script about an adventurous archaeologist (which would later become *Indiana Jones: Raiders of the Lost Ark* [1981]), it is likely Lucas viewed Kasdan as someone who would be able to infuse Brackett's more classically dialogue-driven draft with a greater sense of action and spectacle.

The development of the scene in which Luke arrives on the planet Dagobah captures this shift well. In Brackett's script, which is hand-dated as 17 February 1978, the following description is given:

96 EXT SPACER AND POND – DAY

The hatch opens. Luke falls into the water and flounders ashore. Artoo appears in the hatch. He beeps, then steps forward and disappears with a splash into the water.

LUKE

Artoo!

He starts to go back. But a small periscope appears above the water, turns till it gets a fix on him, then moves steadily through the water.

98 ARTOO

We watch the periscope as the submerged 'droid trundles toward the muddy beach. Artoo emerges, retracing the periscope. He [...] looks around for Luke, then moves to stand beside a prostrate body; Luke has passed out again. Artoo bubbles electronic profanity and ejects a stream of muddy water.[18]

Brackett's early draft captures the playfulness of the Artoo (R2D2) character that is seen in the finished film, but characterises Luke differently, exaggerating his physical frailty at this stage in the narrative so as to reinforce the need for Jedi training under the tutelage of Yoda (named 'Minch' in Brackett's script).

In Kasdan's penultimate draft, described as both the 'Fourth Draft' and 'Shooting Script', which is dated 24 October 1978, this same sequence is imparted with added tension and spectacle:

272. EXT SWAMP – DUSK

Luke dives in near the spot where Artoo fell. He surfaces and scans the water frantically until he sees a small periscope pop up. The periscope turns until it gets a fix on Luke, then lets out a bubbling beep, and starts through the water toward the muddy beach. Luke follows.

273. EXT SWAMP – DUSK

We see the POINT OF VIEW of an underwater swimming "thing" as it watches R-2 and his young master struggling toward shore. R-2 is powered by two bubbling jets.

274. EXT SWAMP – DUSK

A dark, ominously finned back breaks the surface. Luke stops swimming for a second and sees the disturbing shape swimming toward him. Luke swims for his life, racing past Artoo and finally scrambling up on shore.

LUKE

Hurry, Artoo![19]

It becomes clear that while Bracket may have considered the crash landing itself to be sufficiently thrilling for a sequence that essentially only serves to establish the Dagobah location, Kasdan's draft introduces additional spectacular content in the form of the underwater 'thing' that terrorises R2D2. Kasdan writes:

275. EXT SWAMP – DUSK

The thing swims up behind the little droid and dives, creating a loud clunk. Artoo's periscope disappears as he lets out a pathetic electronic scream. Luke wades a few feet into the murky pool looking for any sign of his little friend. The black surface is as still as death itself ... a few bubbles begin to appear, then PHHEEWAATT! The runt-sized robot is spit out of the water, makes a graceful arc and comes crashing down in a patch of moss.

LUKE

Artoo, are you okay?

Artoo responds with a series of feeble whistles and tones.

LUKE

If you said you thought coming here was a bad idea, I'm beginning to agree with you.[20]

Not only is the action of this sequence enhanced through R2D2's flight through the air, but the suggested underwater POV shot from the creature's perspective also adds extra tension to the encounter, leaving the reader with only a brief glimpse of the creature's finned back.

However, this description does not correspond to how the sequence appears in the final film. The probable reason for this can be found in the storyboards, dated September 1978, produced by Beddoes. The fact that Beddoes' storyboards predate Kasdan's fourth draft suggests a work-flow where the screenplay and storyboard developed in parallel, with both documents working towards a common goal. Contained within Beddoes' storyboards though are frequent handwritten comments that suggest the storyboard, not the screenplay, established the space in which creative decisions were made regarding the upcoming principal photography. There is also evidence of parallel development of this sequence through competing storyboard drafts, with an undated story-board sequence, produced by McQuarrie, reproduced in J.W. Rinzler's excellent *Star Wars Storyboards: The Original Trilogy* (2014). This details the swamp chase and underwater POV, and offers the following hand-written suggestion regarding the cinematography: 'Luke passes Artoo swiftly (undercrank)/monster sweeps in (extreem [sic] Foreground)?'.[21] However, it is Beddoes' storyboard that most accurately records the editorial process, confirming the removal of the Dagobah underwater POV shot seen in **Figure 6.1**.

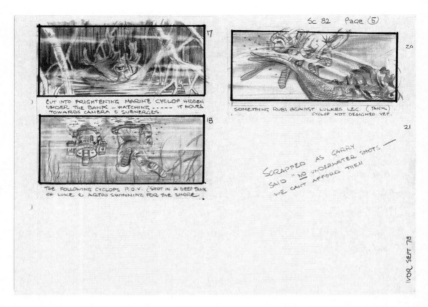

Figure 6.1 A storyboard page detailing an unseen shot from the Dagobah swamp sequence, produced in 1978 by Ivor Beddoes for *Star Wars – The Empire Strikes Back* (1978). Image provided courtesy of Lucasfilm and the British Film Institute

On a page labelled 'Sc82 PAGE 5' we see the planned underwater POV, which is detailed over three panels (a fourth appears to have been removed). These panels, numbered 17 to 21, depict, in order: a one-eyed creature, in medium close up, half submerged; an underwater POV of Luke and R2D2's bodies swimming away from the implied camera position; and a medium close-up of the creature brushing past Luke's legs, again, from an underwater perspective. Consequently, the storyboard page in question reveals the effects-minded thought processes of the production team, with one handwritten comment beneath image 18, referring to the fact that the sequence will need to be 'shot in a deep tank', while another note beneath image 20 introduces the reminder: 'Cyclop [sic] not designed yet'.[22] These notations clearly reveal that Beddoes' storyboard occupied a central role as the production team sought to realise Kasdan's aquatic action. Ultimately, Garry Waller, an animator working in the miniature and optical effects unit, called for the sequence to be cut, as a handwritten comment on the storyboard records: 'Scrapped as Garry said "No underwater shots – we cant [sic] afford them"'.[23]

Accordingly, a fifth – and this time final – screenplay, dated 20 February 1979, was drafted by Kasdan, working from the changes mapped out in the storyboard:

275 EXT SWAMP – DUSK

The monster thing appears behind the little droid and dives, creating a loud clunk. Artoo's periscope disappears as he lets out a pathetic electronic scream. Luke wades a few feet into the murky pool looking for any sign of his little friend. The black surface is as still as death itself ... a few bubbles begin to appear, then PHHEEWAATT!! The runt-sized robot is spit out of the water, makes a graceful arc and comes crashing down in a patch of moss.

LUKE

Artoo, are you okay?

Artoo responds with a series of feeble whistles and tones.

LUKE

If you're saying coming here was a bad idea, I'm beginning to agree with you.[24]

Superficially, Kasdan's revised description, now divested of added underwater spectacle, offers a return to the action as defined by Brackett, but with an added moment of visual humour as the sequence concludes: 'As Luke glances around at the spooky swamp jungle that surrounds him, Artoo answers by ejecting a stream of muddy water from one of the ports in his head'.[25] Yet, rather than revealing a singular editorial U-turn on the part of the scriptwriter, the director, or even the producer, this revision reveals the collaborative nature of the film's production. As Beddoes himself remarked in February 1979, 'Unlike the sketches for the ice planet [Hoth], which were all on one sheet, this sequence was drawn on separate frames and assembled, cut, changed, and altered as individual sketches or eliminated, while connecting drawings were made as the script itself was changed around'.[26] This fragmentary development process is neatly recorded in the storyboard pages visible in **Figures 1.4** and **6.1–6.2**, with **Figure 6.1** clearly revealing the cut-and-paste method described by Beddoes, while **Figure 6.2** records a passage of special-effects discussion concerning how Yoda might be endowed with greater believability. Tracing the evolution of this particular sequence makes apparent that the storyboard did not simply develop alongside the screenplay, but that it ultimately refashioned the screenplay after its own image.

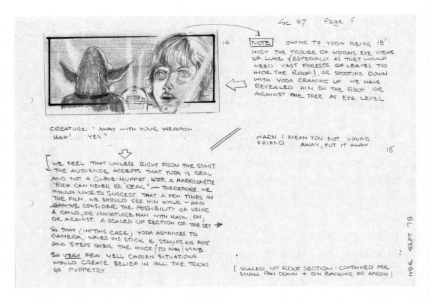

Figure 6.2 A storyboard page detailing a production discussion, produced in 1978 by Ivor Beddoes for *Star Wars – The Empire Strikes Back* (1978). Image provided courtesy of Lucasfilm and the British Film Institute

Storyboarding and Coppola

In contrast to the predominantly set-based production of *The Empire Strikes Back*, *Apocalypse Now* pushed the envelope in terms of spectacular location film-making. While the *Apocalypse Now* shoot has become infamous for the challenges faced relating to casting, logistics, weather, military cooperation, and the general physical and mental well-being of those involved in the film's production, the importance of the storyboard to the film's successful completion has been largely overlooked.

The screenplay for *Apocalypse Now* evolved slowly, starting in 1969 in the hands of Milius, who had been invited by Coppola to start the writing process shortly before the director became sidetracked with other ambitious projects such as *The Godfather* (1970), *The Conversation* (1974), and *The Godfather Part II* (1974).[27] Once Coppola returned to the project he immediately started an ambitious rewrite of the Milius script, attempting to weave together multiple threads: the original script, a critique of the Vietnam War, and the twisted colonial psychology

depicted in Joseph Conrad's novella *Heart of Darkness* (1899). This placed a heavy burden on both the script and Coppola. As a consequence, the screenplay – as a singular, coherent, printed document – never fully materialised. Coppola has since remarked: 'When I shot the film, I knew the script so well that I only carried the little green paperback of Joseph Conrad's *Heart of Darkness* in my pocket, so I could review the scene I was shooting with whatever I could glean from the original text'.[28] Despite this poetic portrayal, script pages, in one form or another, did circulate during principal photography, yet the stance taken by certain cast members towards the script did prevent the text becoming a settled or stable document.

While Coppola encouraged improvisation during the shoot, Dennis Hopper's repeated deviation from the scripted dialogue eventually wore on the director, with Coppola exclaiming at one stage: 'For God sakes, we've done thirty-seven takes, and you've done them all your way! Would you do just one for me, Hopper?'[29] Marlon Brando was equally free-spirited, turning up for just three weeks of shooting (for which Coppola had agreed to pay him three million dollars) without having read Conrad's novella, thus forcing Coppola to halt the shooting of his scenes in order to first talk Brando through the Kurtz character's motivation. The documentary *Hearts of Darkness* (1991), which draws on behind-the-scenes footage shot by Coppola's wife Eleanor during the production, captures the fear and frustration experienced at that time by a director faced with the prospect of not being able to successfully film the actor's crucial concluding scenes.

Tellingly, the solution was improvisation and not a revised script. Speaking at the Cannes Film Festival in 1979, where *Apocalypse Now* won the *Palme d'Or*, Coppola announced: 'My film is not about Vietnam, it *is* Vietnam. It's what it was really like. It was crazy. And the way we made it was very much like the way the Americans were in Vietnam. We were in the jungle, there were too many of us, we had access to too much money, too much equipment, and little by little we went insane'.[30] To capture this imbalance between the belligerents, Coppola developed spectacular ambitions regarding how the film should look. In order to help plan this hyperbolic aesthetic, Coppola had the storyboard artists Alex Tavoularis and Tom Wright explore colouration as well as staging during the initial storyboarding process, before translating these images into more practically minded storyboard pages that shifted the emphasis from aesthetic composition to logistical preparation.[31]

The advantages of the initial colour storyboards can be seen over a series of pages detailing the sequence in which Lieutenant Colonel Kilgore (Robert Duvall) calls in a strategic napalm strike in order to expedite his platoon's surf time, showing both the madness and the superiority of the U.S. Army in comparison to that of the Vietnamese. Although napalm had been used in previous wars, napalm has become closely associated with the Vietnam War, perhaps as a consequence of the U.S. Army's pronounced use of the chemical weapon during the conflict. On the colour storyboard page depicting the moment of the air strike, a large ribbon of red and yellow flame stretches across the middle of the panel, with the fighter jets responsible for the delivery of the napalm pictured in the top right-hand corner of the image (**Figure 6.3**).

As a consequence of the storyboard panel's widescreen aspect ratio, the positioning of the blue sky and the muddy riverbank along the top and bottom margins of the implied frame, respectively, serves to emphasize the destruction through the napalm explosion's domination of the centre frame. Although the fighter jets approach from the opposite direction in the final film, the colour and framing of the napalm explosion correspond closely to the storyboard. By contrast, the script, which does contain the famous napalm monologue delivered by Kilgore (named Kharnage at this point in development), offers little detail in terms of the visual look of the sequence beyond: 'Fire and Wind and Water', 'It must be fantastic' and 'design this battle with Dean [Tavoularis – brother of Alex]'.[32]

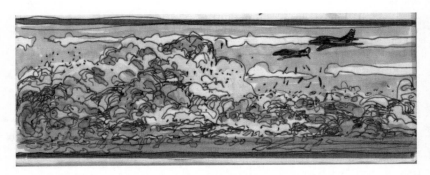

Figure 6.3 A storyboard page (reproduced here in black and white) detailing the napalm air strike, produced c. 1975 by Alex Tavoularis and Tom Wright for *Apocalypse Now* (1979). Image provided courtesy of American Zoetrope

Coinciding with the shift from pre-production to production, the storyboards themselves evolved as working documents. This development is particularly apparent across the storyboards that portray Kilgore's airborne beachhead assault. As with the napalm sequence, Tavoularis and Wright produced a series of colour storyboards, which in this instance depicted vast numbers of Bell UH-1 Iroquois (informally known as Huey) helicopters bearing down, in tight formation, on the targeted beachhead. The first storyboard page in this sequence gives an insight as to the size of the helicopter squadron imagined by Coppola, Tavoularis, and Wright as we see a large clearing filled with helicopters being prepared for takeoff, accompanied by the handwritten description: 'MATTE SHOT – Hundreds of Hueys'.[33] In the storyboards that follow, the helicopters are depicted in large airborne formations, with one storyboard (numbered 17) carrying the note: 'LOW ANGLE – FULL SHOT – HELECOPTERS – MASSIVE GROUP' (**Figure 6.4**).[34] Coppola, Tavoularis, and Wright were imagining a sequence that would, again, convey the might of the U.S. military, although it is unclear whether Richard Wagner's 'Ride of the Valkyries' had been chosen at this stage in pre-production: **Figure 6.4**, which has been supplied by American Zoetrope, does not include any reference to music, yet a comparable image widely available online appears to

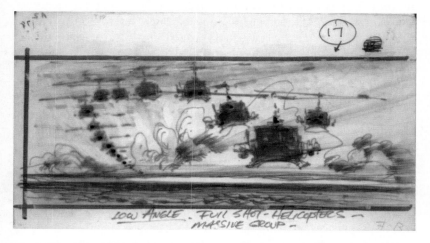

Figure 6.4 A storyboard page (reproduced here in black and white) detailing a shot from the famous helicopter assault, produced c. 1975 by Alex Tavoularis and Tom Wright for *Apocalypse Now* (1979). Image provided courtesy of American Zoetrope

show the same storyboard page but in a less cropped format, with an additional reference to 'BLARING MUSIC'.

Inevitably, the demands of production required that the more conceptual storyboards evolve into more multipurpose working storyboards, better suited to enable the realisation of the desired imagery. To help coordinate the shooting of the complex helicopter assault sequence, these additional storyboards were drafted to include detailed logistical notes. These working storyboards adopt a consistent portrait layout, with the shot number and description heading each page, below which one or more storyboard panels are included, followed by the subheadings: Time, FX, Stunts, Aircraft (only included when required), Camera, and Playback (again, only included when required). Surprisingly, discussion of these revised storyboards is frequently absent in the few published accounts of Tavoularis and Wright's contributions to the development of *Apocalypse Now*, such as those published by *Cahiers du Cinema* and *Empire Online*.[35]

Perhaps this might also be related to the uncertainty that now concerns the originating artist of the boards, with both Tavoularis and Wright working with Coppola during the U.S.-based development phase, yet Tavoularis working alone when on location. As Tavoularis notes: 'Wright drew a set of pen and ink boards colored with felt markers in Los Angeles before the film went into production. I drew storyboards during filming in the Philippines, most of what I drew was pen & ink with no color, mostly to choreograph the complex helicopter village attack scenes'.[36] Comparing the colour storyboard sequence described previously to how it appears in this new format reveals several important developments. On page 11 of this revised storyboard, which contains panel '54A', for example, 'WAGNER P.A.' is defined as the soundscape for this sequence next to the Playback subheading (**Figure 6.5**).[37] The following page, which details panel '55', carries the description 'VIEW FROM BEHIND GROUP OF HELICOPTERS SOARING TOWARD VILLAGE', above a panel depicting a dozen helicopters at various distances from the implied camera position (**Figure 6.6**).[38]

At the bottom of **Figure 6.6** we also find the following logistical details:

```
TIME:
FX:          NONE
STUNTS:      NONE
AIRCRAFT:    8 to 12 HUEYS
CAMERA:      Jet Ranger, Helly mount.[38]
```

54A -- MEDIUM DOLLY SHOT -- RUNNING THROUGH TRENCHES TO MAN
ANTI-AIRCRAFT

BACKGROUND:
Check P. KAMA:
Running through trenches to anti-aircraft -- uncover weapon,
prepare to operate. Crates of munnitions----- stacked.

TIME:

FX: NONE

STUNTS: Running and jumping.

AIRCRAFT: NONE

CAMERA: DOLLY

PLAYBACK: WAGNER P.A.

Figure 6.5 A storyboard page containing production information, produced c. 1976 by Alex Tavoularis for *Apocalypse Now* (1979). Image provided courtesy of American Zoetrope

55

SHOT 55 -- VIEW BEHIND GROUP OF HELICOPTERS SOARING TOWARD VILLAGE

HUEYS SOARING TOWARD VILLAGE IN DISTANCE.

TIME:

FX: NONE

STUNTS: NONE

AIRCRAFT: 8 to 12 HUEYS

CAMERA: Jet Ranger, Belly mount.

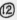

Figure 6.6 A storyboard page containing production information, produced c. 1976 by Alex Tavoularis for *Apocalypse Now* (1979). Image provided courtesy of American Zoetrope

These additional notes indicate that Coppola, having planned to have helicopters fill the sky, adopted a necessarily pragmatic approach when it came to actually capturing this image. Working with the intended 2.35:1 aspect ratio in mind, Tavoularis' storyboards continue this practical thinking by utilising the narrowness of the panel to exaggerate the density of the helicopter formation. Unfortunately, when it came to filming the sequence, this vision was consistently undermined by the lack of film experience amongst the pilots recruited from the Philippine Military. Doug Claybourne, a production assistant with first-hand experience of the Vietnam War and who served as the helicopter wrangler for the sequence in question, notes:

> they just weren't movie pilots. This was a 2:35 frame so it was wider but lower, and it was hard to get them to fly within that frame. We had to drag them down to the ground and tell them that they'd have to go up and do it again. Remember, there were no digital effects: if you see 14 fourteen [sic] helicopters, that's how many there were. It wasn't like Michael Bay's Pearl Harbor.[40]

While the storyboards provided a way of carefully plotting much of the imagery prior to filming, it is important to remember that pre-visualisation through storyboarding always sets in motion a dialectical negotiation between imagination and image making – a dialectic that became painfully apparent to Coppola during the production of *Apocalypse Now*.

Jurassic Park (1993)

Clearly, this chapter has been as much about recognising the contributions of Spielberg, Lucas, and Coppola to the development of a particular mode of spectacular, effects-heavy cinema, as it has been concerned with reclaiming a history for those storyboard artists such as Alves, Beddoes, Tavoularis, and Wright, whose work established the imagined spaces in which the more prominent directors worked. This shift towards the spectacular in mainstream American film-making continued apace throughout the 1990s, and remains a feature of contemporary film-making. In line with this increasing emphasis on spectacle, the storyboard artist continued to occupy a significant position throughout the 1990s

During the production of Spielberg's *Jurassic Park*, for example, the importance of the storyboard reached new heights. Dave Lowery, one of the storyboard artists to have worked on the pre-production of the film, supports the notion that screenplay and storyboard development

took place in parallel, while noting that it was Michael Crichton's manuscript that understandably governed the film's early development: 'You always rely on the richness of the story – the plot and the characters come from that; the script and the storyboards really just plot that out in a visual way'.[41] After Universal Pictures acquired the rights to film the adaptation, Crichton himself begrudgingly took on the responsibility of reworking the text into a screenplay; however, after three drafts his work was jettisoned in favour of a complete rewrite. Nonetheless, Crichton's revelation that '[t]here were storyboards and sketches [...] immediately – within weeks after he [Spielberg] acquired the book – and so I was able to do a lot of writing from those', suggests a production process that privileged the drawn over the (re)written.[42] Given the spectacular nature of the *Jurassic Park* story, with 14 dinosaur set pieces featuring in Crichton's original text, it is easy to see why the storyboard, not the screenplay, became the key production document during the film's early development.

One set piece that directly benefited from the storyboarding process was the velociraptor kitchen sequence. Not only did the storyboard provide the space for this idea to take shape, but the storyboard also became a point of textual convergence for numerous members of the film crew during the planning and filming of the sequence. Although the set was seemingly straightforward, the crew relied directly on the storyboard for a sense dimensionality: 'Because the choreography of the raptors was of the utmost importance, the kitchen set had actually been designed around the action illustrated in the storyboards [...]. In reality, a standard-size industrial kitchen would never have accommodated the raptors' maneuvers'.[43] As a working document, the *Jurassic Park* storyboard functioned in different ways for different people, at all times helping to share detailed visual information accurately and in an organised fashion across the film set.

Crucially, while the writers (first Crichton, followed Malia Scotch Marmo, and finally David Koepp) were hired to carve out a stable screenplay, the storyboard artists (principally Lowery and Marty Kline) created a space where ideas could be conceived, plotted, and evaluated without demanding that any such pre-visualisation immediately contribute towards a fixed and final storyboard document. Rick Carter, who was the film's production designer, notes that although *Jurassic Park* went through an unusually long period of preparation, this ultimately proved beneficial, remarking: 'If we had tried to do this picture in a normal fashion and on a normal schedule, we would have been totally out of control. As it was, a lot of storyboarding had gone on, but there was a

constant revising of the storyboards and the concepts for the scenes'.[44] Fittingly, Carter adopts a Darwinian register when describing this work-flow: 'There would be an idea and it would go through a lot of different writers and storyboard artists and dinosaur designers – and then it would just go by the wayside. Then a new idea would emerge and we'd see how long that one lasted. It was like survival of the fittest'.[45] While this approach might have challenged earlier Hollywood conventions, as a method by which to cultivate a modular, digital cinema of effects, the process proved ideal amidst the emerging computer-generated spectacle of the 1990s.

Jurassic Park also serves as a useful example of how challenging it can be to gain an accurate picture of a modern film's production. Since the mid-1990s, partly stimulated by the development of digital distribution platforms such as DVD, the World Wide Web, and most recently Blu-ray, there has been a growing interest in and circulation of paratextual film materials. Alongside this, synergistically minded film studios have also sought to extend the profitability of their special-effects blockbusters through the increasingly common practice of publishing 'Making Of' companion editions. Of the films discussed in this chapter, several have been subject to such multiplatform exploitation, with *Jurassic Park*, *The Empire Strikes Back,* and *Apocalypse Now* available as both DVD and Blu-ray editions, which tempt consumers with the promise of greater access to additional content. However, an unfortunate consequence of this drive to recommodify these paratextual materials is the quiet modi-fication that frequently occurs, in order to re-engineer them in readiness for redistribution via DVD, Blu-ray, the Web, or print publication. The evolution of such materials from pre-production through production to publication reinforces the need for a more nuanced taxonomy of the storyboard than currently exists.

The problems become immediately apparent when comparing the storyboards published in *The Making of Jurassic Park* (1993) with those held in the MHL. The pages of the archived storyboard are printed with dates ranging throughout 1992, and use different coloured sheets of paper to convey production context (with yellow designating a live-action shot, blue designating ILM's first unit, and pink designating ILM's second unit). Arranged in portrait orientation, each Letter-sized page contains at the top: the date, a scene number, and a stamp mark stating 'SS APPROVED', recording Spielberg's approval of a storyboard page through the use of his initials. At the bottom of each page is a rectan-gular box divided into the following sections: scene/shot, unit, ILM, and 'Stan Winston' (the individual who coordinated all of the animatronic

puppetry). It is in this box that the digital and puppet-based effects requirements of each scene are recorded. Occupying the middle of the page is the storyboard panel, often with a handwritten note beneath to link the image to a specific moment of description or dialogue from the screenplay. By contrast, the published storyboards reproduce only the panel, at a reduced size, along with the written description. These reduced panels are also combined so that they run sequentially, vertically down the page. Consequently, all of the production information contained in the archived storyboard is omitted. By doing this, and by only including storyboard sequences (seven in total) that correspond closely to the final film, *The Making of Jurassic Park* encourages a faulty, linear reading of the film's development.

While the *Empire Strikes Back* and the *Apocalypse Now* storyboards that have been made publicly available do contain the production details omitted from the published *Jurassic Park* storyboards, other compromises remain. For example, the reproductions of Tavoularis' colour storyboards for *Apocalypse Now*, which feature as additional content on DVD and Blu-ray editions of the film and have also been published online by the Director's Guild of America[46] and *Empire Magazine*,[47] do not reflect the size of Tavoularis and Wright's original storyboards, which in some cases exceed Ledger/A3. Similarly, those storyboards from *The Empire Strikes Back* that are included in Rinzler's *The Making of The Empire Strikes Back: The Definitive Story Behind the Film* (2010) and aforementioned *Star Wars Storyboards: The Original Trilogy* vary in size, never matching the original Letter/A4.[48] More significant is that the storyboards that have been selected for publication only detail sequences that feature largely unchanged in the released versions of these two films, thereby fuelling the misapprehension that both movies blossomed, almost fully formed, from the minds of their creators. However, as we will see in Chapter 7, given the relatively recent emergence of digital pre-visualisation software, the challenges noted here are not the only ones that have the potential to shape our developing understanding of the storyboard.

7
Storyboarding in the Digital Age

While the majority of live-action film-makers now rely on digital technology – at the point of capture, when editing, or as a means of promotion and distribution – the act of storyboarding for a live-action film may still resemble any one of the variety of approaches already discussed in this book. However, the increasing ubiquity of digitally animated effects in seemingly live-action sequences, whether for the sake of overt spectacle or not, has prompted film-makers to turn to the additional intermediary stage of digital pre-visualisation ('previs') in order to more closely control the creation of the image.[1]

Michael Fink, a veteran of the visual effects industry, having worked on many of the most influential effects-heavy films from *Blade Runner* (1982) through to *Avatar* (2009), offers the following summary of the shifting practices associated with the move from paper-based storyboarding to digital alternatives:

> There's no Art Department set up with room for the storyboard any more, they [the storyboard artists] are vendors, they come in, they show their boards, and they go away. But it used to be [that] storyboard artists, visual effects people, and the art director, and the production designers, the director, the producer ... were all in the same building, all in the same rooms. And there was a lot of cross-pollination; so the production illustrator would walk past a storyboard and say, 'god I love that frame, can I have that', and he'd do a quick Xerox, and then they'd go off and they'd draw an illustration of it. So the whole sense of flow and the way collaboration works is different. Storyboards are almost always now a point of departure; it

isn't just a means to an end, it's just one of the steps along the way to the end.[2]

Fink's assessment of this change is not rooted in sentimentality for an idealised golden age, but rather reflects the altered position of the story-board within the filmmaking process:

> It used to be that you drew the storyboards and then you shot it, but now you do thumbnails, you may never do finished boards. ... I've seen artists come in and say, 'I'll take these thumbnails and I'll flesh them out and get them back to you', and the director will say, 'you know, they're pretty good, just leave them here, or just make them all the same size, lay them out, but they don't have to be any better than this'. Because they know the next step is previs, and they've got what they need to do previs.[3]

Previs has become *the* step in the pre-production process that the film crew strive to reach as quickly as possible. As with the animatic and the storyboard before it, previs presents the most accurate vision possible with the resources available (technical ability, hardware, and budget) of how the final film should look. Ultimately, it is that uncertainty regarding how the final image will look when relying on storyboards and animatics that producers, directors, and the surrounding design team have sought to minimise through the use of previs.

Consider, for example, the film *Gravity* (2013), which made extensive use of previs during a two-year pre-production cycle. Emmanuel Lubezki, who worked with the film's director, Alfonso Cuarón, as cinematogra-pher, offers a stark assessment of the utility of the storyboard during production: 'The camera moves are really complex, but we started in the most simple way – first with storyboards, and then with a bunch of puppets and toy versions of the International Space Station and the space shuttle Columbia'.[4] Lubezki continues: 'We talked about them in the most primitive terms with the animators. It was great to start with some puppets, then have the animator come back with a black-and-white block animation, and then start to add volume, color and light. It's truly about layers and layers of work'.[5] Lubezki's association of the storyboards with the puppetry, and his choice of the word 'primitive' to describe this process, paints an unambiguous image of the position of the storyboard in this digital production process.

Compared with what Cuarón, Lubezki, and their partners at Framestore and Shepperton achieved through the previs process, it quickly becomes

clear why Lubezki might adopt such a tone when discussing the story-board. In collaboration with Framestore, Cuarón and Lubezki were able to 'define the trajectory of the film's action above the Earth', which allowed them to determine accurately how Earth would look in the background of each shot, and also produce a rough previs that contained all of the virtual camera moves.[6] The technical directors at Framestore were then able 'to produce the lighting design of every virtual sequence in the film', laying the foundation for a detailed 'techvis', which effectively combined the previs and lighting information in order 'to produce camera-movement trajectories and lighting environments for both characters' points of view for use in production'.[7] When principal photography took place at Shepperton studios, the techvis data was used on set 'to produce motion-control camera moves and animated lighting in the LED Box'.[8] The LED box was a structure big enough to suspend an actor within it, walled with square panels of LEDs rigged in such a way as to allow the performer to be almost fully enclosed in the cube, with just a gap left open for the camera to shoot through. The LED box allowed Cuarón and Lubezki to review pro-filmically the intended lighting of each sequence involving the actors (Sandra Bullock and George Clooney), while enabling the actors to respond to the intended lighting by making nuanced adjustments to their performance, such as squinting or shielding their eyes, that would otherwise be difficult to anticipate by working with conventional green screen methods. While perhaps an extreme example, the use of previs during the production of *Gravity* highlights the ways that film-makers stand to benefit from the use of pre-visualisation technologies.

Previs has proven its worth not only in the realm of digital special effects, but also as a useful step in the planning of practical effects. During the pre-production of *War Horse* (2011), a sequence was sent for previs design to Mark Austin, then Head of Animation at the pre-visualisation specialists The Third Floor. In this sequence, the camera was required to push back into a trench, allowing room for a horse to charge past. Austin reflects:

> I found myself backing through the trench wall. We were working to scale blueprints of the set being constructed in England, and when I asked how to proceed they asked how deep an alcove I would need. Marking the blueprint with the camera position, the changes were sent to England for the modification of the practical set, thus avoiding what would have been days of delay with full crew standing about waiting.[9]

In keeping with the centrality of storyboarding in Steven Spielberg's earlier film projects (see Chapter 6), Austin adds:

> the storyboard/previs artist collaboration was truly cohesive. We worked in one single room together. The board artist did phenomenally tight boards really locking down the shots and thus saving us time finding that sweet spot. In return we would provide perspective shots of the set/structure/grouping that he would otherwise have to toil over. It really was the most harmonious team I ever worked with, and I think some of my best work was done because of that dynamic.[10]

Evidently the storyboard continues to be an important document, and storyboard artists remain valued members of the pre-production team, yet it remains to be seen whether the development of alternative digital pre-production processes – most notably previs – will ultimately close down the collaborative spaces that have traditionally been opened up by the storyboard.

One area of contemporary cinema where this may become a particularly pressing concern is animation, where there is 'no "accidental" imagery', and 'consequently, all of its elements take on associative weight, accumulating into a mode of storytelling which self-consciously constructs its formal idioms to work as *saturated* image forms, where character, context and choreography all simultaneously and equally signify meaning'.[11] Such a form therefore requires careful planning and pre-production. While the production pipeline of computer-generated animation is of course heavily reliant on digital technology, hand-drawn and stop-motion animation now also relies heavily on digital equipment, with styluses, tablets, digital cameras, and compositing, colouring, and editing software used to create the required image. Despite this increased digitisation, the storyboard remains a central and valuable pre-production document within the mainstream animation industry.

This persistence of the storyboard is at least partly due to the document's ability to prompt and focus cognition through what Janet Blatter determines to be three distinct phases of storyboard review: 'filmic', 'fictive', and 'directive'. Her article 'Roughing It: A Cognitive Look at Animation Storyboarding' (2007) considers the different ways that storyboards are read depending on the production context. When preparing this article, she followed the work of several anonymised individuals at a studio given the alias BLAST, focusing on a particular story development session that scrutinised the 'workable' nature of the rough storyboards.

Blatter noticed how the different individuals working on the rough boards switched between different modes of cognition throughout the review process.

Blatter describes the first mode as filmic, and in order to review a storyboard from this perspective,

> artists must consider the cognitive issues as filmic continuity (in terms of action), consistency (in terms of location or staging in previous panels) and visual perception (in terms of clarity). In this worktask, artists are affected by the nature of the film medium, the temporal dimension of film, the learned 'conventional' aspects of 'action' within motion pictures.[12]

With this information sufficiently present in the rough storyboard, the reviewers are then able to adopt what Blatter terms a fictive mode of cognition. She qualifies this by noting that in narrative animation, animators 'create a fictive world in part based on their knowledge of how viewers will understand the story as the film unfolds. The narrative can be discussed in terms of having an internal and external logic in both physical and psychological dimensions'.[13] In his book *The Animated Bestiary: Animals, Cartoons, and Culture* (2009), Paul Wells characterises this tension as 'the *Madagascar* problem' – a reference to the 2005 DreamWorks film – noting that: 'animated animal narratives essentially remain coherent and plausible so long as they retain the inner logic that informs the anthropomorphic intentions and outlook of the characters, but they fail more readily if they do not manage to accommodate what simplistically may be called recognizably true animal actions, behavior, and primal motivation'.[14] When reviewing a rough storyboard in this fictive manner, the artists will make simultaneous use of the filmic register in order to make their evaluations (much like the *apparent* editorial process discussed in Chapter 2 in relation to Disney's 1928 short *Plane Crazy*, whereby the second stretchy dachshund gag was likely omitted because it challenged the believability of the fictive space). In describing the directive mode, Blatter highlights the problematic depictions of storyboard review (as a linear process) that feature in popular how-to and industry publications, noting that 'unlike the *ideal* presented in manuals, studio animation *practice* is messier'.[15] In the directive mode, those reviewing the rough storyboard do so with a focus divided between differing production demands. In short, 'the rough storyboard needs to be "workable" to the director and the cleanup artists with regard to their respective goals' – these goals being both practical

(do we have the resources to achieve this?) and dramatic (is this scene appropriate for our intended audience?).[16] By reading the storyboard in this manner, as a production document that prompts various modes of cognition, Blatter identifies a key reason why storyboarding remains a key stage in the production of animation. However, since the publication of Blatter's article in 2007 the paper-based practices on which her research is founded have been reconfigured and replaced by digital alternatives – such as previs. It will be useful then to consider in more detail how the act of storyboarding has changed at large studios such as Pixar, DreamWorks, and Disney; at LAIKA, a mid-level studio; and at A+C, a small studio with a standing staff of less than ten.

Storyboarding at Pixar

John Lasseter once remarked of computer animation that the 'term CGI is a misnomer – the computer doesn't generate the images. That would be like calling traditional animation Pencil-Generated Imagery. No matter what the tool is, it requires an artist to create art'.[17] Pixar did not become the leading animation studio of the past 20 years by virtue of simply being the first to pursue feature-length computer animation; it achieved this status as a consequence of prioritising storytelling, rather than by fetishising technology.[18] In this sense, much of Pixar's success can be traced back to the storyboarding practices that were employed at the studio prior to and during the production process.

The storyboarding process at Pixar follows closely the practices that were formalised by Disney's story department in the 1930s (see Chapter 2). Joe Ranft, who was Head of Story at Pixar until his premature death in 2005 at the age of 45, once aptly summed up this process in a storyboard that captured several of these practical continuities.[19] Reading horizontally across the board, on the first row Ranft depicts the act of pinning discrete, hand-drawn sketches to a larger board. On the second and third rows we see the storyboard artist reflecting on the constructed sequence, reviewing his own work, which triggers visualised thoughts such as 'acting', 'composition', and 'staging', which in turn prompt him to make changes to the arrangement and content of the individual drawings that are pinned to the larger board. In rows three and four, we see the pitching of the storyboard to the story department (including Lasseter in caricature), which results in numerous changes being made to the storyboard that principally reflect the vision of the studio head. Finally, we see the storyboard artist return to his desk, either to rework the presented sequence or to begin the next.

Despite the striking similarities depicted between past and present approaches to storyboarding, Pixar's practice encourages a more meritocratic environment than was developed at the Disney studio during the 1930s, where, it is widely recounted, Walt Disney expected to have the last word. However, this did change over time, and Disney's largely autocratic approach to collaborative decision-making during animation production dissipated throughout his stewardship of the company, as other ventures such as live-action film-making, television production, and theme park construction competed for his attention. Ranft's representation of Lasseter taking on the Disney role by virtue of being the individual primarily responsible for unpicking the pitched storyboard should not be considered mean-spirited, but rather as gentle raillery between friends and colleagues. In fact, Ranft was a firm believer in the process he depicted. As John Canemaker notes, throughout his career, 'Ranft repeated three mantras to himself, his crews, and his colleagues to encourage them: "Storyboarding is story reboarding." "The journey is the reward." And, most important, "Trust the process."'[20]

Despite the obvious digitality of Pixar's work and the centrality of computer-based processes to it, the hand-drawn paper storyboard retains a position of significance within the production pipeline, reflected in the continuing prominence of storyboards in DVD special features and print publications issued to accompany prominent film releases. From one perspective, this is commercially predictable, and Disney has profited greatly in recent years through its consistent publication of 'archive' and 'making of' coffee-table editions. Alternatively, this repeated focus on the analogue craft of paper storyboarding might also represent a nostalgic attempt by Disney and Pixar to draw connections between the nondigital traditions of hand-drawn animation and the computer-generated present.

Internally, there is also evidence to suggest that those working at Pixar are eager to recognise the value of the storyboarding process. In 2013, while researching this book, we had the opportunity to visit the Pixar studio shortly after the release of *Monsters University* (2013). With production cycles typically lasting upwards of three years, Pixar has a tradition of celebrating the completion of a feature by staging an exhibition of selected pre-production materials within the studio. Alongside the temporary collection of materials relating to *Monsters University* stood a permanent installation, occupying several walls, dedicated solely to the storyboarding process.

Of the items on display, two in particular deserve mention. Under the heading 'Fun Facts', a wooden plaque records 'Storyboards Delivered for

Each Pixar Feature Film (Since We Started Counting)'. Ranging from *A Bug's Life* (1998) through to *Brave* (2012), the number of storyboards created for each film never dropped below 20,000, and peaked with 98,173 during the production of *WALL-E* (2008). This figure might seem monumental, but *WALL-E* endured one of the longer production cycles at Pixar, with the storyboard development starting in a meaningful way in 2004.[21] Furthermore, given the film's non-verbal first half, greater emphasis would have been placed on ensuring that a full sense of character and story could be articulated visually – probably encouraging greater scrutiny and revision during the storyboarding process than might otherwise have been the case.

While many of the digital storyboard pages from *Monsters University* had been printed to form part of the temporary exhibition, the second item worthy of note was a permanent installation featuring a short video originally produced to accompany the DVD release of *A Bug's Life*. In this video we see Ranft in a staged story-pitching session with director Andrew Stanton and story department member Bob Peterson.[22] Standing in a room filled wall to ceiling with large-scale storyboards, Ranft acts out the sequence for his colleagues as he works through the storyboard under review. The sequence in question concerns the introduction of the circus insects, which, in the film, takes place immediately after the protagonist Flik is sent to seek the assistance of larger insects to help the ants defend themselves from the villainous grasshoppers. Throughout this sequence we see Ranft, Stanton, and Peterson act out the switches between filmic, fictive, and directive modes of review that most likely occurred when the sequence was originally pitched. On a filmic level, Stanton interrupts Ranft's fictive narration, suggesting how the staging of Heimlich's entrance could be revised to enhance the sequence's physical comedy. Stanton's suggestion also reflects a simultaneous directive assessment of what the intended audience – largely a juvenile and family demographic – might find humorous. Later in this sequence we see the trio pause to debate which candy would be the funniest for a fly to hold, with Red Vines and sombrero JuJu Beans considered before the original suggestion of Candy Corn is accepted. In each of these instances the storyboard establishes a shared space where creative decisions can be tested from a number of related, yet distinct, perspectives.

Despite the staged nature of this video, it captures the genuine fluidity of story development at Pixar, where a narrative's component parts are tested and reviewed step by step, and also the manner in which the storyboard artist would pitch his vision to the senior production team. Fundamentally, the video demonstrates the importance to the optimal

production of animated film-making of storyboarding, whether paper-based or digital, animation being a medium in which it is not cost effective to animate multiple versions of a scene and then choose the best during the editing process – a luxury enjoyed by many live-action film-makers.

Storyboarding at DreamWorks and Disney

Besides Pixar, DreamWorks and Disney have continued to dominate the animation sector throughout the industry's transition to digital production. Since the year 2000, DreamWorks has released 24 computer-animated features (at the time of publication *Home* [2015] is the most recent), while Disney/DisneyToon have managed 13, the most recent being *Big Hero 6* (2014). Rex Grignon, Head of Character Animation at DreamWorks Animation, views this change positively. Discussing the storyboard review process used in recent years at DreamWorks, where the storyboard artist pitches a sequence on a large screen and each storyboard panel is projected in succession, Grignon argues that 'nothing has been lost with the switch to digital storyboarding; everything that could be done on paper previously can be done just as effectively on screen'.[23] When asked whether the digital pipeline still afforded opportunities to review the storyboard on both a micro and macro level, as was made possible by large-scale paper storyboards, Grignon noted how 'the thumbnail view of the individual storyboard files can allow for an overview-type appreciation, but with the ability to bring each panel up on a large screen in succession, the digital review process goes beyond the paper-based approach'.[24]

However, as evidenced during the production of DreamWorks' recent feature *Penguins of Madagascar* (2014), the usage of digital storyboards remains far from uniform. Samy Fecih, who worked as a character animator during the production of this film, relied on digital storyboards, shared across a private network, to deliver work in a timely fashion from his desk at DreamWorks' India-based animation unit. Significantly, his use of these digital storyboards varied throughout his work on the film. Discussing a sequence in which he animated the character of Private, the comically dim-witted penguin of the group who is unable to resist pressing a button that he should not press, Fecih reveals how he did not use the storyboard at all during this animation. Instead, he took inspiration exclusively from the roughly animated previs: 'When we are launching a sequence we have the previs in 3D, so we see the layout already done, and we're like, "OK, this is what we need to do". And

when I saw it, I had straight away an idea of how it should be and I didn't want the storyboard to influence me.'[25] While a storyboard had been created for this sequence, and had informed the creation of the previs, both the animator and the associated supervisors were comfortable in disregarding it. Here, it is tempting to draw a comparison to traditional live-action film-making practice, as the animation team, much like the live-action crew, recognise that at some stage during the creative process focus must turn away from the storyboard (and all other pre-production documentation – including the screenplay) in order to create space for the desired image to be crafted.

However, Fecih notes that this was an exceptional sequence, and in other instances he relied on the storyboard to help with the complexities of staging. He made use of the storyboard in this manner when animating a sequence involving Private and Skipper, where they interact side by side, with one penguin closer to the 'camera' than the other. As he recalls:

> The angle was very tough, we needed to look at him [Skipper], but still see his [Private's] face at the same time, but we don't want to see just the cheek, we don't just want the corner of the eye, so this shot was super tough, and I looked at it and I didn't feel it. So I looked at the storyboard to see what ideas they had, what was the angle, what was the silhouette, and I tried to work a little bit around it, and on this shot the storyboard was very useful.[26]

The cognitive processes mapped out by Blatter revealingly relate to this digital workflow. Fecih's decision to actively resist the influence of the storyboard in the first example discussed reveals an awareness – conscious or otherwise – on the part of the animator of how the storyboard encourages, and perhaps even drives, certain decision-making processes. Only through an avoidance of the storyboard, and the associated filmic, fictive, and directive modes of cognition, could Fecih be certain that his creative vision would be realised. Yet, in Fecih's second example, we see the continued significance of the storyboard in its newly digital form. Given the continental distances between his Indian base and DreamWorks' main studio base in North America, having instant access to the most up-to-date storyboard files online, and not having to wait for storyboards to be faxed or even posted, Fecih was able to make informed filmic and fictive decisions without having to interrupt his creative momentum. Clearly, the digital production pipeline now in place at DreamWorks serves the studio well.

While Disney now also shares this same commitment to a digitally managed workflow, it remains a more traditionalist studio than DreamWorks, with some artists continuing to make use of paper-based storyboards. According to Jeff Snow, a story department veteran of both the DreamWorks and Disney studios, paper storyboards continue to occupy an important role at Disney. This is especially the case when multiple members of the story team are required to work together on a scene. Snow observes that, conceptually, 'several people working together will still scribble out ideas on paper and assemble them on traditional cork boards, just as has been done from the beginning'.[27] In fact, in Snow's experience, 'there are even still some artists at Disney who draw traditionally and scan their artwork into the computer'.[28]

However, this use of more traditional methods of storyboarding in some quarters should not be interpreted as a sign that Disney constitutes a site of belated resistance in the face of a digital revolution that has already won the day. In a number of ways, Snow is keen to highlight the positives that digital processes can bring to the act – and art – of storyboarding:

> Certainly on a production pipeline, it's much more efficient, as panels no longer have to be collected, numbered and shot for editorial use. The work process is much faster as well. Revisions are much easier and faster as well, for example if there are expressions that would better reflect the acting recording, which was most likely done after the boards themselves, it is an easy thing to go back into a [storyboard] sequence and match acting expressions to the recording. The digital process has given the story artist many more tools to use. Programs such as Photoshop have enabled artists to use pretty much any artistic technique they can conceive of. It's a virtual studio in a box. Additionally, because of the technology, one can easily revise and expand their sequences, thus creating animatics with much more ease, and even providing the ability to time out the boards prior to them even going to editorial. In this way, there exists the ability to realize the sequence in a much more controlled way.[29]

Snow strikes a cautionary note, though, considering what impact this 'Pandora's box' of digital tools might have on the development of story – the storyboard's very raison d'être:

> There exists the potential for so many bells and whistles that it tends to focus filmmakers on the execution of a scene rather than its

content. More and more emphasis has generally fallen on making a pretty story reel, rather than creating a solid story, and often times the efficacy of a scene is obfuscated by its execution.[30]

Clearly, the position and purpose of the digitally reconfigured storyboard is shifting; equally, while there are similarities in the usage of the storyboard at the studios of Pixar, DreamWorks, and Disney, there is no universally agreed practice.

Storyboarding at LAIKA

The capriciousness of digital technology is perhaps best illustrated in the working practices at LAIKA. Founded in 2005, LAIKA is an animation studio specialising in stop motion, and has enjoyed considerable success with the three feature films that it has released to date: *Coraline* (2009), *ParaNorman* (2012), and *The Boxtrolls* (2014). During the production of *Coraline*, a story that the studio adapted from a Neil Gaiman novella, storyboarding practice changed on several occasions. Vera Brosgol, a storyboard artist who has worked at LAIKA on all three of the studio's features, notes:

> When I first started on *Coraline* in 2005 we were working entirely on paper, pinning boards up and pitching them. They would then get scanned to enter the editorial process. After my first few sequences the crew transitioned over to using Wacom Cintiqs for drawing straight into Photoshop, then printing things out and pinning them up to pitch. Then by the end of the production there was no more printing and pinning. We'd pitch at our computers (sometimes even creating our own rough animatics in iMovie if we needed to communicate specific timing) and things went straight into editorial. This was all in the space of two years.[31]

While this might seem unusual, perhaps even counterproductive, it is important to keep in mind that *Coraline* was LAIKA's first animated feature film, and despite the considerable experience that director Henry Selick brought to the production, having previously directed the stop-motion features *The Nightmare Before Christmas* (1993), *James and the Giant Peach* (1996), and the hybrid *Monkeybone* (2001), the studio needed to respond to the changing digital technologies that had become available during the development of *Coraline*. Furthermore, Selick himself was, at that time, making his first foray of any substantial

kind into the realm of computer-generated animation, which culminated in the release of the short *Moongirl* in 2005. It is likely then that the push towards digital production practices would have been felt on at least two fronts: externally, in the shape of industrial convention, and internally from Selick.

When work began on *ParaNorman*, expectations of a digital production pipeline were well established at LAIKA. The increased modularity that this digital environment permitted assisted the development of *ParaNorman* in several important ways. It enabled Brosgol and her fellow storyboard artists to 'work faster, re-use backgrounds and poses, render out lighting suggestions if necessary, and just generally come closer to the finished product than ... with just pencil sketches on paper'.[32] In relation to *ParaNorman*, the ability to integrate the storyboarding process with previs allowed the storyboard artists to make use of the 'real' backgrounds being created by the previs department. On this point, Brosgol suggests: 'not only do we save time by not drawing complicated backgrounds, but we also don't risk giving the camera department a storyboard with an impossible angle that they then have to problem-solve. The more information we can get in our boards for production, the better – that's what they're for, after all'.[33] Blatter focuses solely on the role of storyboard in her work, choosing to ignore the role of previs, which was increasingly used by the mid-2000s. However, had she sought to anticipate the relationship between storyboard and previs, the resulting impression would surely resemble the working practice described by Brosgol. At the heart of Brosgol's description of this integrated workflow lies an appreciation of when and how storyboarding and previs can be most useful; while both the storyboard and previs open up useful spaces in which to explore filmic and fictive considerations, it is now arguably previs that best serves the directive review process.

This integration of digital assets – between storyboard and previs files – also increased the speed and accuracy at which Christopher Murrie, the film's editor, could keep the story development moving. Unlike on a live-action film where editing is typically restricted to post-production, editing can occur throughout production on an animated project, with very rough story sketches through to approved stills all helping to refine story development. Murrie comments:

I'll get storyboards and two days later we'll have a cut and I'll show it to the directors and we'll change things and that loop goes around and around and around. All the while, I'll start taking boards and

cutting them up and putting them together – combining angles, widening a shot. I become an adjunct to the story department, I get to play cinematographer, I get to play director a little. We might cut the whole film two or three times over before we start shooting, which is fantastic for an editor. You get to cut the film you want to make. You aren't stuck with any poorly planned shots. If I want the coverage, I just ask for it to be drawn.[34]

Crucially, the activity described here by Murrie is best supported by the digital and modular storyboarding described previously. Only when storyboard artists such as Brosgol are able to *draw* directly from, and on, previs-generated backgrounds is Murrie able to truly avoid poorly planned shots. Clearly, on a broader conceptual level, Murrie's chosen phraseology when remarking about 'coverage' evokes a practice much more commonly associated with live-action film-making, serving to reveal the degree to which the boundaries of animation and live-action have blurred in this digital age.

In the sequence detailed across **Figures 7.1–7.5**, which depicts the market scene from *The Boxtrolls* that leads to Eggs and Winnie meeting for the first time, we get a clear sense of the expanded storyboarding process now employed by LAIKA.

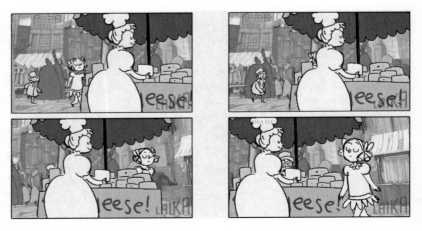

Figure 7.1 A sequence of storyboards produced by Vera Brosgol at LAIKA for *The Boxtrolls* (2014). Image provided courtesy of LAIKA

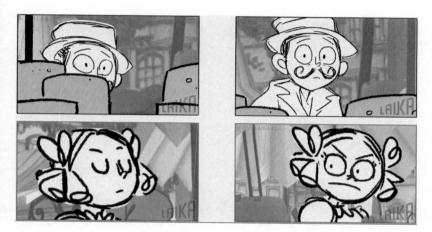

Figure 7.2 A sequence of storyboards produced by Vera Brosgol at LAIKA for *The Boxtrolls* (2014). Image provided courtesy of LAIKA

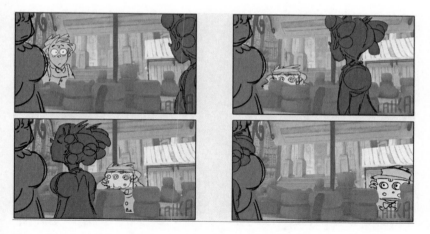

Figure 7.3 A sequence of storyboards produced by Emanuela Cozzi at LAIKA for *The Boxtrolls* (2014). Image provided courtesy of LAIKA

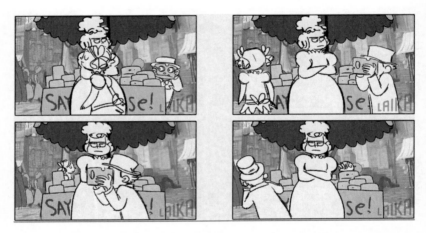

Figure 7.4 A sequence of storyboards produced by Vera Brosgol at LAIKA for *The Boxtrolls* (2014). Image provided courtesy of LAIKA

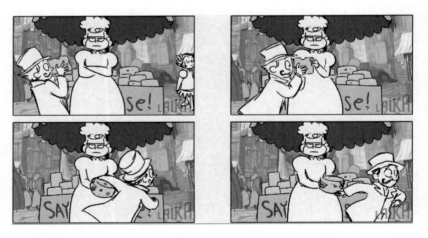

Figure 7.5 A sequence of storyboards produced by Vera Brosgol at LAIKA for *The Boxtrolls* (2014). Image provided courtesy of LAIKA

In all of the panels across **Figures 7.1–7.5**, the storyboard artists Brosgol and Emanuela Cozzi made use of rough computer-generated backgrounds, greatly enhancing the speed at which they could produce the sequence of images. Furthermore, the sequence reveals an appetite during pre-production to plot carefully the movement of Eggs as he comically stalks Winnie past a cheese stall. Brosgol and Cozzi did not work together on these images; rather, Cozzi's contribution is contained within the panels of **Figure 7.3**, which represents an additional page of storyboard coverage, most likely requested to further detail Eggs's movements as he grabs a block of cheese to hide his face – a moment that is minimally defined in the action presented in Brosgol's boards. Beyond the shared digital background, upon which Brosgol and Cozzi both work, this division of labour can be clearly seen in the contrasting illustration styles of the two storyboard artists, with Brosgol favouring a uniform black on white aesthetic with bold, economical pen strokes, while Cozzi adopts greyscale shading to distinguish between foreground and middle ground characters, and also favours a more finely detailed line style. Unsurprisingly, during the production of their most recent feature, LAIKA adopted a cloud-based file-sharing system, similar to those employed at the other major studios such as Disney, DreamWorks, and Pixar, to better manage the increased flow of work between departments – of which the expanded storyboarding processes described are just the tip of the iceberg.

Storyboard productivity at LAIKA has increased dramatically, with the 82,000 storyboards created for *ParaNorman* easily surpassed by the 269,561 created during production on *The Boxtrolls*.[35] It is impossible to know for certain if this increased use of storyboard pages in LAIKA's latest feature is a direct result of the greater speed with which storyboards can be created, revised, and shared in a fully digital production environment; an alternative possibility is simply that a greater focus has been placed on refining story in the face of increasing commercial pressures. However, it is tempting to make a connection between the digital working environment and the increased use of storyboards given the developments at Pixar, where the 227,246 boards for *Monsters University*[36] represents a large increase on the numbers produced for their earlier films, and at DreamWorks, who passed 100,000 storyboards on both *How to Train Your Dragon 2* (2014)[37] and *Penguins of Madagascar*.[38]

Storyboarding at A+C

While it is possible that there may be a complete shift away from paper-based storyboarding at the large U.S. studios such as DreamWorks, Disney, Pixar, and LAIKA over the coming years, it seems likely that paper-based storyboards will continue to be an integral part of the digital animation production pipeline at smaller studios. With a standing staff of less than ten, UK-based animation studio A+C face the constant challenge of having to court commercial sector work in order to keep the studio's balance sheet healthy, whilst keeping the production of the studio's first animated feature moving forward.[39] Therefore, compared with the studios discussed above, which are able to dedicate a large crew to the production of one feature, the A+C crew will, at times, be working on several projects simultaneously. Faced with these pressures, it is the paper-based storyboard, rather than the purely digital equivalent, that A+C favours.

As seen in **Figures 7.6–7.7**, the wall-mounted storyboards provide a fixed location for crew members to review and amend the planned work as it develops, and, because A+C's production cycles can be relatively short (anywhere between as little as a few days for a motion graphic brief, and up to eight weeks for stop motion work), the speed and economy of editing paper-based storyboards compared to a digital alternative fits perfectly with the studio's production profile.

Figure 7.6 A wall-mounted storyboard sequence at A+C Studios, taken by Chris Pallant in 2014. Permission courtesy of A+C Studios

Figure 7.7 A wall-mounted storyboard sequence at A+C Studios with Studio Head Dan Richards pictured, taken by Chris Pallant in 2015. Permission courtesy of A+C Studios

The boards pictured in **Figures 7.6–7.7** were all created digitally, both in terms of the studio template and the images contained within the individual frames. Once mounted on the studio walls, however, the boards allow handmade markings to be recorded and viewed by the entire team in a centralised manner, facilitating decisions such as whether to illustrate the approved image, remove it, or make some other edit to the frame.

Stuart Clark, Head of Production at A+C remarks:

> Because we are always working as a team, [on] most of the projects we do we will each be doing a scene. If it's a 2D animation or if it's a stop motion, then I'll be working on the post, but I might need to know in the edit what goes together where, and then if I need to discuss it with someone it is easy to just point at the wall and say, 'well I don't understand how that's meant to be linking with that, and the script doesn't really quite tell me', rather than get them to have to fish it out on their computer or me fish it out on mine.[40]

Returning to the critical framework mapped out by Blatter, A+C's decision to continue to use paper-based storyboards, albeit created digitally, represents a directive-orientated decision. Evidently, the team at A+C recognise the benefits of having paper storyboards present during

production, because they not only transform an area of the studio into one that facilitates filmic and fictive discussion, but also provide the studio management with a macro-level impression of how production is progressing, and how best the studio's limited resources might be deployed. The management of physical resources is an acute concern for stop motion studios regardless of whether they operate on a small scale, such as A+C, or a much larger scale, as is the case for Aardman. In an interview with Paul Ward, Richard Phelan, a storyboard artist for Aardman, notes: 'The differences between 2D, CG, and Stop-Motion often come into effect later in the boarding process as the initial pass is an attempt to make the story as good as possible. Afterwards we will then go through the boards to look for things like: what sets are needed, number of puppets, camera movements, etc. and make amendments.'[41]

A fusing of the processes identified by Blatter became particularly apparent during A+C's production of the stop-motion short film *Brick Bowl* (2015). Having moved to a new, larger studio at the end of 2014, the studio's Head and Creative Director Dan Richards decided that A+C needed a project to make a big media impact early in 2015 to put the studio's newly increased production capabilities in the shop window. Understanding the global appeal of the Super Bowl adverts, Richards set himself and his team a challenge to make Lego-brick versions of them: 'to produce between 1–3 minutes of animation, based on the adverts, and which would be completed, from initial ideas, through storyboarding, set building, animation, post-production, and final edit, within 36 hours'.[42] While the decision to impose a fixed time limit on the production cycle echoes challenges such as the 48hr Film Project (a rolling, international short-form film competition that was established in 2001), Richards would have also understood the need to release the short while the Super Bowl ads were still attracting attention across mainstream and social media. If this brief was not already challenging enough, Richards also made the decision to work entirely with Lego bricks to produce the animation. Central to the success of this project was the storyboard.

Situated centrally in the studio, the storyboard (**Figure 7.7**), digitally produced by Josh Hicks and Dayle Sanders, served as the guide for all aspects of the production, and was continually updated by Richards, by hand, as each advert-inspired sequence was completed. The Super Bowl adverts were not simply strung together, however, as Richards and Hicks actually worked to translate elements of each advert into a new overarching narrative. Speaking to *Wired*, Richards notes how this initial process 'held up the whole production', meaning that the 'writing and storyboarding team were under pressure from the start, with a whole

crew waiting to build, animate and complete post-production'.[43] Once completed, however, the storyboard pages were printed and centrally wall-mounted; in addition, copies of individual sequences were wall-mounted in the relevant production stations throughout the studio.

An example of this appears in **Figure 7.8**, where several storyboard pages can be seen on the wall and also on the animation rostrum, thereby occupying the same physical space as the animation production, which sees Clark (foreground) supervising a scene involving a Lego version of *Breaking Bad's* Walter White. First-hand observation of the process depicted in **Figure 7.8** revealed that Clark and animator Dave Cubitt shifted rapidly between the filmic, fictive, and directive modes described by Blatter, repeatedly returning to the surrounding storyboard pages for reference. On a filmic level, Clark and Cubitt paused to consider how best to animate the snowballed protagonist's entrance into the pharmacy staffed by White – focussing on questions such as continuity of motion and how best to light the action. On a fictive level, Clark posed questions to Cubitt concerning the pharmacy's sliding doors, revealing a desire to have the doors open in a believable fashion. Lastly, on a directive level, the challenge of working with Lego prompted a continual re-evaluation of any proposed action in terms of whether this would be possible with the Lego resources available – in this sequence, the size

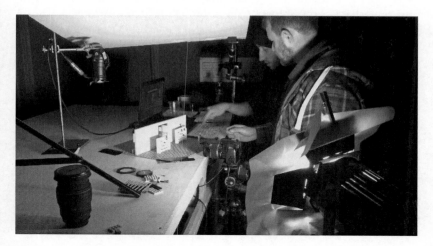

Figure 7.8 Storyboards being consulted during the animation process, with Head of Production Stuart Clark (foreground) and animator Dave Cubitt (background) pictured, taken by Chris Pallant in 2015. Permission courtesy of A+C Studios

of the snowball was dictated by the amount of available Lego bricks that matched the established colour palette. Throughout A+C's work, and especially during the making of *Brick Bowl*, digitally produced storyboards, combined with wall mounting and hand marking, rather than previs, remain the preferred method by which to manage the studio's production process.

In the context of pure animation production, whether at a large, medium, or small studio, the storyboard remains a key document despite the transformations in working practices inspired by new digital technologies. As this chapter has highlighted, in the context of narrative animation this is directly related to the fact that the storyboard remains the best document through which to define what Wells terms 'micro-narratives'. Cleary, the storyboard supports the production team's '"micro-narrativisation", the identification of the minutiae in story expression, particularly on visual and conceptual terms, as the core principle in animated narrative development and accumulation'.[44] However, what has become clear through interviews and archival research is that the concept of *what* exactly a storyboard is – and can be – varies dramatically. Within the animated medium more specifically, the storyboard, whatever shape it might take, seems set to continue being a central pre-production and production document. Moreover, it is within animation discourse, both popular and academic, that the greatest strides have been taken to recognise storyboard illustration as an art in its own right. This is perhaps a reflection of the more easily demonstrated value of line-based illustration, in the form of storyboards, to the development of moving image texts which, until the late twentieth century and the introduction of new computer orthodoxies, were visibly animated by hand – through either stop motion or drawn processes.

In the realm of live-action cinema, with its attendant preoccupation with the photographic image, the tradition of celebrating the contributions of storyboard artists is less well established. However, if the online circulation – and celebration – of storyboard images from both animated and live-action productions is any guide, then the numerous image-heavy forums, boards, and blogs suggest that the tide has turned. Nonetheless, the future usage of the storyboard in live-action production looks uncertain. Where animation and live-action meet, in the service of creating digital effects, the position and purpose of the storyboard is becoming increasingly eroded by the use of digital previs.

Conclusion

What pressures might redefine the storyboard in the not-too-distant future? The storyboard's current form has been shaped by the comparatively passive and classically linear experience of cinematic narrative; yet with the increasing popularity, profitability, and critical acclaim surrounding the modern video game, it is perhaps this moving image medium that may exert the greatest influence over the future development of the storyboard.[1] With growing frequency, action-based feature films – particularly stereoscopic releases – include sequences that might be mapped directly into a companion video game. An example is the sweeping barrel escape in Peter Jackson's *The Hobbit: The Desolation of Smaug* (2013), which features as the 'Barrels out of Bond' level in the video game *LEGO: The Hobbit* (2014). While such crossovers seemingly originate in the cinematic domain, with the film typically released before the game, it is clear that film-makers working in mainstream cinema are increasingly – and understandably – looking to video games for direction, and not the other way around. This raises an important question regarding the future role of the storyboard in such a cross-media system, because the storyboard is a much less widely used pre-production and production document in video game development.

While narrative progression is a key concern for many game designers, which is reflected in the increasingly nuanced story worlds of games such as *Bioshock* (2007), *Red Dead Redemption* (2010), and *The Last of Us* (2013), player experience is the greatest concern during production. Game designer Robin Walker, discussing the development of the multiplayer first-person shooter *Half-Life 2* (2004), reframes the importance of a strong beginning in experiential rather than narrative terms:

> In imagining a video game in development out in the world, I sometimes envision a downward sloping curve, with players on the Y axis

and time in game along the X axis. As you move along the X axis over time, players drop out of your game. Some will give it one minute, less will give it one hour, significantly less will finish the game entirely. So that first minute is experienced by the largest percentage of people playing your game and so therefore is the most important. By building this first minute last, once most of the other unknowns are sorted out, the *Half-Life 2* team was able to benefit from the process of making the game itself to emphasize what is arguably the most important part of the overall experience – the beginning.[2]

Such a reframing of the importance of the beginning will surely prompt interest amongst those familiar with the narrative models often championed by professional screenwriters, screenwriting gurus, and scholars of the screenplay form. From Aristotle to Robert McKee, the linearity of the three-act structure faces a considerable challenge from the growing influence of digital interactive narrative design.

With the graphical capabilities of modern computer technology it is easy to imagine a near future where films are visually designed through an interactive digital space. Video game developers begin to work almost immediately on fashioning the play space, incrementally adjusting it, testing parameters, stability, appeal, until the three-dimensional world found in the game is satisfactorily defined, and with the ability to update these worlds through further downloadable updates, this refinement is now often only barely achieved by the release date. From an early stage in this development process these worlds are three-dimensional, and while they might not feature fully modelled assets or final textures, the developers are able to explore the possibilities of this space. While previs already offers the filmmaker a three-dimensional vision of the yet-to-be-created film world, previs is rarely interactive, rather taking the shape of a rough computer animation experienced along a linear timeline, with the ability to scrub either backwards or forwards through time. A tantalising convergence therefore appears inevitable: the locations and shot setups might be modelled in a three-dimensional space akin to that seen in previs, but movement through this space could remain dynamic, allowing the implied camera to move from shot to shot, but at the same time allowing visual designers to manipulate the mise-en-scène, framing, lighting, and potential lens selection on the fly. Such a digital pre-production space would almost certainly prompt a rethinking of the role of the storyboard.

The profound modularity of the digital domain poses perhaps the greatest challenge to the continued utility of the more traditional

models of storyboarding that have provided the focus of this book. Massive, online 'remix' sites offer a good example of where this is already starting to become the case. To date, it has been the storyboard that has frequently provided the most elegant means by which to collate, revise, and record a range of pre-production activities: the addition or removal of shots and/or scenes; changes to shot composition, camera movement, and location; and revisions concerning the relationship between the script and the storyboard, with sections of the script easily cut and pasted upon the storyboard.

However, the dynamic framework of the modern website itself has become *the* structuring document for projects such as *hitRECord* and *Star Wars Uncut*. Founded by Joseph Gordon-Levitt in 2004, *hitRECord* is described as 'an open collaborative production company'.[3] Over the past decade the site has grown substantially, and since 2014 has a regular, user-generated content show, hosted by Gordon-Levitt on the U.S. television channel Pivot. However, the main focus of *hitRECord* remains short-form collaborative projects that are planned, developed, and hosted on the website. Although the content of some of the films can be frivolous, a range of projects tackling serious subjects, both past and present, appeared amongst the many collaborations listed on the site in January 2015. For example, one such short from 2010 called 'They Can't Turn the Lights Off', an animation created in support of the challenge to California's 'Proposition 8' state constitutional amendment (2008), which banned gay marriage, appeared in the trending list amongst many newer projects. Writing on her collaboration page, the user responsible for the project, 'The Teafaerie', writes:

> there was a strong public outcry to televise the trial. Yesterday Judge Walker announced the amazing final results on public comments: 138,542 in favor of allowing it to be recorded for youtube, 32 opposed. Nevertheless, today the Supreme court voted 5–4 to block the tubing of the trial. Some people don't want there to be moving visual images from this trial spread around. The transcripts, however, are being microblogged by people with phones in the courtroom. I say they need to be animated.[4]

The initial impact of this animation appears to have been relatively modest, attracting just over 40,000 views on YouTube. However, the short captures through its lyrics a sense of the emergent digital activism that was growing exponentially in the wake of the controversies surrounding the WikiLeaks leaking of sensitive military documents: 'the

remix culture climbed aboard, and they wrote a script and they hit record, and all around the world the trial at last was shown'. User interest on *hitRECord* developed, and in 2012 a sequel was produced collaboratively, again focussing on the abuse of civil rights by the US government, which ultimately screened at the Sundance Film Festival later that year. Indeed, during the final preparations of this book the Supreme Court ruled in favour of making same-sex marriage a right throughout the United States of America.

The appeal of this site lies in its ability to resist the conventions of past production, with any element – a sentence, words, a word, or even a font – capable of sparking the imagination of another user, who might then share a melody, an image, or another sentence within the same collaborative pool. Soon, these fragments begin to be shaped into larger works; but, crucially, not immediately into one singular creation. Multiple works drawing from the same constituent ingredients might very easily take shape in parallel, without entering into competition with one another. In such a creative ecosystem the storyboard – which, despite its potential modularity, is often used to fix information into a singular serial form – is likely to play only a limited role. Examples of storyboard design are few and far between on *hitRECord*, as contributors jump straight to *doing* rather than *planning*, finding creativity in the misadventures of a potentially chaotic process rather than via the more structured and linear methods associated with more traditional forms of audiovisual production.

Slower in terms of production activity, but no less collaborative, is the *Star Wars Uncut* project started by Casey Pugh in 2009. Described by Pugh as 'a crazy fan mashup remake of the original Star Wars movies', *Star Wars Uncut*, which won an Emmy for Outstanding Creative Achievement In Interactive Media in 2010, offers a novel method of re-imagining the original 1977 film, with significant implications for the conception of storyboarding.[5] In order to allow anyone with access to the Internet and basic recording equipment to contribute to the mashup remake, Pugh divided the film into 15-second segments, irrespective of scene content, and then invited contributors to 'claim' a segment. After reviewing the submissions with a panel of judges the film was cut back together with the original musical score maintained underneath to provide a sense of continuity. In Pugh's own words the 'resulting movie is equal parts fun, kooky, and dearly nostalgic'.[6]

Beyond the modular method through which Pugh sourced contributors, the visual means by which he represented this on the website, with 480 stills from the film presented from left to right across six columns

and 80 rows, evokes some of the storyboards discussed in this book. Yet this arrangement moves beyond the traditional limits of the storyboard, because by dragging the mouse across each individual still, from left to right, it is possible to see a rough key-frame breakdown of the content within that 15-second sequence. Presenting the project in such a way effectively returns the film's final imagery to the status of storyboard panels, albeit of a more interactive variety. Seeing the film presented in this way also evokes comparisons with the colour boards and mood boards that are often produced during the production of animated features. Such boards serve a highly specific function, attempting to plot the 'feeling' of a film over its duration via the use of repeated colour association. Mood boards are most useful when viewed at a smaller size than storyboards so that the reviewer can gain a quick impression of the colour changes throughout a project as a whole. Unlike the example of *hitRECord* where the future of the storyboard looks uncertain, if there is to be a storyboard 2.0 then it might well take a form similar to the dynamic web layout used by Pugh: facilitating mass collaboration through digitally enhanced modularity, yet simultaneously unfixing and fixing the film-to-be as a serial object made up of a sequence of images.

With the abundance of digital alternatives to traditional storyboard practices increasing steadily, it is likely that the storyboard may pass in and out of favour in professional film-making practice, depending on the habits of the director and producer involved. In fact, it is not just the storyboard process that might change as a consequence of the technologies now available: the role of the location scout may also be at the point of profound change. The decision made by Wes Anderson to scout the locations for his film *Moonrise Kingdom* (2012) using Google Maps is both eerily reminiscent of – and radically removed from – the approach taken by Stanley Kubrick, who famously had thousands of location photographs (of streets, doorways, and storefronts, amongst other things) taken before filming *Eyes Wide Shut* (1999), so that he could design his locations from the comfort of his own home.[7]

Storyboarding occupies a conflicted position in contemporary audiovisual culture. On the one hand, scholarly interest in the form is currently small but growing, the commercial exploitation of storyboards has never been greater, while from a popular perspective the storyboard has become a surprisingly visible subject – and instrumental plot device – within film and television texts such as *Argo* (2012), where the storyboard for the fake *Argo* film project proves crucial during the film's climatic escape sequence, and *Mad Men* (2007–2015), where storyboards frequently feature during the advertising agency's pitching

sessions. On the other hand, we may be looking at the beginning of the end as far as the instrumentality of the storyboard to moving image production is concerned. In the cinematic domain, digital tools such as previs are starting to occupy much of the ground historically covered by the storyboard and the storyboard artist, while in the increasingly dominant realm of the video game, radically different production processes minimise the utility of the storyboard as a method of managing creative endeavour centrally. Yet sketched-based pre-visualisation will always play a part in moving image production; as long as we live in a world with pens and scraps of paper, sketches will be jotted down. The challenge is to better record this activity and preserve the material texts, so that future scholars interested in the multivalent world of pre-production might have the means by which to take this field of study further.

Notes

Introduction

1. Kristina Jaspers, 'Zur Entstehungsgeschichte und Funktion des Storyboards', in Katharina Henkel, Kristina Jaspers, and Peter Mänz (eds), *Zwischen Film und Kunst: Storyboards von Hitchcock bis Spielberg* (Bielefeld: Kerber, 2012), p. 15. We are indebted to Julia Knaus for all translations from the original German of this book.
2. Jean-Claude Carrière, *The Secret Language of Film*, trans. Jeremy Leggatt (London: Faber, 1995), p. 150.
3. Nathalie Morris, 'Unpublished Scripts in BFI Special Collections: A Few Highlights', *Journal of Screenwriting* 1.1 (2010), pp. 197–198.
4. Fionnuala Halligan, *Movie Storyboards: The Art of Visualizing Screenplays* (San Francisco: Chronicle, 2013), p. 9.
5. Alan David Vertrees, *Selznick's Vision: Gone with the Wind and Hollywood Filmmaking* (Austin: University of Texas Press, 1997), pp. 67, 117.
6. See Steven Price, *A History of the Screenplay* (Basingstoke: Palgrave, 2013).
7. Katharina Henkel and Rainer Rother, 'Vorwort', in Katharina Henkel, Kristina Jaspers, and Peter Mänz (eds), *Zwischen Film und Kunst: Storyboards von Hitchcock bis Spielberg* (Bielefeld: Kerber, 2012), p. 8.
8. Vincent LoBrutto, *The Filmmaker's Guide to Production Design* (New York: Allworth, 2002), p. 62.
9. Halligan, p. 8.
10. John Hart, *The Art of the Storyboard: Storyboarding for Film, TV, and Animation* (Boston: Focal Press, 1999), p. 5.
11. Steven Maras, *Screenwriting: History, Theory and Practice* (London: Wallflower, 2009), p. 120.
12. Maras, p. 123.
13. Kathryn Millard, 'The Screenplay as Prototype', in Jill Nelmes (ed.), *Analysing the Screenplay* (London: Routledge, 2011), p. 156. Millard develops related arguments in 'After the Typewriter: The Screenplay in a Digital Era', *Journal of Screenwriting* 1.1 (2010), pp. 11–25, and in Millard, *Screenwriting in a Digital Era* (Basingstoke: Palgrave, 2014).
14. In addition to Maras and Millard, on this point see also Steven Price, *The Screenplay: Authorship, Theory and Criticism* (Basingstoke: Palgrave, 2010), pp. 46–47.
15. Jaspers, p. 12.
16. Hart, p. 1.
17. Hart, p. 3.
18. Hart, pp. 3–4.
19. See, for example, Andreas C. Knigge, '"Watch Me Move": Über die Beziehung zwischen Storyboards und Comics', in Katharina Henkel, Kristina Jaspers,

and Peter Mänz (eds), *Zwischen Film und Kunst: Storyboards von Hitchcock bis Spielberg* (Bielefeld: Kerber, 2012), p. 18.

20. Michael Farr, *The Adventures of Hergé: Creator of Tintin* (London: John Murray, 2007), p. 59.
21. Farr, p. 73.
22. Jean-Marc and Randy Lofficier, *The Pocket Essential Tintin* (Harpenden: Pocket Essentials, 2002), p. 90.
23. Tony Tarantini interview with Chris Pallant, 25 July 2015.
24. LoBrutto, p. 62.
25. Jaspers, p. 13.
26. Edwin G. Lutz, *Animated Cartoons* (New York: Charles Scribner's Sons, 1920), p. 60.
27. Edward Carrick, *How To Do It Series Number 27: Designing for Films* (London and New York: The Studio Publications, 1949), p. 14.
28. Tony Tarantini, 'Pictures That Do Not Really Exist: Mitigating the Digital Crisis in Traditional Animation Production', *Animation: Practice, Process, and Production* 1.2 (2011), pp. 257–261.
29. Tarantini, p. 258.
30. Rex Grignon interview with Chris Pallant, 16 June 2014.
31. Frank Gladstone interview with Chris Pallant, 2 August 2013.
32. Jaspers, p. 13.
33. Kristina Jaspers, *Zwischen Film und Kunst. Storyboards von Hitchcock bis Spielberg – Exhibition Guide* (Berlin: Deutsche Kinemathek, 2011) p. 6.
34. Accessed 9 January 2015, retrieved from http://www.moleskine.com/gb/collections/model/product/storyboard-notebook-large.
35. All of the these examples are based on the authors' review of the original documents held at the Academy of Motion Picture Arts and Sciences' Margaret Herrick Research Library (MHL).
36. Jaspers, p. 13.
37. Vladimir Nilsen, *The Cinema as a Graphic Art: On a Theory of Representation in the Cinema* (New York: Hill and Wang, 1936); see also Jaspers, p. 3.
38. Jaspers, p. 3.
39. Jay Leyda and Zina Voynow, *Eisenstein at Work* (New York: Pantheon, 1982), p. 24.
40. Halligan, p. 6.
41. Katharina Henkel, Kristina Jaspers, and Peter Mänz (eds), *Zwischen Film und Kunst: Storyboards von Hitchcock bis Spielberg* (Bielefeld: Kerber, 2012).
42. Steve Wilson, *The Making of Gone with the Wind* (Austin: University of Texas Press, 2014).
43. Accessed 10 April 2015, retrieved from http://www.blu-ray.com/movies/Alien-Anthology-Blu-ray/5090/#Review.

1 The Pre-History of Storyboarding

1. Edward Azlant, *The Theory, History, and Practice of Screenwriting, 1897–1920*, diss. (Ann Arbor, MI: University Microfilms International, 1980), p. 65.
2. Ann Martin and Virginia M. Clark, *What Women Wrote: Scenarios, 1912–1929* (Frederick, MD: University Publications of America, 1987), p. v.
3. Martin and Clark, p. vi.
4. For a fuller discussion of the relationship between copyright and early American screenwriting, see Steven Price, *A History of the Screenplay* (Basingstoke: Palgrave, 2013), pp. 36–51.

5. Vivian Halas and Paul Wells, *Halas & Batchelor Cartoons: An Animated History* (London: Southbank, 2006), p. 124–29.
6. Philip Brookman, *Eadweard Muybridge* (London: Tate Publishing, 2010), pp. 86–87.
7. For example: Bruce Kawin's *How Movies Work* (1992), John Hart's *The Art of the Storyboard: Storyboarding for Film, TV, and Animation* (1999) and *The Art of the Storyboard: A Filmmaker's Introduction* (2008), and Wendy Tumminello's *Exploring Storyboarding* (2005).
8. Speaking at the 'Storyboarding: Text-Image-Movement' conference, held at the Deutsche Kinemathek, Berlin in July 2015, Jens Meinrenken, as part of his paper 'Sequential Art: The Relationship between Comic, Storyboard and Film', noted how Méliès's notoriety as a cartoonist contributed to this ambiguity, with the artist willingly responding to requests to reproduce drawings from his films, sometimes many years after their initial release.
9. Due to publisher restraint we are only able to reproduce this image in black and white. This same limitation also prevents the colour reproduction of Figures 1.6, 1.7, 2.1, 3.2, 4.6, 6.3, 6.4, 7.1–7.8.
10. Jacques Malthête and Laurent Mannoni, *L'Œuvre de Georges Méliès* (Paris: Éditions de La Martinière, 2008), pp. 136–203.
11. Harvey Deneroff, 'A Trip to the Moon: Back in Color', *Comments and Thoughts on Animation and Film*, retrieved from http://deneroff.com/blog/2011/05/10/a-trip-to-the-moon-back-in-color/, accessed 10 January 2015.
12. Serge Bromberg and Eric Lange, *La Couleur Retrouvée du Voyage dans la Lune/A Trip to the Moon Back in Color* (no place: Groupama Gan Foundation for Cinema and Technicolor Foundation for Cinema Heritage, 2011), p. 77.
13. Randy Duncan and Matthew J. Smith, *The Power of Comics: History, Form and Culture* (New York: Continuum, 2009), p. 4.
14. Pascal Lefèvre, 'Incompatible Visual Ontologies? The Problematic Adaptation of Drawn Images', in Ian Gordon, Mark Jancovich, and Matthew P. McAllister, (eds), *Film and Comic Books* (Jackson: University Press of Mississippi, 2007), p. 2.
15. Scott McCloud, *Understanding Comics: The Invisible Art* (New York: HarperCollins, 1994), p. 7.
16. McCloud, p. 66.
17. Gilbert Seldes, 'Golla, Golla, the Comic Strips Art! An Aesthetic Appraisal of the Rubber-Nosed, Flat-Footed Little Guys and Faerie Monsters of the Funnies', *Vanity Fair* (May 1922), p. 71.
18. Paul Wells, *Understanding Animation* (London: Routledge, 1998), p. 17.
19. Donald Crafton, *Before Mickey: The Animated Film 1898–1928* (Chicago: University of Chicago Press, 1993), p. 37.
20. Crafton, p. 37.
21. Seldes, p. 108.
22. Crafton, p. 178.
23. David Nasaw, *The Chief: The Life of William Randolph Hearst* (London: Gibson Square, 2002), p. 257.
24. Ibid.
25. Sophie Geoffroy-Menoux, 'Enki Bilal's Intermedial Fantasies: From Comic Book *Nikopol Trilogy* to Film *Immortals (Ad Vitam)*' in *Film and Comic Books*, (eds.) Ian Gordon, Mark Jancovich, and Matthew P. McAllister (Jackson: University Press of Mississippi, 2007), p. 268.
26. Winsor McCay, *Winsor McCay: Little Nemo 1905–1914* (Köln: Evergreen, 2000), p. 33.

x

27. John Canemaker, *Winsor McCay: His Life and Art* (New York: Abbeville Press, 1987), p. 133.
28. McCay, p. 42.
29. Scott Bukatman, *The Poetics of Slumberland: Animated Spirits and the Animating Spirit* (Berkeley: University of California Press, 2012), p. 104.
30. Lefèvre, p. 2.
31. Phil A. Koury, *Yes, Mr. DeMille* (New York: G.P. Putnam's Sons, 1959), p. 26.
32. *The Squaw Man*, 'Full Cast and Crew' *IMDB*, accessed 5 April, 2015, retrieved from http://www.imdb.com/title/tt0004635/fullcredits?ref_=tt_ov_st_sm.
33. Robert S. Birchard, *Cecil B. DeMille's Hollywood* (Lexington: University of Kentucky Press, 2004), p. 21.
34. Robert M. Henderson, *D.W. Griffith: His Life and Work* (New York: Garland Publishing, 1985), p. 201.
35. David A. Cook, *A History of Narrative Film* (New York: Norton, 2008), p. 81.
36. Karl Brown, *Adventures with D.W. Griffith* (London: Faber, 1988), pp. 87–88.
37. Richard Schickel, *D.W. Griffith* (London: Pavilion, 1984), p. 391.
38. Variety Staff, 'Review: "Broken Blossoms – Or the Yellow Man and the Girl"' *Variety*, 31 December 1918, accessed 12 January 2015, retrieved from http://www.variety.com/review/VE1117789562?refcatid=31.
39. Brown, p. 192.
40. Henderson, p. 201.
41. Henderson, p. 201, emphasis added.
42. Brown, p. 226.
43. Schickel, p. 391.
44. Dan Torre and Lienors Torre, 'From Animated Sketches to Animation Empire: The Pioneering Years of Australian Animation (1900 – 1930)', forthcoming in *Senses of Cinema* 77 (November 2015).
45. Vladimir Nilsen, *The Cinema as a Graphic Art* (New York: Hill and Wang, 1936), p. 159.
46. Jay Leyda and Zina Voynow, *Eisenstein at Work* (New York: Pantheon, 1982), p. 36.

2 Storyboarding at Disney

1. Ronald Haver, *David O. Selznick's Hollywood* (New York: Knopf, 1980), p. 246.
2. Christopher Finch, *The Art of Walt Disney: From Mickey Mouse to the Magic Kingdoms* (New York: Harry N. Abrams, 1973), p. 82.
3. Instructions, *Disney Story-boards* (London: Paul Lamond Games, 1991), np.
4. Pinocchio Card A1, *Story-boards*.
5. For example, Michael Barrier's *Hollywood Cartoons: American Animation in its Golden Age* (1999) and *The Animated Man: A Life of Walt Disney* (2008), Richard Holliss and Brian Sibley's *The Disney Studio Story* (1988), and Richard Schickel's *The Disney Version: The Life, Times, Art and Commerce of Walt Disney* (1997).
6. For consistency, the compound form 'storyboard' will be used from this point forward.
7. John Canemaker, *Paper Dreams: The Art and Artists of Disney Storyboards* (New York: Hyperion, 1999), p. 8 (emphasis added).
8. Canemaker, p. 8.
9. Leslie Iwerks and John Kenworthy, *The Hand Behind the Mouse* (New York: Disney Editions, 2001), p. 56.

10. Canemaker, p. 8.
11. Michael Barrier, *The Animated Man: A Life of Walt Disney* (Berkeley: University of California Press, 2008), p. 73.
12. Barrier, p. 73.
13. *Steamboat Willie* and *Mickey's Good Deed* storyboards can be found in Canemaker (1999), pp. 9–12, while complete storyboard pages for *When the Cat's Away* are featured on the blog *Classic Cartoons*, under the 3 April, 2008 post 'Assorted Disney's rarities!': http://classiccartoons.blogspot.co.uk/2008/04/assorted-disneys-rarities.html
14. Michael Barrier, *Hollywood Cartoons: American Animation in its Golden Age* (Oxford: Oxford University Press, 1999), p. 68.
15. Barrier, *Hollywood Cartoons*, p. 72.
16. Diane Disney Miller, *The Story of Walt Disney* (Henry Holt, New York, 1958), p.123.
17. Barrier, *The Animated Man*, p. 105.
18. Richard Schickel, *The Disney Version: The Life, Times, Art and Commerce of Walt Disney* (Chicago: Ivan R. Dee, 1997), p. 148.
19. Barrier, *Hollywood Cartoons*, p. 116.
20. Barrier, *Hollywood Cartoons*, p. 116.
21. Allan Neuwirth, *Makin' Toons* (New York: Allworth Press, 2003), p. 93.
22. Matt Stahl, 'Cultural Labor's "Democratic Deficits": Employment, Autonomy and Alienation in US Film Animation', *Journal for Cultural Research* 14.3 (2010), p. 282.
23. Matt Stahl, 'Non-Proprietary Authorship and the Uses of Autonomy: Artistic Labor in American Film Animation, 1900–2004', *Labor* 2.4 (2005), p. 103.
24. For a more comprehensive study of the impact of Frederick Winslow Taylor's *Principles of Scientific Management* (1911) on animation production see: Donald Crafton's *Before Mickey: The Animated Film, 1898–1928* (1982).
25. Stahl, Non-Proprietary Authorship, pp. 87–88.
26. Stahl, p. 100.
27. Neuwirth, p. 94.
28. Neuwirth, p. 59.
29. Mark Langer, 'Animatophilia, cultural production and corporate interests: the case of "Ren & Stimpy"', *Film History* 5.2 (1993), p. 125.
30. Paul Wells, 'Boards, beats, and bricolage: Approaches to the animation script', in Jill Nelmes (ed.), *Analysing the Screenplay* (London: Routledge, 2011), p. 94, emphasis in original.
31. John Lasseter, 'Tell Me A Story', in *Walt Disney Animation Studios – The Archive Series: Story* (New York: Disney Editions, 2008), p. 8.
32. Steven Watts, *The Magic Kingdom: Walt Disney and the American Way of Life* (Columbia: University of Missouri Press, 1997), p. 66.
33. Barrier, *The Animated Man*, p. 110.
34. Disney Advert, *Motion Picture Herald*, October 1, 1932.
35. Bob Thomas, *Walt Disney, the Art of Animation: The Story of the Disney Studio Contribution to a New Art* (New York: Simon & Schuster, 1958), p. 53.
36. Barrier, *Hollywood Cartoons*, p. 215.
37. Canemaker, pp. 116–117.
38. Canemaker, pp. 114–118.
39. Canemaker, p. 115, emphasis added.
40. Watts, p. 191.

41. Watts, p. 191.
42. Barrier, *Hollywood Cartoons*, p. 218.
43. Paul Wells, *The Fundamentals of Animation* (Lausanne: AVA, 2006), p. 88.
44. Paul Ward, 'Some Thoughts on Practice-Theory Relationships in Animation Studies', *Animation: An Interdisciplinary Journal* 1:2 (2006), p. 233.
45. Chris Pallant, *Demystifying Disney: A History of Disney Feature Animation* (New York: Continuum, 2011), p. 42.
46. Neal Gabler, *Walt Disney: The Triumph of the American Imagination* (New York: Alfred A. Knopf, 2006), p. 292.
47. Watts, p. 397.
48. Watts, pp. 397–398.
49. Watts, p. 398.
50. 'Previs', rather than 'previz' (which is the more common spelling in the United States) will be used in this study as the abbreviation relating to the digital previsualisation process.

3 William Cameron Menzies, *Alice in Wonderland,* and *Gone with the Wind*

1. Unless noted, quotations from David O. Selznick's memos are from Rudy Behlmer, (ed.), *Memo from David O. Selznick* (New York: Viking, 1972).
2. Scott Curtis, 'The Last Word: Images in Hitchcock's Working Method', in Will Schmenner and Corinne Granof, (eds), *Casting a Shadow: Creating the Alfred Hitchcock Film*, p. 21. Fionnuala Hughes similarly remarks as recently as 2013 that the film was 'completely storyboarded' (p. 20).
3. Alan David Vertrees, *Selznick's Vision:* Gone with the Wind *and Hollywood Filmmaking* (Austin: University of Texas Press, 1997), p. 59.
4. Scot Holton and Robert Skotak, 'William Cameron Menzies: A Career Profile', *Fantascene* 4 (1978), p. 5.
5. Paul Rotha, 'The Art Director and the Composition of the Scenario', *Close Up* (May 1930), pp. 379–380.
6. David Bordwell, 'William Cameron Menzies: One Forceful, Impressive Idea', March 2010, accessed 24 January 2015, retrieved from http://www.davidbordwell.net/essays/menzies.php#_Ednref9.
7. Richard Sylbert and Sylvia Townsend, *Designing Movies: Portrait of a Hollywood Artist* (Westport, CT: Praeger, 2006), p. 34.
8. Bordwell, op. cit.
9. Charles Higham, interview with James Wong Howe, *Hollywood Cameramen: Sources of Light* (Bloomington: Indiana University Press, 1970); quoted in Sylbert, p. 32.
10. Ezra Goodman, 'Production Designing', *American Cinematographer* (March 1945), p. 82.
11. *Alice in Wonderland* – script (undated), Norman Z. McLeod papers, MHL, 1.f–2.
12. *David Copperfield* (MGM, 1935), screen play by Howard Estabrook, adaptation by Hugh Walpole, 8 September 1934, BFI S5237.
13. For a discussion of the use of this form in Hollywood films of this period, see Steven Price, *A History of the Screenplay* (Basingstoke: Palgrave, 2013), pp. 149–151.
14. *Alice in Wonderland* – script, William H. Wright papers, MHL, 2-f.8, 2-f.9, 2-f.10, 2-f.11. Pages 277–356 are missing from the collection.

15. Vertrees, *Selznick's Vision*; Steve Wilson, *The Making of* Gone with the Wind (Austin: University of Texas Press, 2014). In addition, very informative studies are provided in Rudy Behlmer's audio commentary accompanying the 65th Anniversary DVD release in 2005, and the made-for-television documentary *The Making of a Legend: Gone With the Wind* (1988), written by David Thomson, also included in the 2005 DVD release. Factual information in the following discussion is derived from these sources. Unless noted, quotations from David O. Selznick's memos are from Rudy Behlmer, (ed.), *Memo from David O. Selznick* (New York: Viking, 1972).
16. *Gone With the Wind: The Making of a Legend*, 1988 TV movie.
17. Vincent LoBrutto, *By Design: Interviews with Film Production Designers* (Westport, CT: Praeger, 1992), p. xii.
18. Vertrees, p. 203.
19. Vertrees, p. 18.
20. p. 59.
21. Quoted in Vertrees, p. 60.
22. Quoted in Rudy Behlmer, (ed.), *Memo from David O. Selznick* (New York: Viking, 1972), p. 151.
23. Quoted in Behlmer, p. 152.
24. Quoted in Behlmer, p. 152.
25. Quoted in Alan David Vertrees, 'Reconstructing the "Script in Sketch Form": An Analysis of the Narrative Construction and Production Design of the Fire Sequence in *Gone with the Wind*', *Film History* 3 (1989), p. 100, n. 5.
26. Vertrees, p. 55.
27. Wilson, p. 104.
28. Commentary written by David Thomson for the TV movie *The Making of a Legend: Gone with the Wind*.
29. Quoted in Thomson, ibid.
30. Thomson, ibid.
31. Vertrees, *Selznick's Vision*, p. 46.
32. Thomson, op. cit.
33. Alan David Vertrees, 'Reconstructing the "Script in Sketch Form": An Analysis of the Narrative Construction and Production Design of the Fire Sequence in *Gone with the Wind*', *Film History* 3 (1989), p. 91.
34. Steve Wilson, *The Making of* Gone with the Wind (Austin: University of Texas Press, 2014).
35. Email correspondence between Steve Wilson and Steven Price, January 2015.
36. Kristina Jaspers, 'Zur Entstehungsgeschichte und Funktion des Storyboards', in Katharina Henkel, Kristina Jaspers, and Peter Mänz (eds), *Zwischen Film und Kunst: Storyboards von Hitchcock bis Spielberg* (Bielefeld: Kerber, 2012), p. 15
37. Quoted in Vertrees, *Selznick*, p. 60.
38. Frank S. Nugent: 'Gone with.' Etc – or the Making of a Movie, in: The New York Times Magazine, 10 December 1939, p. 17; quoted in Jaspers, p. 16. The photograph is reproduced in Katharina Henkel, Kristina Jaspers, and Peter Mänz (eds), *Zwischen Film und Kunst: Storyboards von Hitchcock bis Spielberg* (Bielefeld: Kerber, 2012), pp. 48–49.
39. Reproduced in Wilson, pp. 164–165, 220–221.
40. A detailed discussion of the uses of, and technical difficulties presented by, the use of Technicolor in the film is presented in Scott Higgins, *Harnessing the Technicolor Rainbow: Color Design in the 1930s* (Austin: University of Texas Press, 2007), pp. 172–207.

41. Wilson, pp. 277–278.
42. Menzies, quoted in Vertrees, *Selznick's Vision*, p. 59.
43. Thomson, op. cit.
44. Wilson, p. 173; Selznick's memo about this, of 13 March, is reproduced in Wilson, pp. 312–313.
45. David Thomson's commentary on the TV movie *The Making of a Legend: Gone with the Wind*.
46. Wilson, p. 72.
47. Vertrees, p. 18.
48. Henkel, p. 24.
49. Wilson, p. 108.
50. Wilson, p. 232.
51. Vertrees, p. 56.
52. Vertrees, p. 69.
53. Bordwell, op. cit.

4 Storyboarding, Spectacle and Sequence in Narrative Cinema

1. Annette Michelson, *Drawing into Film: Directors' Drawings* (New York: Pace Gallery, 1993), p. 1.
2. Michelson, pp. 1–2.
3. Fionnuala Halligan, *Movie Storyboards: The Art of Visualizing Screenplays* (San Francisco: Chronicle, 2013), p. 168.
4. Raphaël Saint-Vincent, '1992, Ou la Découverte du (Nouveau) Monde du Storyboard en France', *Storyboard* 4 (June–August 2003), pp. 53–57.
5. For discussion of this point, see Steven Price, *A History of the Screenplay* (Basingstoke: Palgrave, 2013), p. 178.
6. Alan David Vertrees, *Selznick's Vision: Gone with the Wind and Hollywood Filmmaking* (Austin: University of Texas Press, 1997), p. 169.
7. Kristina Jaspers, 'Zur Entstehungsgeschichte und Funktion des Storyboards', in Katharina Henkel, Kristina Jaspers, and Peter Mänz (eds), *Zwischen Film und Kunst: Storyboards von Hitchcock bis Spielberg* (Bielefeld: Kerber, 2012), p. 13.
8. Vincent LoBrutto, *The Filmmaker's Guide to Production Design* (New York: Allworth, 2002), p. 62.
9. LoBrutto, p. 62.
10. John Hart, *The Art of the Storyboard: A Filmmaker's Introduction* (Burlington, MA: Focal Press, 2008), p. 27.
11. Thomas Schatz, *The Genius of the System: Hollywood Filmmaking in the Studio Era* (New York: Henry Holt, 1996).
12. Katharina Henkel and Rainer Rother, 'Vorwort', in Katharina Henkel, Kristina Jaspers, and Peter Mänz (eds), *Zwischen Film und Kunst: Storyboards von Hitchcock bis Spielberg* (Bielefeld: Kerber, 2012), p. 8.
13. 'Catching a Plane: Storyboard to Screen', Blue-Ray Extra in *Casino Royale: Deluxe Edition*, Sony Pictures Home Entertainment, 2008.
14. Peter Lamont, question and answer session at the 'Bond in Motion' exhibition, London Film Museum, 22 March 2015.
15. Elizabeth Cowie, 'Classical Hollywood Cinema and Classical Narrative', in Steve Neale and Murray Smith (eds), *Contemporary Hollywood Cinema* (London: Routledge, 1998), p. 178.

16. Price, pp. 132–139.
17. Halligan, p. 57.
18. Katharina Henkel, 'Zur Umsetzung von Gezeichneten in Bewegte Bilder: in Fimcheck', in Katharina Henkel, Kristina Jaspers, and Peter Mänz (eds), *Zwischen Film und Kunst: Storyboards von Hitchcock bis Spielberg* (Bielefeld: Kerber, 2012), p. 25.
19. Some of the major arguments on each side of this debate are conveniently presented in Steve Neale and Murray Smith (eds), *Contemporary Hollywood Cinema* (London: Routledge, 1998); see in particular Richard Maltby, '"Nobody Knows Everything": Post-Classical Historiographies and Consolidated Entertainment', pp. 3–21, and Murray Smith, 'Theses on the Philosophy of Hollywood History', pp. 21–44.
20. William Goldman, *Adventures in the Screen Trade* (New York: Warner, 1983), p. 153.
21. David Bordwell, Janet Staiger, and Kristin Thompson, *The Classical Hollywood Cinema: Film Style and Mode of Production to 1960* (London: Routledge, 1985).
22. Robert L. Carringer, *The Making of Citizen Kane*, 2nd edition. (Berkeley: University of California Press, 1996), p. 44.
23. Carringer, p. 40.
24. Carringer, p. 42.
25. Carringer, p. 41.
26. Carringer, *The Magnificent Ambersons: A Reconstruction* (Berkeley: University of California Press, 1993), p. 35.
27. Carringer, *The Magnificent Ambersons*, p. 48.
28. Carringer, *Citizen Kane*, pp. 141–148.
29. Halligan, p. 40.
30. Michelson, p. 2.
31. Reproduced in Michelson, pp. 34–35.
32. *Viva Villa!* – storyboards (undated), James Wong Howe papers, MHL, 15. f-169.
33. James Wong Howe, 'Upsetting Traditions with *Viva Villa*', *American Cinematographer* (June 1934), p. 64.
34. Dan Gagliasso, 'Heir to a Tradition', *American Cowboy* (July–August 2006), p. 72.
35. *Shane*, script notes by Joe De Yong, 22 July 22 1951, George Stevens papers, MHL, 255.f-2995.
36. Andrew Horton, *Henry Bumstead and the World of Hollywood Art Direction* (Austin: University of Texas Press, 2003), pp. 60–65, 90–92.
37. Turner, p. 11.
38. David Sylvester, *Moonraker, Strangelove and Other Celluloid Dreams: The Visionary Art of Ken Adam* (London: Serpentine Gallery, 1999), p. 14.
39. Laurent Bouzereau, *The Art of Bond: From Storyboard to Screen: The Creative Process Behind the James Bond Phenomenon* (London: Boxtree, 2006), p. 39.
40. For a detailed analysis, see Adrian Turner, *Goldfinger* (London: Bloomsbury, 1998), pp. 187–208.
41. Bouzereau, p. 37.
42. Bouzereau, p. 39.
43. Bouzereau, p. 117.
44. See Paul Joseph Gulino, *Screenwriting: The Sequence Approach* (New York: Continuum, 2004).
45. Jürgen Berger, *Production Design: Ken Adam: Meisterwerke der Filmarchitektur* (Munich: L. Werner, 1994), p. 56.
46. Léon Barsacq, *Caligari's Cabinet and Other Grand Illusions: A History of Film Design*, rev. Elliott Stein (New York: Little, Brown, 1976), p. 165.

47. Sylvester, pp. 72, 93.
48. Sylvester, pp. 58–59, 67.
49. Vertrees, p. 180ff.
50. Bouzereau, op. cit.; Paul Duncan (ed.), *The James Bond Archives: 007* (Cologne: Taschen, 2012).
51. Numerous examples of Harryhausen's early input during the development of film projects can be found in Ray Harryhausen and Tony Dalton's *Ray Harryhausen's Fantasy Scrapbook: Models, Artwork and Memories from 65 Years of Filmmaking* (London: Aurum, 2011).
52. For more discussion of the Dynamation process, see Ray Harryhausen and Tony Dalton, *Ray Harryhausen: An Animated Life* (London: Aurum, 2009), p. 121.
53. Ray Harryhausen and Tony Dalton, *The Art of Ray Harryhausen* (London: Aurum, 2011), p. 101.
54. For a more detailed discussion of the instrumental role played by physical landscapes in the shaping of stop-motion animation, see Chris Pallant, 'The Stop-Motion Landscape', in Chris Pallant (ed.), *Animated Landscapes: History, Form, and Function* (New York: Bloomsbury Academic, 2015), pp. 33–49.
55. Harryhausen and Dalton, p. 200.
56. Michael Carreras, *One Million Years B.C.* (London: Hammer; Seven Arts Productions, c. 1965), p. 68 –The Ray & Diana Harryhausen Foundation Archives.
57. Conversation between Chris Pallant, Ray Harryhausen, and Tony Dalton, 1 November 2012.
58. Conversation between Chris Pallant, Tony Dalton, and Phil Boot, 4 April, 2013; Harold Lamb and Emily Barrye's *Gwangi* – 'Revised Estimating Script' (6 October 1941); and Willis O'Brien's storyboard held in The Ray & Diana Harryhausen Foundation Archive.

5 Hitchcock and Storyboarding

1. Bill Krohn, *Hitchcock at Work* (London: Phaidon, 2000), p. 9.
2. Krohn, p. 97.
3. *Torn Curtain* – production 1965–1966, Alfred Hitchcock papers, MHL, 79.f–913.
4. 'The Making of *Saboteur*', in *The Alfred Hitchcock Collection*, DVD (Universal, 2001).
5. 'The Making of *Saboteur*', DVD.
6. Krohn, pp. 208–209.
7. Krohn, p. 12.
8. Philip J. Skerry, *Psycho in the Shower: The History of Cinema's Most Famous Scene* (New York: Continuum, 2009), p. 220.
9. For examples see Skerry, pp. 263–269.
10. Joseph Stefano, *Psycho*, first draft screenplay, 19 October 1959; quoted in Skerry, pp. 231–232.
11. Stephen Rebello, *Alfred Hitchcock and the Making of Psycho* (New York: St. Martin's, 1990), p. 48.
12. Quoted in Rebello, p. 109.
13. François Truffaut, *Hitchcock*, rev. ed. (London: Paladin, 1986), p. 422.
14. Rebello, p. 101.
15. Quoted in Rebello, p. 101.

16. Philip Oakes, 'Bass Note', *Sunday Times*, 9 December 1973, p. 36.
17. Rebello, pp. 109–110.
18. Krohn, p. 230.
19. Rebello, p. 112.
20. Pat Kirkham, 'Reassessing the Saul Bass and Alfred Hitchcock Collaboration', *West 86th* 18.1 (2011).
21. Rebello, p. 104.
22. Kirkham; Krohn, p. 230.
23. Krohn, p. 230.
24. David Bordwell, 'William Cameron Menzies: One Forceful, Impressive Idea', March 2010, accessed 24 January 2015, retrieved from http://www.davidbordwell.net/essays/menzies.php#_Ednref9.
25. Mark Kermode, 'Psycho: The Best Horror Film of all Time', *Guardian* online, 22 October 2010, accessed 30 December 2014, retrieved from http://www.theguardian.com/film/2010/oct/22/psycho-horror-hitchcock.
26. Jennifer Bass and Pat Kirkham, *Saul Bass: A Life in Film and Design* (London: Laurence King, 2011), p. 186.
27. Fionnuala Halligan, *Movie Storyboards: The Art of Visualizing Screenplays* (San Francisco: Chronicle, 2013), p. 30.
28. Krohn, p. 225.
29. Joseph W. Smith III, *The* Psycho *File* (Jefferson, NC: McFarland, 2009) p. 72.
30. The MHL's Production Art Database descriptions of the Bass images discussed in this chapter can be accessed via http://collections.oscars.org/prodart/ and entering 'shower' as the keyword and *Psycho* as the film title.
31. Production Art Database, Saul Bass papers, Box 90-OS, f.1108, MHL.
32. Quoted in Rebello, pp. 102–103, emphasis in original.
33. Quoted in Rebello, p. 103, emphasis in original.
34. Quoted in Rebello, pp. 104–105.
35. Quoted in Rebello, p. 105.
36. 'Who Directed the *Psycho* Shower Scene?', 15 February 2014, accessed 6 January 2014, retrieved from http://vashivisuals.com/directed-shower-scene-psycho/.
37. Quoted in Rebello, p. 106.
38. Quoted in Rebello, p. 116.
39. *Psycho* – storyboards, Saul Bass papers, MHL, Box 90-OS, f.1106, File number 421_1106; Box 90-OS, f.1107, file number 421_1107.
40. Raphaël Saint-Vincent, 'Le Storyboard Hitchcockien, ou les Fondements d'une Mythologie', *Storyboard* 3 (March–May 2003), pp. 34–39.

6 Constructing the Spielberg-Lucas-Coppola Cinema of Effects

1. Tom Gunning, 'The Cinema of Attraction[s]: Early Film, Its Spectator and the Avant-Garde', in Wanda Strauven (ed.), *The Cinema of Attractions Reloaded* (Amsterdam: Amsterdam University Press, 2006) p. 387.
2. Janet Staiger, 'The Hollywood Mode of Production to 1930', in David Bordwell, Janet Staiger, and Kristin Thompson, *The Classical Hollywood Cinema: Film Style and Mode of Production to 1960* (London: Routledge, 1985), p. 116.
3. Robert C. Allen, 'The Movies in Vaudeville: Historical Context of the Movies as Popular Entertainment', in Tino Balio (ed.), *The American Film Industry* (Madison: University of Wisconsin Press, 1985), p. 58.

4. For more on the economic and social challenges that reduced the profit-ability of Hollywood during this period, see Drew Casper's *Hollywood Film 1963–1976: Years of Revolution and Reaction* (Malden, MA: Wiley-Blackwell, 2011) pp. 31–57; while further discussion of mainstream Hollywood's eventual shift towards a more conservative attitude towards the end of the 1970s can be found in Linda Ruth Williams and Michael Hammond's edited collection *Contemporary American Cinema* (2006) and Robin Wood's *Hollywood from Vietnam to Reagan ... And Beyond* (New York: Columbia University Press, 2003), in which the author updates his original text, first published in 1986, to trace the legacy of this conservative shift throughout the 1990s.

5. Steven Spielberg, quoted in *Room 666* (Wim Wenders, 1982).

6. John Baxter, *Steven Spielberg: The Unauthorised Biography* (New York: HarperCollins, 1996), p. 79.

7. William Goldman, *Adventures in the Screen Trade* (New York: Warner, 1983), p. 153.

8. *Movie of the Weekend: Duel*, draft teleplay by Richard Matheson, 16 August 1971, p. 24; held at Script Collections, Writers Guild of America, Los Angeles.

9. '*Duel': A Conversation with Director Steven Spielberg* (2004), accessed 5 January, 2015, retrieved from http://www.youtube.com/watch?v=ZwUAJKHbeOU.

10. Ibid.

11. Bryan Bishop, 'From demons to Diesel: a conversation with Furious 7 director James Wan', *The Verge*, accessed 23 June 2015, retrieved from http://www.theverge.com/2015/4/3/8328299/fast-and-furious-7-director-james-wan-interview

12. Joseph McBride, *Steven Spielberg: A Biography* (London: Faber and Faber, 1997), pp. 238–239.

13. Baxter, p. 129.

14. Baxter, p. 130.

15. Joe Alves,'Home', *The Movie Art of Joe Aleves*, accessed 7 December 2014, retrieved from http://www.joealvesmovieart.com.

16. Dale Pollock, *Skywalking: The Life and Films of George Lucas* (London: Elm Tree, 1983), p. 216.

17. Howard Maxford, *George Lucas Companion: The Complete Guide to Hollywood's Most Influential Film-maker* (London: Batsford, 1999), p. 79.

18. Leigh Brackett, *Star Wars Sequel* (1978), pp. 50–51 – Screenplay dated 17 February 1978; held at Special Collections, Williamson SF Library, Eastern New Mexico University.

19. Lawrence Kasdan, *Star Wars: Empire Strikes Back – Fourth Draft* (1978), pp. 75–77 – draft screenplay, dated 24 October 1978; MHL.

20. Ibid., pp. 75–77.

21. J.W. Rinzler, *Star Wars Storyboards: The Original Trilogy* (New York: Abrams, 2014), p. 135.

22. Ivor Beddoes, *Star Wars: Empire Strikes Back – Storyboard Sept 78* (1978), sc. 82, p. 5; Special Collections, British Film Institute, London.

23. Ibid.

24. Leigh Brackett and Lawrence Kasdan, *Star Wars, Episode Five: The Empire Strikes Back*, Fifth Draft (20th Century-Fox, 1980), p. 75; MHL.

25. Ibid., p. 75.

26. Rinzler, p. 137.
27. James M. Welsh, Gene D. Phillips, and Rodney F. Hill, *The Francis Ford Coppola Encyclopedia* (Lanham: Scarecrow Press, 2010), p. 130–131.
28. Francis Ford Coppola quoted in 'Full Disclosure Collector's Edition Booklet: In the Heart of the Movie', *Apocalypse Now* Blu-Ray Collector's Edition.
29. Coppola, quoted in John Gallagher, *Film Directors on Directing* (New York: Greenwood, 1989), p. 135.
30. Coppola, quoted in *Hearts of Darkness* (Fax Bahr, George Hickenlooper, and Eleanor Coppola, 1991).
31. During the researching of this book it has become clear that some confusion exists regarding the exact attribution of these colour storyboards. At the Storyboarding Symposium held in Berlin in July 2015, the authors of this book discussed with Kristina Jaspers her interview with Dean Tavoularis, in which Dean claimed responsibility for the storyboards in question. However, in the interview conducted by Chris Pallant with Alex Tavoularis, which is referenced in this chapter, Alex claimed joint responsibility for the storyboards with Tom Wright. It seems likely that both claims are in fact fair. Dean's official role as Production Designer for *Apocalypse Now* means that he would have ultimate responsibility for coordinating the storyboarding process. Contrastingly, Alex is recorded as serving as Production Illustrator within the Art Department - meaning that while he may well have created the drawings with Tom Wright, this material, once approved, would have been referred upwards to Dean. This working arrangement is reflected in the comments made by Dean in Fionnuala Halligan's book, where Dean remarks: 'It was especially Alex who worked on the storyboards [...] although sometimes we worked on it together' (Halligan, *The Art of Movie Storyboards* [San Francisco: Chronicle, 2013], p. 96).
32. John Milius, *Apocalypse Now Draft Screenplay* (The Coppola Company, no date), pp. 31–43; included in *Apocalypse Now* Blu-ray Collector's Edition special features.
33. Alex Tavoularis and Tom Wright, *Apocalypse Now Storyboard* (no date), Sc 44, p. 1; included in *Apocalypse Now* Blu-ray Collector's Edition special features.
34. Ibid.
35. Stéphane Delorme, 'Interview with Dean Tavoularis' *Cahiers du Cinema*, no.665 March 2011, accessed 5 December 2014, retrieved from http://www.cahiersducinema.com/Mars-2011-No665,1967.html; Phil De Semlyen, 'Anatomy of a Scene: Apocalypse Now', *Empire Online*, accessed 5 December 2014, retrieved from http://www.empireonline.com/features/apocalypse-now-storyboards/.
36. Alex Tavoularis, email interview with Chris Pallant, 2 December 2013.
37. Alex Tavoularis, *Apocalypse Now Storyboard* (no date), p. 54a; included in *Apocalypse Now* Blu-ray Collector's Edition special features.
38. Ibid.
39. Ibid.
40. Doug Claybourne quoted in: Phil De Semlyen, 'Anatomy of a Scene: Apocalypse Now', *Empire Online*, accessed 5 December 2014, retrieved from http://www.empireonline.com/features/apocalypse-now-storyboards/p6.
41. Dave Lowery, interview with Chris Pallant and Steven Price, 4 July, 2013.

42. Michael Crichton, quoted in Don Shay and Jody Duncan, *The Making of Jurassic Park: An Adventure 65 Million Years in the Making* (New York: Ballantine Books, 1993), pp. 9–10.
43. Shay and Duncan, p. 90.
44. Rick Carter, quoted in Shay and Duncan, p. 42.
45. Carter, quoted in Shay and Duncan, pp. 42–43.
46. Drawing Board series, *Directors Guild of America*, accessed 12 December 2014, retrieved from http://www.dga.org/Craft/DGAQ/All-Articles/1302-Spring-2013/Drawing-Board-Apocalypse-Now.aspx.
47. Phil De Semlyen, 'Anatomy of a Scene: Apocalypse Now', *Empire Online*, accessed 5 December 2014, retrieved from http://www.empireonline.com/features/apocalypse-now-storyboards.
48. A similar level of manipulation can be found in Ray Harryhausen and Tony Dalton's *The Art of Ray Harryhausen* (2005), which presents **Figures 4.2 and 4.3** that appear in this book in their original individual form, as one composite image that omits the first two rows of panels featured in **Figure 4.2**.

7 Storyboarding in the Digital Age

1. In several of the interviews conducted during the preparation of this book, it became clear that the term 'pre-visualisation' rests uneasily with many of the artists that identify with the process. A common objection centred around the fact that all *pre*-visualisation work is fundamentally just visualisation, and, by extension, the question was raised whether storyboarding should now be considered *pre-pre*-visualisation. Given the rise of the previs as a distinct pre-production process it is useful to have a word that refers directly to this, and which also serves to distinguish it from storyboarding and the pro-filmic event. Nonetheless, it is interesting to note the critical tone that the storyboard artists that we interviewed frequently adopted when discussing the previs process.
2. Michael Fink interview with Chris Pallant, 2 July 2013.
3. Ibid.
4. Benjamin B, 'Gravity: Facing the Void', *American Cinematographer*, November 2013, accessed Nov 15, 2014, retrieved from https://www.theasc.com/ac_magazine/November2013/Gravity/page1.php.
5. Ibid.
6. Ibid.
7. Ibid.
8. Ibid.
9. Mark Austin interview with Chris Pallant, 5 February 2014.
10. Ibid.
11. Paul Wells, 'Boards, beats, and bricolage: Approaches to the animation script', in Jill Nelmes (ed.), *Analysing the Screenplay* (London: Routledge, 2011), p. 90, emphasis in original.
12. Janet Blatter, 'Roughing It: A Cognitive Look at Animation Storyboarding', *Animation Journal*, vol. 15 (2007), p. 9.
13. Ibid., p. 11.
14. Paul Wells, *The Animated Bestiary: Animals, Cartoons, and Culture* (Piscatawy, NJ: Rutgers University Press, 2009), p. 22.
15. Ibid., p. 11 (emphasis in original).
16. Ibid., p. 11.

17. Aylish Wood, *Talking About Maya: Interviews with Users of Autodesk Maya, a Report by Dr Aylish Wood* (Canterbury: University of Kent, 2013), p. 31.
18. In a corporate sense, the Pixar studio has been owned by Disney since 5 May 2006, when it was acquired for $7.4 billion, and has produced work since that date under the name Disney-Pixar. However, as has been discussed at length elsewhere (Pallant, 2011; Haswell 2014), Pixar's staff, creative practice, and artistic direction have remained relatively autonomous since the 2006 takeover, partly as a consequence of the Emeryville-based studio maintaining a geographical distance from Disney's Burbank base of operations, and also as a result of Pixar head John Lasseter being installed as Chief Creative Officer across both Disney Feature Animation and Pixar following the takeover. In light of this relative independence, the title Pixar, rather than Disney-Pixar, will be used in this chapter.
19. Michael Sporn, 'Joe and Joe', *MichaelSpornAnimation*, 2 August 2010, accessed 10 April, 2015, retrieved from http://www.michaelspornanimation.com/splog/?p=2326.
20. John Canemaker, *Two Guys Named Joe: Master Animation Storytellers Joe Grant and Joe Ranft* (New York: Disney Editions, 2010), p. 14.
21. Tim Hauser, *The Art of WALL-E* (San Francisco: Chronicle Books, 2008), *passim*.
22. Discussions with Pixar supervising technical director, Daniel McCoy, suggest to the authors that the video was staged: co-director John Lasseter's absence from the meeting, an unlikely arrangement at the time of *A Bug's Life's* production; Stanton's position in relation to the board being reviewed, which would have afforded a poor view, suggesting that his comments are performative rather than critical; and lastly the fact that Pixar does not typically record storyboard-pitching sessions for reference.
23. Rex Grignon interview with Chris Pallant, 17 June 2014.
24. Ibid.
25. Samy Fecih interview with Chris Pallant, 28 July 2014.
26. Ibid.
27. Jeff Snow interview with Chris Pallant, 8 July 2014.
28. Ibid.
29. Ibid.
30. Ibid.
31. Vera Brosgol interview with Chris Pallant, 14 July 2014.
32. Ibid.
33. Ibid.
34. Jed Alger, *The Art and Making of ParaNorman* (San Francisco: Chronicle Books, 2012), p. 23.
35. Vera Brosgol interview with Chris Pallant, 31 July 2014.
36. *Monsters University* data taken from an interview with head of story Kelsey Mann featured on the official 'Disney Insider' blog, accessed 20 November 2014, retrieved from http://blogs.disney.com/insider/articles/2013/04/09/the-story-behind-the-story-of-monsters-university/.
37. Dean Takahashi, 'The Making of DreamWorks Animation's Tech Wonder: How to Train Your Dragon 2', *VentureBeat.com*, 25 July 2014, accessed 7 January 2015, retrieved from http://venturebeat.com/2014/07/25/dragon-making-main/.
38. Approximate numbers confirmed by Sami Fecih, 21 January 2015.

39. The following discussion of working practices at A+C is informed by studio observation and interviews with studio staff conducted by Chris Pallant at numerous times between 2013 and 2015.
40. Stuart Clark interview with Chris Pallant, 12 July 2014.
41. Paul Ward, 'Storyboarding, storytelling and animation labour – Aardman style', conference paper, presented at the 27th Society for Animation Studies Annual Conference, Canterbury Christ Church University, UK, 14 July 2015.
42. Chris Pallant, 'Report: #BrickBowl – 36hr Animation Project', *animationstudies 2.0*, 3 February, 28 March 2015, retrieved from http://blog.animationstudies.org/?p=1031.
43. Matt Kamen, '"Brick Bowl" is Lego Animation at its Finest', *Wired*, 4 February 2015, 26 March 2015, retrieved from http://www.wired.co.uk/news/archive/2015–02/04/brick-bowl-completed.
44. Wells (2011), p. 90.

Conclusion

1. There is a distinction to be made between 'video' games and 'computer' games, with the former referring to games played on specialist consoles (such as those made by Microsoft, Nintendo, and Sony), and the latter referring to games played on a PC (which places a greater emphasis on the gamer to manage the hardware of their computer to ensure optimal compatibility). For the benefit of style, video game will be used here as shorthand to refer to both video and computer game culture.
2. Michael Thornton Wyman, *Making Great Games: An Insider's Guide to Designing and Developing the World's Greatest Video Games* (Oxford: Focal Press, 2011), p. 169.
3. *hitRECord.org*, accessed 18 January 2015, retrieved from http://www.hitrecord.org.
4. The Teafaire, 'Prop 8. Court Trial Animation', *hitRECord.org*, 13 January 2010, accessed 10 January 2015, retrieved from http://www.hitrecord.org/collaborations/5129?page=1.
5. Casey Pugh, 'About', *Star Wars Uncut*, accessed 10 January 2015, retrieved from http://www.starwarsuncut.com/about.
6. Casey Pugh, 'About', *Star Wars Uncut*, accessed 10 January 2015, retrieved from http://www.starwarsuncut.com/about.
7. Ari Karpel, 'Moving Storyboards and Drumming: Wes Anderson Maps out the Peculiar Genius of "Moonrise Kingdom"', *Fast Company*, accessed 4 January 2015, retrieved from http://www.fastcocreate.com/1681005/moving-storyboards-and-drumming-wes-anderson-maps-out-the-peculiar-genius-of-moonrise-kingdo#1.

Bibliography

Alger, Jed. *The Art and Making of ParaNorman*. San Francisco: Chronicle, 2012.

Allen, Robert C. 'The Movies in Vaudeville: Historical Context of the Movies as Popular Entertainment.' In *The American Film Industry*, edited by Tino Balio, 57–82. Madison: University of Wisconsin Press, 1985.

Azlant, Edward. *The Theory, History, and Practice of Screenwriting, 1897–1920*. Dissertation. Ann Arbor, MI: University Microfilms International, 1980.

B, Benjamin. 'Gravity: Facing the Void.' *American Cinematographer*. November 2013. Accessed 15 November 2014. Retrieved from https://www.theasc.com/ac_magazine/November2013/Gravity/page1.php.

Barrier, Michael. *Hollywood Cartoons: American Animation in its Golden Age*. Oxford: Oxford University Press, 1999.

Barrier, Michael. *The Animated Man: A Life of Walt Disney*. Berkeley: University of California Press, 2008.

Barsacq, Léon. *Caligari's Cabinet and Other Grand Illusions: A History of Film Design*. Revised by Elliott Stein. New York: Little, Brown, 1976.

Bass, Jennifer, and Pat Kirkham. *Saul Bass: A Life in Film and Design*. London: Laurence King, 2011.

Bass, Saul. *Psycho* – storyboards, Saul Bass papers. Margaret Herrick Library, Box 90-OS, f.1106, File number 421_1106; Box 90-OS, f.1107, file number 421_1107.

Baxter, John. *Steven Spielberg: The Unauthorised Biography*. New York: HarperCollins, 1996.

Beddoes, Ivor. *Star Wars: Empire Strikes Back – Storyboard Sept 78*. 1978.

Behlmer, Rudy. *Memo from David O. Selznick*. New York: Viking, 1972.

Berger, Jürgen. *Production Design: Ken Adam: Meisterwerke der Filmarchitektur*. Munich: L. Werner, 1994.

Birchard, Robert S. *Cecil B. DeMille's Hollywood*. Lexington: University of Kentucky Press, 2004.

Bishop, Bryan. 'From demons to Diesel: a conversation with Furious 7 director James Wan'. *The Verge*. 3 April 2015. Accessed 23 June 2015. Retrieved from http://www.theverge.com/2015/4/3/8328299/fast-and-furious-7-director-james-wan-interview

Blatter, Janet. 'Roughing It: A Cognitive Look at Animation Storyboarding.' *Animation Journal*, vol. 15 (2007): 4–23.

Bordwell, David. 'William Cameron Menzies: One Forceful, Impressive Idea', *David Bordwell's Website on Cinema*, March 2010, accessed 24 January 2015. Retrieved from http://www.davidbordwell.net/essays/menzies.php#_Ednref9.

Bordwell, David, Janet Staiger, and Kristin Thompson, *The Classical Hollywood Cinema: Film Style and Mode of Production to 1960*. London: Routledge, 1985.

Bouzereau, Laurent. *The Art of Bond: From Storyboard to Screen: The Creative Process Behind the James Bond Phenomenon*. London: Boxtree, 2006.

Brackett, Leigh. *Star Wars Sequel*. 1978.

Brackett, Leigh, and Lawrence Kasdan. *Star Wars, Episode Five: The Empire Strikes Back – Fifth Draft*. 20th Century-Fox, 1980.

Bromberg, Serge, and Eric Lange. *La Couleur Retrouvée du Voyage dans la Lune/A Trip to the Moon Back in Color*: Groupama Gan Foundation for Cinema and Technicolor Foundation for Cinema Heritage, 2011.

Brookman, Philip. *Eadweard Muybridge*. London: Tate, 2010.

Brown, Karl. *Adventures with D.W. Griffith*. London: Faber, 1988.

Bukatman, Scott. *The Poetics of Slumberland: Animated Spirits and the Animating Spirit*. Berkeley: University of California Press, 2012.

Canemaker, John. *Paper Dreams: The Art and Artists of Disney Storyboards*. New York: Hyperion, 1999.

Canemaker, John. *Two Guys Named Joe: Master Animation Storytellers Joe Grant and Joe Ranft*. New York: Disney Editions, 2010.

Canemaker, John. *Winsor McCay: His Life and Art*. New York: Abbeville, 1987.

Carreras, Michael. *One Million Years B.C.* London: Hammer; Seven Arts Productions, c. 1965. The Ray and Diana Harryhausen Foundation Archives.

Carrick, Edward. *How To Do It Series Number 27: Designing for Films*. London and New York: The Studio Publications, 1949.

Carrière, Jean-Claude. *The Secret Language of Film*. Translated by Jeremy Leggatt. London: Faber, 1995.

Carringer, Robert L. *The Magnificent Ambersons: A Reconstruction*. Berkeley: University of California Press, 1993.

Carringer, Robert L. *The Making of Citizen Kane*. Berkeley: University of California Press, 1996.

Cavalier, Stephen. *The World History of Animation*. London: Aurum, 2011.

Cook, David A. *A History of Narrative Film*. New York: Norton, 2008.

Crafton, Donald. *Before Mickey: The Animated Film 1898–1928*. Chicago: University of Chicago Press, 1993.

Cristiano, Giuseppe. *The Spiritual Journey of the Freelance Storyboard Artist*. Raleigh, NC: Lulu, 2011.

Cristiano, Giuseppe. *The Storyboard Artist: A Guide to Freelancing in Film, TV, and Advertising*. Studio City: Michael Wiese, 2011.

Cristiano, Giuseppe. *Storyboard Design Course: Principles, Practice, and Techniques*. Hauppauge, NY: Barron, 2007.

Curtis, Scott. 'The Last Word: Images in Hitchcock's Working Method.' In *Casting a Shadow: Creating the Alfred Hitchcock Film*, edited by Will Schmenner and Corinne Granof. Evanston: Northwestern University Press, 2007: 15–27.

Dawkins, Richard. *The Selfish Gene*. Oxford: Oxford University Press, 1976.

De Semlyen, Phil. 'Anatomy of a Scene: Apocalypse Now.' *Empire Online*. Accessed 5 December 2014. Retrieved from http://www.empireonline.com/features/apocalypse-now-storyboards/.

De Yong, Joe. *Shane*, script notes by Joe De Yong, 22 July 1951. George Stevens papers, Margaret Herrick Library, 255.f–2995.

Deneroff, Harvey. 'A Trip to the Moon: Back in Color.' *Comments and Thoughts on Animation and Film*, 10 May 2011. Accessed 10 January 2015. Retrieved from http://deneroff.com/blog/2011/05/10/a-trip-to-the-moon-back-in-color/.

Disney Advert, *Motion Picture Herald*, 1 October 1932.

Disney Miller, Diane. *The Story of Walt Disney*. New York: Henry Holt, 1958.

Drawing board series. *Directors Guild of America*. Accessed 12 December 2014. Retrievedfromhttp://www.dga.org/Craft/DGAQ/All-Articles/1302-Spring-2013/ Drawing-Board-Apocalypse-Now.aspx.

Paul Duncan, ed., *The James Bond Archives: 007*. Cologne: Taschen, 2012.

Duncan, Randy, and Matthew J. Smith. *The Power of Comics: History, Form and Culture*. New York: Continuum, 2009.

Estabrook, Howard. *David Copperfield* (MGM, 1935), screen play by Howard Estabrook, adaptation by Hugh Walpole, 8 September 1934. BFI S5237.

Farr, Michael. *The Adventures of Hergé: Creator of Tintin*. London: John Murray, 2007.

Gabler, Neal. *Walt Disney: The Triumph of the American Imagination*. New York: Alfred A. Knopf, 2006.

Gagliasso, Dan. 'Heir to a Tradition'. *American Cowboy* (July–August) 2006: 70–72.

Gallagher, John. *Film Directors on Directing*. New York: Greenwood, 1989.

Geoffroy-Menoux, Sophie. 'Enki Bilal's Intermedial Fantasies: From Comic Book Nikopol Trilogy to Film Immortals (Ad Vitam).' In *Film and Comic Books*, edited by Ian Gordon, Mark Jancovich, and Matthew P. McAllister, 268–284. Jackson: University Press of Mississippi, 2007.

Goodman, Ezra. 'Production Designing'. *American Cinematographer* (March) 1945: 82–83, 100.

Guise, Chris. *The Art of* The Adventures of Tintin. New York: Harper Design, 2011.

Gulino, Paul Joseph. *Screenwriting: The Sequence Approach*. New York: Continuum, 2004.

Gunning, Tom. 'The Cinema of Attraction[s]: Early Film, Its Spectator and the Avant-Garde.' In *The Cinema of Attractions Reloaded*, edited by Wanda Strauven, 381–388. Amsterdam: Amsterdam University Press, 2006.

Halligan, Fionnuala. *Movie Storyboards: The Art of Visualizing Screenplays*. San Francisco: Chronicle, 2013.

Harlan, Jan, and Jane M. Struthers. A.I. Artificial Intelligence: *From Stanley Kubrick to Steven Spielberg: The Vision Behind the Film*. London: Thames and Hudson, 2009.

Harryhausen, Ray, and Tony Dalton. *Ray Harryhausen: An Animated Life*. London: Aurum, 2009.

Harryhausen, Ray, and Tony Dalton. *The Art of Ray Harryhausen*. London: Aurum, 2011.

Harryhausen, Ray, and Tony Dalton. *Ray Harryhausen's Fantasy Scrapbook: Models, Artwork and Memories from 65 Years of Filmmaking*. London: Aurum, 2011.

Hart, John. *The Art of the Storyboard: A Filmmaker's Introduction*. Burlington, MA: Focal Press, 2008.

Hart, John. *The Art of the Storyboard: Storyboarding for Film, TV, and Animation*. Boston: Focal Press, 1999.

Haswell, Helen. "To Infinity and Back Again: Hand-Drawn Aesthetic and Affection for the Past in Pixar's Pioneering Animation." *Alphaville: Journal of Film and Screen Media* 8 (Winter) 2014: Online.

Hauser, Tim. *The Art of WALL-E*. San Francisco: Chronicle Books, 2008.

Haver, Ronald. *David O. Selznick's Hollywood*. New York: Knopf, 1980.

Henderson, Robert M. *D.W. Griffith: His Life and Work*. New York: Garland, 1985.

Henkel, Katharina, Kristina Jaspers, and Peter Mänz. *Zwischen Film und Kunst: Storyboards von Hitchcock bis Spielberg*. Bielefeld: Kerber, 2012.

Henkel, Katharina, and Rainer Rother. 'Vorwort'. In *Zwischen Film und Kunst: Storyboards von Hitchcock bis Spielberg*, edited by Katharina Henkel, Kristina Jaspers, and Peter Mänz. Bielefeld: Kerber, 2012: 8–9.

Higham, Charles. *Hollywood Cameraman: Sources of Light*. New York: Garland, 1970.

Hitchcock, Alfred. *Torn Curtain* – production 1965–1966, Alfred Hitchcock papers. Margaret Herrick Library, 79.f–913.

Holliss, Richard, and Brian Sibley. *The Disney Studio Story*. London: Octopus, 1988.

Holton, Scot, and Robert Skotak. 'William Cameron Menzies: A Career Profile', *Fantascene* 4 (1978): 4–11.

Horton, Andrew. *Henry Bumstead and the World of Hollywood Art Direction*. Austin: University of Texas Press, 2003.

Howe, James Wong. 'Upsetting Traditions with *Viva Villa*'. *American Cinematographer* (June) 1934: 64, 71.

Instructions. *Disney Story-boards board game*. London: Paul Lamond Games, 1991.

Iwerks, Leslie, and John Kenworthy. *The Hand Behind the Mouse*. New York: Disney Editions, 2001.

Jaspers, Kristina. 'Zur Entstehungsgeschichte und Funktion des Storyboards'. In *Zwischen Film und Kunst: Storyboards von Hitchcock bis Spielberg*, edited by Katharina Henkel, Kristina Jaspers, and Peter Mänz. Bielefeld: Kerber, 2012: 12–17.

Kamen, Matt. '"Brick Bowl" is Lego Animation at its Finest'. *Wired*. 4 February 2015, 26 March 2015. Retrieved from http://www.wired.co.uk/news/archive/2015–02/04/brick-bowl-completed.

Karpel, Ari. 'Moving Storyboards and Drumming: Wes Anderson Maps out the Peculiar Genius of "Moonrise Kingdom"'. *Fast Company*. Accessed 4 January 2015. Retrieved from http://www.fastcocreate.com/1681005/moving-story-boards-and-drumming-wes-anderson-maps-out-the-peculiar-genius-of-moonrise-kingdo#1.

Kasdan, Lawrence. *Star Wars: Empire Strikes Back – Fourth Draft*. 24 October 1978.

Kawin, Bruce. *How Movies Work*. Berkeley: University of California Press, 1992.

Kermode, Mark. 'Psycho: The Best Horror Film of All Time'. *Guardian* online. 22 October 2010. Accessed 30 December 2014. Retrieved from http://www.theguardian.com/film/2010/oct/22/psycho-horror-hitchcock.

Kirkham, Pat. 'Reassessing the Saul Bass and Alfred Hitchcock Collaboration'. *West 86th* 18.1 (2011) Online.

Knigge, Andreas C. '"Watch Me Move": Über die Beziehung zwischen Storyboards und Comics'. In *Zwischen Film und Kunst: Storyboards von Hitchcock bis Spielberg*, edited by Katharina Henkel, Kristina Jaspers, and Peter Mänz. Bielefeld: Kerber, 2012: 18–23.

Koury, Phil A. *Yes, Mr. DeMille*. New York: G.P. Putnam, 1959.

Krohn, Bill. *Hitchcock at Work*. London: Phaidon, 2000.

Kushins, Josh. *The Art of John Carter: A Visual Journey*. New York: Disney Editions, 2012.

Langer, Mark. 'Animatophilia, cultural production and corporate interests: the case of "Ren & Stimpy"'. *Film History* 5.2 (1993): 125–141.

Lasseter, John. 'Tell Me a Story.' In *Walt Disney Animation Studios – The Archive Series: Story*. New York: Disney Editions, 2008.

Lawrence, David G., and Jeffery Cummins. *California: The Politics of Diversity*. Stamford, CT: Cengage, 2015.

Lefèvre, Pascal. 'Incompatible Visual Ontologies? The Problematic Adaptation of Drawn Images.' In *Film and Comic Books*, edited by Ian Gordon, Mark Jancovich, and Matthew P. McAllister. Jackson: University Press of Mississippi, 2007: 1–12.

Leyda, Jay, and Zina Voynow. *Eisenstein at Work*. New York: Pantheon, 1982.

LoBrutto, Vincent. *By Design: Interviews with Film Production Designers*. Westport, CT: Praeger, 1992.

LoBrutto, Vincent. *The Filmmaker's Guide to Production Design*. New York: Allworth, 2002.

Lofficier, Jean-Marc, and Randy Lofficier. *The Pocket Essential Tintin*. Harpenden: Pocket Essentials, 2002.

Lutz, Edwin G. *Animated Cartoons*. New York: Charles Scribner, 1920.

Malthête, Jacques, and Laurent Mannoni. *L'Œuvre de Georges Méliès*. Paris: Éditions de La Martinière, 2008.

Martin, Ann, and Virginia M. Clark. *What Women Wrote: Scenarios, 1912–1929*. Frederick, MD: University Publications of America, 1987.

Matheson, Richard. *Movie of the Weekend: Duel*. Revised draft, 1 September 1971.

Maxford, Howard. *George Lucas Companion: The Complete Guide to Hollywood's Most Influential Film-Maker*. London: Batsford, 1999.

McBride, Joseph. *Steven Spielberg: A Biography*. London: Faber, 1997.

McCay, Winsor. *Winsor McCay: Little Nemo 1905–1914*. Köln: Evergreen, 2000.

McCloud, Scott. *Understanding Comics: The Invisible Art*. New York: HarperCollins, 1994.

McLeod, Norman Z. *Alice in Wonderland* – script (undated). Norman Z. McLeod papers, Margaret Herrick Library special collections, 1.f–2.

Michelson, Annette. *Drawing into Film: Director's Drawings*. New York: Pace Gallery, 1993.

Milius, John. *Apocalypse Now* – script. The Coppola Company, no date.

Morris, Nathalie. 'Unpublished Scripts in BFI Special Collections: A Few Highlights', *Journal of Screenwriting* 1.1 (2010): 197–202.

Morton, Drew. 'Sketching Under the Influence? Winsor McCay and the Question of Aesthetic Convergence Between Comic Strips and Film.' *Animation: An Interdisciplinary Journal* 5.3 (2010): 295–312.

Nasa, David. *The Chief: The Life of William Randolph Hearst*. New York: Houghton Mifflin, 2000.

Neer, Robert M. *Napalm: An American Biography*. Cambridge, MA: Harvard University Press, 2013.

Neuwirth, Allan. *Makin' Toons*. New York: Allworth Press, 2003.

Nilsen, Vladimir. *The Cinema as a Graphic Art: On a Theory of Representation in the Cinema*. New York: Hill and Wang, 1936.

Nugent, Frank S. '"Gone with." Etc – or the Making of a Movie,' *The New York Times Magazine*, 10 December 1939.

Oakes, Philip. 'Bass Note'. *Sunday Times*. 9 December 1973.

Ohlsen, Nils. 'Das Storyboard: Ein Unentdecktes Genre Zwischen Film- und Bildkunst'. In *Zwischen Film und Kunst: Storyboards von Hitchcock bis Spielberg*, edited by Katharina Henkel, Kristina Jaspers, and Peter Mänz. Bielefeld: Kerber, 2012: 36–41.

Pallant, Chris. *Demystifying Disney: A History of Disney Feature Animation*. New York: Continuum, 2011.

Pallant, Chris. 'Report: #BrickBowl – 36hr Animation Project'. *animationstudies 2.0*. 3 February 2015. 28 March 2015. Retrieved from http://blog.animationstudies.org/?p=1031.

Pallant, Chris. 'The Stop-Motion Landscape'. In *Animated Landscapes: History, Form, and Function*, edited by Chris Pallant. New York: Bloomsbury Academic, 2015: 33–49.

Pollock, Dale. *Skywalking: The Life and Films of George Lucas*. London: Elm Tree, 1983.

Price, Steven. *A History of the Screenplay*. Basingstoke: Palgrave, 2013.

Price, Steven. *The Screenplay: Authorship, Theory, and Criticism*. London: Palgrave, 2010.

Pugh, Casey. 'About'. *Star Wars Uncut*. Accessed 10 January 2015. Retrieved from http://www.starwarsuncut.com/about.

Rebello, Stephen. *Alfred Hitchcock and the Making of Psycho*. New York: St. Martin's, 1990.

Rinzler, J.W. *The Making of The Empire Strikes Back: The Definitive Story Behind the Film*. London: Aurum, 2010.

Rinzler, J.W. *Star Wars Storyboards: The Original Trilogy*. New York: Abrams, 2014.

Rinzler, J.W. *Star Wars Storyboards: The Prequel Trilogy*. New York: Abrams, 2013.

Rotha, Paul. 'The Art Director and the Composition of the Scenario'. *Close Up* (May) 1930: 379–380.

Saint-Vincent, Raphaël. '1992, Ou la Découverte du (Nouveau) Monde du Storyboard en France'. *Storyboard* 4 (June–August) 2003: 53–57.

Saint-Vincent, Raphaël. 'Le Storyboard Hitchcockien, ou les Fondements d'une Mythologie'. *Storyboard* 3 (March–May) 2003: 34–39.

Salisbury, Mark. *Prometheus: The Art of the Film*. London: Titan Books, 2012.

Schickel, Richard. *The Disney Version: The Life, Times, Art and Commerce of Walt Disney*. Chicago: Ivan R. Dee, 1997.

Schickel, Richard. *D.W. Griffith*. London: Pavilion, 1984.

Seldes, Gilbert. 'Golla, Golla, the Comic Strips Art! An Aesthetic Appraisal of the Rubber-Nosed, Flat-Footed Little Guys and Faerie Monsters of the Funnies.' *Vanity Fair*, May 1922.

Shay, Don, and Jody Duncan. *The Making of Jurassic Park: An Adventure 65 Million Years in the Making*. New York: Ballantine Books, 1993.

Simon, Mark A. *Storyboards: Motion in Art*. Burlington, MA: Focal Press, 2012.

Skerry, Philip J. *Psycho in the Shower: The History of Cinema's Most Famous Scene*. New York: Continuum, 2009.

Smith, Dave, and Steven Clark. *Disney The First 100 Years*. New York: Disney Editions, 2002.

Smith III, Joseph W. *The Psycho File*. Jefferson, NC: McFarland, 2009.

Stahl, Matt. 'Cultural Labor's "Democratic Deficits": Employment, Autonomy and Alienation in US Film Animation'. *Journal for Cultural Research* 14.3 (2010): 271–293.

Stahl, Matt. 'Non-Proprietary Authorship and the Uses of Autonomy: Artistic Labor in American Film Animation, 1900–2004'. *Labor* 2.4 (2005): 87–105.

Sylbert, Richard, and Sylvia Townsend. *Designing Movies: Portrait of a Hollywood Artist*. Westport, CT: Praeger, 2006.

Sylvester, David. *Moonraker, Strangelove and Other Celluloid Dreams: The Visionary Art of Ken Adam*. London: Serpentine Gallery, 1999.

Takahashi, Dean. 'The Making of DreamWorks Animation's Tech Wonder: *How to Train Your Dragon 2*'. *VentureBeat.com*, 25 July 2014. Accessed 7 January 2015. Retrieved from http://venturebeat.com/2014/07/25/dragon-making-main/.

Tarantini, Tony. 'Pictures That Do Not Really Exist: Mitigating the Digital Crisis in Traditional Animation Production'. *Animation: Practice, Process, and Production* 1.2 (2011): 249–271.

Tavoularis, Alex. Apocalypse Now *Storyboard*. Blu Ray: Collector's Edition (Optimum, 2011).

Tavoularis, Alex, and Tom Wright. Apocalypse Now *Storyboard*. Directors Guild of America, Los Angeles.

Taylor, Frederick Winslow. *Principles of Scientific Management*. New York: Harper, 1911.

Thomas, Bob. *Walt Disney, the Art of Animation: The Story of the Disney Studio Contribution to a New Art*. New York: Simon & Schuster, 1958.

Truffaut, François. *Hitchcock*. London: Paladin, 1986.

Tumminello, Wendy. *Exploring Storyboarding*. Stamford, CT: Cengage, 2005.

Turner, Adrian. *Goldfinger*. London: Bloomsbury, 1998.

Variety Staff. 'Review: "Broken Blossoms – Or the Yellow Man and the Girl"' *Variety*, 31 December 1918. Accessed 12 January 2015. Retrieved from http://www.variety.com/review/VE1117789562?refcatid=31.

Vertrees, Alan David. 'Reconstructing the "Script in Sketch Form": An Analysis of the Narrative Construction and Production Design of the Fire Sequence in *Gone with the Wind*', *Film History* 3 (1989): 87–104.

Vertrees, Alan David. *Selznick's Vision: Gone with the Wind and Hollywood Filmmaking*. Austin: University of Texas Press, 1997.

Walt Disney Animation Studios, *The Archive Series: Story*. New York: Disney Editions, 2008.

Ward, Paul. 'Some Thoughts on Practice-Theory Relationships in Animation Studies'. *Animation: An Interdisciplinary Journal* 1.2 (2006): 229–245.

Watts, Steven. *The Magic Kingdom: Walt Disney and the American Way of Life*. Columbia: University of Missouri Press, 1997.

Wells, Paul. 'Boards, beats, and bricolage: Approaches to the animation script'. In *Analysing the Screenplay*, edited by Jill Nelmes, 89–105. London: Routledge, 2011.

Wells, Paul. *The Animated Bestiary: Animals, Cartoons, and Culture*. Piscatawy, NJ: Rutgers University Press, 2009.

Wells, Paul. *The Fundamentals of Animation*. Lausanne: AVA, 2006.

Wells, Paul. *Understanding Animation*. London: Routledge, 1998.

Welsh, James M., Gene D. Phillips, and Rodney F. Hill, *The Francis Ford Coppola Encyclopedia*. Lanham, MD: Scarecrow, 2010.

'Who Directed the *Psycho* Shower Scene?' *Vashi Visuals*. 15 February 2014. Accessed January 6, 2014. Retrieved from http://vashivisuals.com/directed-shower-scene-psycho/.

Wilson, Steve. *The Making of* Gone with the Wind. Austin: University of Texas Press, 2014.

Wood, Aylish. *Talking About Maya: Interviews with users of Autodesk Maya, a Report by Dr Aylish Wood.* Canterbury: University of Kent, 2013.

Wright, William H. *Alice in Wonderland* – script William H. Wright papers, Margaret Herrick Library special collections, 2–f.8, 2–f.9, 2–f.10, 2–f.11.

Wyman, Michael Thornton. *Making Great Games: An Insider's Guide to Designing and Developing the World's Greatest Video Games.* Boston: Focal 2011.

Filmography

'?' Motorist, The. Dir. Walter R. Booth. Wr. Uncredited. UK, 1906.

Adventures of Tom Sawyer, The. Dirs. Norman Taurog, George Cukor, and William A. Wellman. Wr. John V.A. Weaver. USA, 1938.

A.I. Artificial Intelligence. Dir. Steven Spielberg. Wrs. Ian Watson and Steven Spielberg. USA, 2001.

Alice in Wonderland. Dir. Norman Z. McLeod. Wrs. Joseph L. Mankiewicz and William Cameron Menzies. USA, 1933.

Animal Farm. Dirs. Joy Batchelor and John Halas. Wrs. Joy Batchelor, John Halas Borden Mace, Philip Stapp, and Lothar Wolff. UK, 1954.

Apocalypse Now. Dir. Francis Ford Coppola. Wrs. John Milius and Francis Ford Coppola. USA, 1979.

Argo. Dir. Ben Affleck. Wr. Chris Terrio. USA, 2012.

Around the World in Eighty Days. Dir. Michael Anderson. Wrs. James Poe, John Farrow, and S.J. Perelman. USA, 1956.

Avatar. Dir. James Cameron. Wr. James Cameron. USA/UK, 2009.

Bambi. Dir. David Hand. Wrs. Perce Pearce, Larry Morey, Vernon Stallings, Mel Shaw, Carl Fallberg, Chuck Couch, and Ralph Wright. USA, 1942.

Battleship Potemkin, The. Dir. Sergei Eisenstein. Wr. Nina Agadzhanova. Soviet Union, 1925.

Big Hero 6. Dirs. Don Hall and Chris Williams. Wrs. Jordan Roberts, Dan Gerson, and Robert L. Baird. USA, 2014.

Birds, The. Dir. Alfred Hitchcock. Wr. Evan Hunter. USA, 1963.

Blade Runner. Dir. Ridley Scott. Wrs. Hampton Fancher and David Webb Peoples. USA/Hong Kong/UK, 1982.

Boxtrolls, The. Dirs. Graham Annable and Anthony Stacchi. Wrs. Irena Brignull and Adam Pava. USA, 2014.

Brave. Dirs. Mark Andrews and Brenda Chapman. Wrs. Brenda Chapman, Mark Andrews, Steve Purcell, Brenda Chapman, Irene Mecchi, and Michael Arndt. USA, 2012.

Brick Bowl. Dir. Dan Richards. Wrs. Josh Hicks and Dan Richards. UK, 2015.

Broken Blossoms. Dir. D.W. Griffith. Wr. D.W. Griffith. USA, 1919.

Buffalo Bill. Dir. William A. Wellman. Wrs. Æneas MacKenzie, Clements Ripley, and Cecile Kramer. USA, 1944.

Bug's Life, A. Dirs. John Lasseter and Andrew Stanton. Wrs. John Lasseter, Andrew Stanton, Joe Ranft, Don McEnery, and Bob Shaw. USA, 1998.

Bulldog Drummond. Dir. F. Richard Jones. Wrs. Sidney Howard and Wallace Smith. USA, 1929.

Cabinet des Dr. Caligari, Das /The Cabinet of Dr. Caligari. Dir. Robert Wiene. Wrs. Carl Meyer and Hans Janowitz. Germany, 1920.

Call of the North, A. Dirs. Oscar Apfel and Cecil B. DeMille. Wr. George Broadhurst. USA, 1914.

Citizen Kane. Dir. Orson Welles. Wrs. Herman J. Mankiewicz and Orson Welles. USA, 1941.

Clash of the Titans. Dir. Desmond Davis. Wr. Beverley Cross. USA, 1981.

Coraline. Dir. Henry Selick. Wr. Henry Selick. USA, 2009.

Die Another Day. Dir. Lee Tamahori. Wrs. Neal Purvis and Robert Wade. UK/USA, 2002.

Dove, The. Dir. Roland West. Wrs. Gerald Beaumont, Paul Bern, Willard Mack, Wallace Smith, and Roland West. USA, 1927.

Dr. No. Dir. Terence Young. Wrs. Richard Maibaum, Johanna Harwood, and Berkely Mather. UK, 1962.

Dr. Strangelove or: How I Learned to Stop Worrying and Love the Bomb. Dir. Stanley Kubrick. Wrs. Stanley Kubrick, Terry Southern, and Peter George. USA/UK, 1964.

Duel. Dir. Steven Spielberg. Wrs. Richard Matheson and Richard Matheson. USA, 1971.

Dumbo. Dir. Ben Sharpsteen. Wrs. Joe Grant, Dick Huemer, Otto Englander, Bill Peet, Aurelius Battaglia, Joe Rinaldi, Vernon Stallings, and Webb Smith. USA, 1941.

Earth vs. the Flying Saucers. Dir. Fred F. Sears. Wrs. Curt Siodmak, George Worthing Yates, and Bernard Gordon. USA, 1956.

Empire of the Sun. Dir. Steven Spielberg. Wr. Tom Stoppard. USA, 1987.

Eyes Wide Shut. Dir. Stanley Kubrick. Wr. Stanley Kubrick and Frederic Raphael. UK/USA, 1999.

Fantasmagorie. Dir. Émile Cohl. Wr. Uncredited. France, 1908.

Film Parade, The. Dir. J. Stuart Blackton. Wr. Howard Gaye. USA, 1933.

For Your Eyes Only. Dir. John Glen. Wrs. Richard Maibaum and Michael G. Wilson. UK, 1981.

Foreign Correspondent. Dir. Alfred Hitchcock. Wrs. Chalres Bennett and Joan Harrison. USA, 1940.

From Russia with Love. Dir. Terence Young. Wr. Richard Maibaum. UK, 1963.

Frozen. Dirs. Chris Buck and Jennifer Lee. Wrs. Jennifer Lee, Chris Buck, and Shane Morris. USA, 2013.

Furious Seven. Dir. James Wan. Wrs. Chris Morgan and Gary Scott Thompson. USA/JAPAN, 2015.

Godfather, The. Dir. Francis Ford Coppola. Wrs. Mario Puzo and Francis Ford Coppola. USA, 1972.

Gone with the Wind. Dir. Victor Fleming. Wr. Sidney Howard. USA, 1939.

Gone With the Wind: The Making of a Legend. Dir. David Hinton. Wr. David Hinton. USA, 1988.

Grasshopper and the Ants, The. Dir. Wilfred Jackson. Wr. Uncredited. USA, 1934.

Gravity. Dir. Alfonso Cuarón. Wrs. Alfonso Cuarón and Jonás Cuarón. USA/UK, 2013.

Gulliver's Travels. Dir. Dave Fleischer. Wrs. Edmond Seward, Dan Gordon, Cal Howard, Tedd Pierce, Izzy Sparber, and Edmond Seward. USA, 1939.

Hearts of Darkness: A Filmmaker's Apocalypse. Dirs. Fax Bahr, George Hickenlooper, and Eleanor Coppola. Wrs. Fax Bahr and George Hickenlooper. USA, 1991.

High Noon. Dir. Fred Zinnemann. Wrs. Carl Foreman. USA, 1952.

Hobbit: The Desolation of Smaug, The. Dir. Peter Jackson. Wrs. Fran Walsh, Philippa Boyens, Peter Jackson, and Guillermo del Toro. USA/New Zealand, 2013.

Home. Dir. Tim Johnson. Wrs. Tom J. Astle and Matt Ember. USA, 2015.

How to Train Your Dragon 2. Dir. Dean DeBlois. Wr. Dean DeBlois. USA, 2014.

Humorous Phases of Funny Faces. Dir. J. Stuart Blackton. Wr. Uncredited. USA, 1906.

Indiana Jones: Raiders of the Lost Ark. Dir. Steven Spielberg. Wrs. Lawrence Kasdan, George Lucas, and Philip Kaufman. USA, 1981.

James and the Giant Peach. Dir. Henry Selick. Wrs. Karey Kirkpatrick, Jonathan Roberts, and Steve Bloom. USA/UK, 1996.

Jason and the Argonauts. Dir. Don Chaffery. Wrs. Jan Read and Beverley Cross. USA/UK, 1963.

Jaws. Dir. Steven Spielberg. Wrs. Peter Benchley and Carl Gottlieb. USA, 1975.

Jaws 3-D. Dir. Joe Alves. Wrs. Richard Matheson, Carl Gottlieb, and Guerdon Trueblood. USA, 1983.

Juarez. Dir. William Dieterie. Wrs. John Huston, Æneas MacKenzie, and Wolfgang Reinhardt. USA, 1939.

Jurassic Park. Dir. Steven Spielberg. Wrs. Michael Crichton and David Koepp. USA, 1993.

Karnival Kid, The. Dirs. Walt Disney and Ub Iwerks. Wr. Uncredited. USA, 1929.

Kings Row. Dir. Sam Wood. Wr. Casey Robinson. USA, 1942.

La Jetée. Dir. Chris Marker. Wr. Chris Marker. France, 1962.

La Légende de Rip Van Winkle/The Legend of Rip Van Winkle. Dir. Georges Méliès. Wr. Uncredited. France, 1905.

Le Voyage dans la Lune/A Trip to the Moon. Dir. Georges Méliès. Wr. Uncredited. France, 1902.

Les Aventures de Robinson Crusoé/The Adventures of Robinson Crusoe. Dir. Georges Méliès. Wr. Uncredited. France, 1902.

Les Quat'Cents Farces du diable/The 400 Tricks of the Devil. Dir. Georges Méliès. Wr. Uncredited. France, 1906.

Little Nemo. Dir. Winsor McCay. Wr. Winsor McCay. USA, 1911.

Mad Men (series). Cr. Matthew Weiner. USA, 2007–2015.

Madagascar. Dirs. Eric Darnell and Tom McGrath. Wrs. Mark Burton, Billy Frolick, Eric Darnell, and Tom McGrath. USA, 2005.

Magnificent Ambersons, The. Dir. Orson Welles. Wr. Orson Welles. USA, 1942.

Man Hunt. Dir. Fritz Lang. Wr. Dudley Nichols. USA, 1941.

Mary Poppins. Dir. Robert Stevenson. Wrs. Bill Walsh and Don DaGradi. USA, 1964.

Mickey's Good Deed. Dir. Burt Gillett. Wr. Uncredited. USA, 1932.

Monkeybone. Dir. Henry Selick. Wr. Sam Hamm. USA, 2001.

Monsters University. Dir. Dan Scanlon. Wrs. Dan Scanlon, Daniel Gerson, and Robert L. Baird. USA, 2013.

Moongirl. Dir. Henry Selick. Wr. Uncredited. USA, 2005.

Moonraker. Dir. Lewis Gilbert. Wr. Christopher Wood. UK, 1979.

Moonrise Kingdom. Dir. Wes Anderson. Wrs. Wes Anderson and Roman Coppola. USA, 2012.

Nightmare Before Christmas, The. Dir. Henry Selick. Wrs. Michael McDowell and Caroline Thompson. USA, 1993.

North by Northwest. Dir. Alfred Hitchcock. Wr. Ernest Lehman. USA, 1959.

North West Mounted Police. Dir. Cecil B. DeMille. Wrs. Alan Le May, Jesse Lasky Jr., and C. Gardner Sullivan USA, 1940.

October. Dirs. Grigori Aleksandrov and Sergei Eisenstein. Wrs. Grigori Aleksandrov and Sergei Eisenstein. Soviet Union, 1928.

One Hundred and One Dalmatians. Dirs. Clyde Geronimi, Hamilton Luske, and Wolfgang Reitherman. Wr. Bill Peet. USA, 1961.

One Million Years B.C. Dir. Don Chaffey. Wr. Michael Carreras. UK, 1966.

ParaNorman. Dirs. Sam Fell and Chris Butler. Wr. Chris Butler. USA, 2012.

Penguins of Madagascar. Dirs. Simon J. Smith and Eric Darnell. Wrs. Michael Colton, John Aboud, Brandon Sawyer, Brent Simons, and Alan J. Schoolcraft. USA, 2014.

Pinocchio. Dirs. Hamilton Luske and Ben Sharpseteen. Wrs. Ted Sears, Otto Englander, Webb Smith, William Cottrell, Joseph Sabo, Erdman Penner, and Aurelius Battaglia. USA, 1940.

Plainsman,The. Dir. Cecil B. DeMille. Wrs. Waldemar Young, Harold Lamb, and Lynn Riggs. USA, 1936.

Plane Crazy. Dirs. Walt Disney and Ub Iwerks. Wr. Uncredited. USA, 1928.

Playful Pluto. Dir. Burt Gillett. Wr. Uncredited. USA, 1934.

Psycho. Dir. Alfred Hitchcock. Wr. Joseph Stefano. USA, 1960.

Red River. Dirs. Howard Hawks and Arthur Rosson. Wrs. Borden Chase and Charles Schnee. USA, 1948.

Red Shoes, The. Dirs. Michael Powell and Emeric Pressburger. Wrs. Michael Powell and Emeric Pressburger. UK, 1948.

Red Sonja. Dir. Richard Fleischer. Wrs. Clive Exton and George MacDonald Fraser. Netherlands/USA, 1985.

Room 666. Dir. Wim Wenders. Wr. Wim Wenders. France/West Germany, 1982.

Saboteur. Dir. Alfred Hitchcock. Wrs. Peter Viertel, Joan Harrison, and Dorothy Parker. USA, 1942.

Schindler's List. Dir. Steven Spielberg. Wr. Steven Zaillian. USA, 1993.

Shane. Dir. George Stevens. Wr. A.B. Guthrie Jr. USA, 1953.

Sleuth. Dir. Joseph L. Mankiewicz. Wr. Anthony Shaffer. USA/UK, 1972.

Snow White and the Seven Dwarfs. Dirs. David Hand (Supervising Director), William Cottrell, Wilfred Jackson, Larry Morey, Perce Pearce, and Ben Sharpsteen. Wrs. Ted Sears, Richard Creedon, Otto Englander, Dick Rickard, Earl Hurd, Merrill De Maris, Dorothy Ann Blank, and Webb Smith. USA, 1937.

Spellbound. Dir. Alfred Hitchcock. Wr. Ben Hecht. USA, 1945.

Spy Who Loved Me, The. Dir. Lewis Gilbert. Wrs. Christopher Wood and Richard Maibaum. UK, 1977.

Squaw Man, The. Dirs. Oscar Apfel and Cecil B. DeMille. Wrs. Oscar Apfel and Cecil B. DeMille. USA, 1914.

Star Wars: Episode IV – A New Hope. Dir. George Lucas. Wr. George Lucas. USA, 1977.

Star Wars: Episode V – The Empire Strikes Back. Dir. Irvin Kershner. Wrs. Leigh Brackett and Lawrence Kasdan. USA, 1980.

Steamboat Willie. Dirs. Un Iwerks and Walt Disney. Wr. Uncredited. USA, 1928.

Tempest, The. Dir. Sam Taylor. Wrs. C. Gardner Sullivan, Lewis Milestone, and Erich von Stroheim. USA, 1928.

Thief of Bagdad, The. Dir. Raoul Walsh. Wrs. Lotta Woods, Douglas Fairbanks, Achmed Abdullah, and James T. O'Donohoe. USA, 1924.

Things to Come. Dir. William Cameron Menzies. Wr. H.G. Wells. UK, 1936.

Tintin and the Lake of Sharks. Dir. Raymond Leblanc. Wr. Michel Régnier. Belgium/France, 1972.

Tom Thumb. Dir. George Pal. Wr. Ladislas Fodor. UK/USA, 1958.

Tora! Tora! Tora! Dirs. Richard Fleischer, Kinji Fukasaku, and Toshio Masuda. Wrs. Larry Forrester, Hideo Oguni, and Ryûzô Kikushima. USA/Japan, 1970.

Toy Story. Dir. John Lasseter. Wrs. John Lasseter, Pete Docter, Andrew Stanton, Joe Ranft, Joss Whedon, Andrew Stanton, Joel Cohen, and Alec Sokolow. USA, 1995.

Vertigo. Dir. Alfred Hitchock. Wrs. Alec Coppel and Samuel A. Taylor. USA, 1958.

WALL-E. Dir. Andrew Stanton. Wrs. Andrew Stanton, Pete Docter, and Jim Reardon. USA, 2008.

War Horse. Dir. Steven Spielberg. Wrs. Lee Hall and Richard Curtis. USA, 2011.

When the Cat's Away. Dir. Walt Disney. Wr. Uncredited. USA, 1929.

World Is Not Enough, The. Dir. Michael Apted. Wrs. Neal Purvis, Robert Wade, and Bruce Feirstein. UK/USA, 1999.

You Only Live Twice. Dir. Lewis Gilbert. Wr. Roald Dahl. UK, 1967.

Video games

Bioshock. 2K Games. USA, 2007.

Half-Life 2. Valve. USA, 2004.

Last of Us, The. Naughty Dog and Soncy Computer Entertainment. USA, 2013.

LEGO: The Hobbit. Warner Bros. Interactive Entertainment. USA, 2014.

Red Dead Redemption. Rockstar Games. USA/UK, 2010.

Index

Unless otherwise stated, titles and dates refer to the release date of the film.

214 *Index*